This volume is dedicated to mothers and their families
—each one unique, esteemed, and irreplaceable.

For David, Tess, and Mira, with love and gratitude
—Patricia Drew

To my very patient boys—Derrick, Jack, and Wyatt
—Rosann Edwards

T0308116

Breasts Across Motherhood

Lived Experiences and Critical Examinations

Edited by Patricia Drew and Rosann Edwards

DEMETER

Breasts Across Motherhood
Lived Experiences and Critical Examinations
Edited by Patricia Drew and Rosann Edwards

Copyright © 2020 Demeter Press

Demeter Press
140 Holland Street West
P. O. Box 13022
Bradford, ON L3Z 2Y5
Tel: (905) 775-9089
Email: info@demeterpress.org
Website: www.demeterpress.org

Demeter Press logo based on the sculpture "Demeter" by Maria-Luise Bodirsky www.keramik-atelier.bodirsky.de

Printed and Bound in Canada

Front cover design: Christie Drew
Typesetting: Michelle Pirovich

Library and Archives Canada Cataloguing in Publication
Title: Breasts across motherhood: lived experiences and critical examinations edited by Patricia Drew and Rosann Edwards.
Names: Drew, Patricia Anne, 1975- editor. | Edwards, Rosann, 1975- editor.
Description: Includes bibliographical references.
Identifiers: Canadiana 20200160621 | ISBN 9781772582178 (softcover)
Subjects: LCSH: Breast—Social aspects. | LCSH: Breastfeeding—Social aspects. | LCSH: Women—Social conditions. | LCSH: Motherhood.
Classification: LCC HQ1206 .B74 2020 | DDC 305.4—dc23

Acknowledgments

We extend our sincere thanks to the chapters' authors; their insights, analyses, and experiences made this book possible. Their contributions comprise a unique and valuable addition to the canon of feminist motherhood studies. Andrea O'Reilly and Demeter Press have a deep commitment to mothers, and we are proud to be included in their collection. We are also very thankful to Christie Drew for creating our book's dynamic cover. Our own families, friends, and colleagues have provided ongoing support and encouragement, and we are truly thankful for them. Finally, we thank the many mothers whose voices illuminate this volume.

Contents

Chapter Eleven
Breasts, Health, and Foster Adoption:
When Breastfeeding Is Considered Sexual Abuse
Debra Guckenheimer

Chapter Twelve
Breast Work: My Breasts Deserve A Trip to Hawaii
for All the Work They've Done Nursing
Catherine Ma

Chapter Thirteen
Older First-Time Moms: Breastfeeding and Finding Their Own Paths
Rosann Edwards

Part Three
Breasts in Later Motherhood

Chapter Fourteen
Intergenerational Breasts:
Breast Reduction Surgery Patients and Family Breast Talk
Patricia Drew

Chapter Fifteen
My Breast Reduction Surgery
Heather Jackson

Chapter Sixteen
A Comparative Analysis of Breast Reconstruction
Postmastectomy: German and American Perspectives
Alina Engelman

Introduction

Patricia Drew and Rosann Edwards

B reasts are integral to mothers' bodies; over the life course, they can swell, droop, lactate, be judged, be aroused, be altered, and be removed. A woman's own breasts may be foremost in her mind during some life events, only to recede into the background at other times. Enveloped by cultural meanings that go beyond their primary function as mammary glands, we cannot fully understand breasts without examining the myriad discussions surrounding them. Social policies, cultural norms, and interpersonal interactions all help construct localized breast discourses, which, in turn, shape mothers' perceptions. Through examining commonalities and differences over the lifespan, we can see that mothers' breast experiences inform us about the social conditions in which women live their lives.

Breasts Across Motherhood: Lived Experiences and Critical Examinations explores women's breasted lives after they become mothers. This multidisciplinary collection brings together perspectives from Spain, Brazil, Canada, and the United States, among other countries. It includes both historical and contemporary examinations, and features diverse types of writing, such as first-person narrative accounts, academic interviews, and art analyses. Each chapter offers readers a unique context for understanding how temporally and geographically situated breast understandings affect mothers' personal views and body practices.

This volume weaves together three distinct academic areas: motherhood, self/identity, and breast and body studies. Previous research has typically focused on one or two of these fields—for instance, sociologist Linda Blum's examination of how ethnicity and class shape women's breastfeeding commitments or historian Marilyn Yalom's exploration of transformations in breast understandings over time. However, few studies have examined how mothers' identities sit at the intersection of breast, identity, and motherhood; even fewer have considered breasts

during multiple phases of motherhood. This book helps to address these absences; collectively, the chapters reveal the pervasive ways that societies shape mothers' embodied experiences and breasted selves. Through this examination, *Breasts Across Motherhood* demonstrates that breasts are a central, organizing feature of women's lives.

Motherhood Studies

It is important to place research on mothers' breasts within the context of motherhood studies—a field that has revolutionized both everyday and academic understandings of mothers. In 1976, American poet and essayist Adrienne Rich argued that mothers' lives are subject to extreme external regulation: "Because young humans remain dependent upon nurture for a much longer period than other mammals, and because of the division of labor long established in human groups, where women not only bear and suckle but are assigned almost total responsibility for children" (11). By highlighting mothers' prescribed roles, Rich showed that women's experiences are heavily shaped by outside forces. Her persuasive arguments led to a flood of research rebutting previous, commonplace assumptions that mothering is an instinctual, individualized experience. Motherhood scholars have, instead, analyzed the economic, social, and political conditions that structure lives. They have found, for instance, that mothers are typically expected to be the primary household managers, to undertake a disproportionate share of actual, hands-on labour, and to organize family life (Hochschild). Correspondingly, mothers are assumed to place their family's needs above career considerations (Gerson), which has led many employers to compensate mothers less than similarly qualified men and childless women (Correll et al.). This economic penalty and the cultural motherhood mandate comprise just one example of how outside factors help to shape women's routine mothering practices. As the chapters in this book reveal, mothers' breast views and practices are similarly affected by externally originating forces.

In 2015, women's studies scholar Andrea O'Reilly asserted that it is important to closely examine three facets of mothers' lives: the experience/role of motherhood, the institution/ideology of motherhood, and the identity/subjectivity of motherhood. In everyday life, motherhood is an enacted experience, including birthing children, taking them to

school, teaching them skills (everything from reading to paying taxes), and worrying about adult children. Breasts figure into the work of motherhood when women nurse their children or pump breastmilk. Mothers may worry about their adolescent daughters' burgeoning breasts or wonder whether their own breasts are healthy. Yet motherhood is also an institution and ideology. Societies and governments organize work, school, and children's activities by frequently assuming that mothers will provide appropriate, unpaid labour. Mothers are similarly expected to make their own accommodations for breast-related activities, including scheduling time away from work for pumping, mammograms, or cancer treatment, and purchasing clothing that will minimize breast attention and mark them as good mothers. Finally, motherhood shapes individuals' social identities and self-concepts. Women often see themselves through the lens of their motherhood experiences and view motherhood as central to their lives. Transgender, adoptive, foster, and step parents have expanded traditional comprehensions of motherhood; indeed, a wide array of individuals may engage in mothering and think of themselves as mothers.

O'Reilly's three motherhood facets do not stand alone; each component influences the others. Institutions and ideologies shape women's daily mothering practices and identities. Women's mothering behaviours reinforce and give weight to institutional expectations. Lastly, women's mother identities and self-concepts act as a foundation for the activities that fill women's daily lives and their responses to institutional demands. By incorporating all three components, scholars can better understand the multiple, mutually influencing factors that shape mothering. Mothers' breasts, as a part of motherhood, can be similarly understood through this multilevel lens.

Self-Concept and Identity Studies

Given that social norms and policies shape breast comprehensions, it is vital to thoroughly consider how these factors affect mothers' inner lives. That is, in addition to influencing mothers' breast decision making, society also affects how mothers think about their breast-related self-concepts and social identities. "Self-concept," as considered here, refers to each individual's ability to see and appraise their inner beings (Mead), whereas "identity" refers to others' classifications and

evaluations of a person (Weigert and Gecas). Self-concept and identity are both significant concepts throughout this collection, as the empirical chapters reveal that women's breast-related experiences alter their views of themselves and others' views of them.

Breast-related social identities and self-concepts can transform as women journey through motherhood. Interpersonal interactions often change at the outset of parenting; alterations can occur in intimate relationships, family interactions, and even with abstract phenomena, such as suddenly finding one's self the target audience of a breast-related public health campaign. In aggregate, these modifications can cause women to feel that they have qualitatively changed. Theorists typically account for identity modifications in distinct ways. Process-oriented researchers emphasize the continued mutability of self/identity and the significant creative ability of individuals to create and recreate the self through social exchanges (Blumer). In contrast, structuralists focus upon the permanence of a multifaceted self/identity and the preexistence of the self prior to interaction; people understand who they are via the social positions they inhabit and the previous experiences they have had (Stryker).

An additional, hybrid approach to understanding self and identity has been taken up by life course and narrative studies theorists, and is useful when considering how breast experiences and interactions affect mothers' selves/identities. This approach incorporates structuralists' emphasis on social location and the preexisting self/identity as well as process-oriented researchers' focus on mutability and change. Life course theory instructs us to pay attention to generational cohort, life choices, individual timing for life events, and the influence of age; each of these elements can greatly influence individuals' self/identity conceptions (Elder; Gergen and Gergen). Narrative researchers similarly assert that life course circumstances, structurally bound positions, and situational malleability are all significant components in the creation of narrative-based self/identity conceptions, but they also believe that individuals' sense of personal biography, which is rooted in narrative and discourse, principally permits a sense of a unitary self/identity. Narrative researchers contend that people construct their selves through themes and stories, selectively drawing from a lifetime of memories and experiences to produce the "what is important to me" or "who I really am" tales (Ochs and Capps).

The chapters in *Breasts Across Motherhood* similarly demonstrate that mothers' breast-related selves/identities are shaped over time. Personal experiences, interpersonal interactions, sociocultural location, and a narrative-based self all play roles in impacting self/identity; as women's experiences shift during the course of motherhood, their breasted selves/ identities also change. As readers move through the book, they will see how life circumstances, history, and location form breast comprehensions, and, also, how mothers' concerns modify with their life stage.

Body, Breast, and Breastfeeding Studies

The interdisciplinary field of body studies is a foundational touchstone for understanding how sociocultural locations can shape women's breast experiences. The contemporary research arises from long-standing debates about how to conceive of the body. To nineteenth-century medical researchers, the body was a physical, biological being of nominal social importance (Fissell). In contrast, nineteenth- and twentieth-century sociobiologists saw the body as a necessary precursor to social relations—they assumed that bodies affected interactions (Shilling) and contended that dysfunctional bodies cause deviant behaviour; for example, women's dysfunctional bodies had previously been thought to cause hysteria (Bordo), hypersexuality (Roberts), and shoplifting (Shuttleworth). In recent decades, academics have argued that social relations are integral to the body; it is viewed as socially understood and socially affected. Sociologists Chris Shilling and Pierre Bourdieu have argued that society transforms bodies; many factors— cultural, economic, and political—are visible on the bodies of society members. On a basic level, government policies, geographic locations, and economic circumstances affect individuals' access to healthcare, exercise, and nutritious foods. Social location further affects what people can do with their bodies—use them for physical labour or leisure, access to food, shelter, and hygiene tools (Sundquist and Johansson). In sum, breasts' appearance, health, and meaning are shaped by spatial, temporal, political, and cultural locations.

In the late twentieth century, researchers began to examine how norms and rules influence body consciousness. French philosopher Michel Foucault has argued that modern bodies are subject to continuous scrutiny and control; the effect of such panopticon surveillance is that

individuals are constantly aware that their bodies and movements are judged and they never know exactly when they may be surveilled, subjected to external power, and, potentially, punished. Even when individuals disagree with some particular expectation, they cannot escape the power of dominant practices and the authorities who enforce them; thus, they are likely to act compliantly. Since mothers are keenly aware that their breast appearance and practices are being judged, they often act in ways that conform to broader expectations and judgments. Deviating from social norms and policies means risking censure and punishment: mothers know they could get into trouble for exposing their breasts at unsuitable times or for engaging in inappropriate breastfeeding. By aligning their behaviours with external standards, mothers' breasts become acceptable.

The significance of culturally mediated bodies applies to all individuals, but it is especially consequential for women (Bartky). Although all people are told how to act, modify, and carry their bodies, men are permitted more freedom, space, and body leniency, so long as they do not stray unduly towards femininity. In contrast, middle- and high-income Caucasian women residing in the West are encouraged to control their bodies through feminized demeanour, restricted movement, and minimizing their body size. The slim, docile womanhood image produced from this expectation is widespread; however, other appearance and behaviour expectations exist for different groups of women. Age, race, class, location, sexual orientation, and gender simultaneously affect body expectations. Patricia Hill Collins, a leading voice in intersectionality theory, has examined the impact of "ideas and social practices that are historically situated within and that mutually construct multiple systems of oppression" (263) and has indicated that these enmeshed, co-determinative categories significantly influence body expectations and experiences. Intersectionality theorists stress the important effects of social inequalities and categorical discrimination on body norms; oppressed women's bodies are routinely evaluated by severe standards rooted in historical discrimination. Regardless of the content of the body expectations placed upon women, all women are subject to some form of body surveillance and expected to modify their behaviour and appearance accordingly.

As a part of women's bodies, breasts are routinely subjected to scrutiny and are considered differently in various life phases. In youth

and adolescence, breasts are portrayed as a burgeoning problem: girls are thought to be emotionally troubled by breast development, especially if it occurs earlier or later than expected. Breasts are commonly assumed to affect not only girls' interpersonal relationships with peers and parents but also their own identities. As girls turn into women, breasts are discussed as existing in relation to problematic cultural ideals, and adolescents may judge their breasts against unattainable bodies described in popular culture. In the West, these ideal breasts are depicted as symmetrical, relatively high on the chest, medium to large, relatively firm, and with moderately sized nipples. Women with breasts that vary from this social ideal may suffer personal and interpersonal consequences; for instance, large-breasted women have been "typed as incompetent, immoral, immodest, and not very smart" (Latteier, 10). When women become mothers, their breasts are typically discussed in relation to breastfeeding, regardless of whether they breastfeed or not. As mothers continue to age, breast health becomes an increasingly salient issue, as with each passing decade, women see more friends and family affected by breast cancer. And at various points between youth and old age, women reflect on their breasts' appearance—that is, whether they think of their breasts' size and shape with fondness, neutrality, or criticism.

For the majority of women, pregnancy and childbirth are their first breast-related encounters with the healthcare system, including medical screenings, advice, and interventions. Although they have spent most of their lives internalizing messages about how bodies and breasts should conform to others' expectations and the impossible-to-reach male ideal, pregnancy is the first time most women encounter the overwhelming message—couched in medicalized terms—that there is always some-thing to be monitored, fixed, improved upon, or in need of expert intervention for breasts to function as nature intended (Conrad; Wieczorkowska).

In many ways, medicalization is another form of surveillance and control over unruly bodies. It refers to the construction of natural processes as medical issues that require medical interventions, usually by medical professionals (Conrad). Medicalization of the human body and, more intensely, women's bodies is not a new phenomenon, as Magdalena Wieczorkowska argues that women's breasts are the most medicalized part of the human body. The pervasive belief that breasts need to be managed and fixed influences medical practices and

interventions as far ranging as the active monitoring of breastfeeding mothers to cosmetic surgery to cancer screening. Peter Conrad asserts that twenty-first-century medicalization has shifted from being physicians acting as gatekeepers of medical knowledge to being driven by the agendas of biotechnology, consumers (and the demands thereof), and managed care. The repercussions of this shift are still emerging, but Conrad warns that all three agendas are already "both exploiting and reinforcing gender boundaries" (11).

Despite Conrad's dire warning about the changing nature of medicalization, the growing phenomenon of online communities and the wide-ranging sharing of ideas and experiences have led to progress in maternal breast agency and autonomy. Sociologist Elianne Riska argues that the turn of the new millennium saw the emergence of empowered medicalization propelled by the Internet, online comm-unities, and increased access to medical knowledge; these developments have allowed women to become active agents in their choice of interventions. Yet ever increasing access to online information and knowledge production remains highly problematic. Women still mistrust their own bodies—for example, relying on lactation professionals to fix early breastfeeding (Edwards) or feeling a loss of agency during breast cancer screening and treatment (Grittiths et al.). Women routinely feel they need to justify their personal breast health decisions to healthcare professionals in situations as diverse as struggling with gender identity and postmastectomy reconstructive surgery (Rubin and Tanenbaum) to choosing not to breastfeed.

Although many studies related to breast medicalization and appearance have focused on Canada and the United States, there is ample evidence that women in other locales are similarly affected by regional standards. For instance, in Taiwan, breast appreciation and care are related to images of breasts as feminine. Women who identify as "T" (the rough equivalent of butch lesbians) rarely express appreciation for their breasts, are likely to engage in binding, and have low rates of undergoing breast cancer screenings. In contrast, "Po" (similar to femme lesbians) women indicate practicing higher levels of breast care and breast appreciation (Wang et al.). Cultural standards similarly shape South African women's breast experiences, where young women who underwent breast reduction surgery did so in order to attain breasts aligned with regional, prevailing ideals venerating smaller breasts

(Lamb and Vincent). Both studies underscore the impact of localized sociocultural norms.

Cultural standards and medical technologies additionally help to shape the chest and breast experiences of noncisgendered parents. Nascent research on transgender families recognizes the varied ways that trans dads and trans moms identify themselves and organize their breasted or chested experiences. Many transgender women describe psychological benefits related to breast development; having breasts enables them to feel that their bodies, self-concepts, and social identities are aligned (Rosenberg et al.). Trans moms can attempt to breastfeed with the use of hormones or milk supplementation, and the first clinical report of successful breastfeeding without supplementation occurred in 2018 (Reisman and Goldstein). The chestfeeding practices of trans men are somewhat more documented than those of trans moms; studies indicate that, regardless of whether they have had male chest-contouring surgery, many can lactate after childbirth (MacDonald). Chestfeeding trans dads express a variety of attitudes about their milk-producing chests, ranging from increased gender dysphoria to increased self-acceptance. Collectively, the emerging scholarship on transgendered parents encourages researchers and readers to expand traditional cisgendered notions of chest and breast experiences.

Regardless of locale and gender identity, and irrespective of individuals' decisions, breastfeeding discourses are a central focus of early parenthood. Breastfeeding is fraught with contractions; it can be an intensely personal, embodied experience and, at the same time, a very public performance (Short et al.). For those who become pregnant and give birth, breastfeeding can represent the continued use and sharing of the maternal body; indeed, this intimate utilization is repeated eight to twelve times a day. Of course, many mothers do not breastfeed, and their ranks include women who became mothers through birthing (whether their own or their partner's birthing experience), adoption, and marriage. Although nursing does not figure into these mothers' daily activities, breastfeeding norms still shape their lives. Mothers' infant feeding choices are scrutinized and moralized at every turn.

If mothers do choose to breastfeed, their experiences are not uniform. For some, the lactating breast and the practice of breastfeeding is the first time they truly own their body, find success, and create an affirming passage into their next life phase (Edwards et al.). For others, it is a loss

of autonomy, a loss of personal freedom, and the first time that their breasts are not their own anymore; these mothers may feel that everyone—from the baby to the stranger in the coffee shop—seems to have more of a say over their breasts than they do. The simple reality is that once women become mothers, nothing is ever the same again. It seems mothers' breasts—and what they do with them—are everybody's business.

Part One: Discourses Surrounding Mothers' Breasts

The first portion of *Breasts Across Motherhood* features five chapters that examine discourses surrounding mothers' breasts. Ranging from localized to widespread and from historical to contemporary, each piece shows how social messages and policies help structure mothers' breast experiences and views. Together, the authors indicate that women's breasted experiences do not arise in a vacuum but rather are socially influenced and temporally and spatially situated.

The collection opens with Lisa Sharik's "Breasts: From Functional to Sexualized," which details how breast comprehensions have been thoroughly transformed in the West. In this chapter, Sharik discusses the eroticization of breasts through biased science and objectifying art; she contends that the emphasis on sexuality has led to the cultural dismissal of the functional, breastfeeding mammary gland. Sharik's insightful account of the changing significance of breasts shows how mothers are compelled to ruminate on the meaning of their breasts as they go through the world.

Jessica M. Rodriguez-Colon extends Sharik's art analysis in "The Madonna's Breast and the Surprise of the Real: From Ideal to Embodied." By juxtaposing classical images of Madonna nursing her child with contemporary, feminist versions, Rodriguez-Colon argues that artists' depictions help to construct cultural interpretations of women's breasts. Within the traditional religious iconography of the Middle Ages, the breastfeeding Madonna is shown engaging in sacred, personal behaviour; this portrayal helped society to view breastfeeding as a private, sacrosanct act. In contrast, contemporary feminist artists emphasize variation and exposure; these new Madonnas have different races, body types, attitudes, and levels of breast display. Rodriguez-Colon concludes that such heterogeneous and reality-based images open the door for the normalization of real mothers' breasts.

Although historical artifacts and past scientific theories certainly affect breast understandings, present-day policies and debates also shape views, which is seen within Irene Rocha Kalil and Adriana Cavalcanti de Aguiar's "'The Body for Someone Else': Mothers' Breasts in Brazilian Probreastfeeding Discourses." The authors analyze mothers' breastfeeding comprehensions within the context of Brazil's annual probreastfeeding public health campaign. Rather than seeing breastfeeding as an individual, private choice, the authors demonstrate that larger forces promote breastfeeding as a national mandate. They first detail how Brazil's campaign posters emphasize that breastfed babies are healthy babies and healthy babies lead to a prosperous nation. Second, the authors document how posters routinely feature photographs that are stylistically reminiscent of classical paintings, enabling the mother/consumer to see breastfeeding as a traditional, timeless behaviour. Finally, Kalil and Cavalcanti de Aguiar note that the use of celebrities in the campaigns turns breastfeeding into a lauded, aspirational act. The myriad textual and visual elements included in the state-sponsored posters strongly promote breastfeeding and validate the identities of women committed to nursing.

Not all countries promote breastfeeding like Brazil. In "Public Breastfeeding as a Scandalous Practice," authors Serena Brigidi, Marta Ausona, Laura Cardús, Maria Berruezo, and Alba Padró reveal that Spanish women's breasts are primarily considered sexual and private. Their chapter demonstrates how politics and cultural representations come together to stigmatize public breastfeeding; the authors detail how the Franco regime's mid-twentieth-century portrayal of motherhood as an obligation led to a post-Franco, feminist backlash against motherhood and nursing. Additionally, Brigidi et al. document frequent Spanish descriptions of breasts and breast milk as "dirty," which negatively affects the public's perception of breastfeeding's appropriateness. Mothers are encouraged to limit nursing to hidden locales where they will not sully public environments or offend passersby. Although anti-public breastfeeding discourses abound in Spain, the authors highlight a countertrend of resistance: women who have come together to resist antibreastfeeding narratives and encourage increased acceptance of mothers' breasts.

The last chapter of Part One reveals how medical discourses simultaneously shape mothers' breastfeeding comprehensions and their

self-perceptions. Kristin J. Wilson and Wendy Simonds's "Tongue Tied: Medicalization of the Mouth-to-Breast Latch" systematically details the development of medical views surrounding tongue- and lip-tie; they also show how various experts support different understandings of the phenomenon and its solution. The lack of a medical community consensus regarding the meaning and treatment of tongue- and lip-tie has placed parents—most often mothers—in the position of medical decision makers. Wilson and Simonds's chapter determines that although mothers frequently blame themselves for early breastfeeding difficulties, tongue- and lip-tie diagnoses allow mothers to eschew personal blame and instead understand their nursing difficulties as located in their babies' physical makeup. When their children undergo treatment, women can see themselves as good mothers who are trying mightily to correct their children's physical imperfections and also to improve their ability to successfully breastfeed.

Part Two: Early Motherhood Narratives

In Part Two of *Breasts Across Motherhood,* the personal meets the political—in this case, medical authorities and representatives of other large cultural institutions. This meeting is akin to a collision when institutions and experts attempt to influence how mothers use their breasts. At times, these external bodies try to sway mothers' attitudes, whereas at other junctures, authorities overtly govern mothers' breasts. In this section, the authors provide narrative accounts and critical analyses related to breasts during the early years of motherhood. The profiled mothers negotiate their personal preferences, social norms, and structural constraints; many are also grappling with how to simultaneously maintain body autonomy while being close to their offspring.

In the opening chapter of Part Two, Erica Cavanagh poignantly asserts that early breast experiences have lasting effects. In "The Story of My Breasts," readers learn how Cavanagh's own body views were altered by others' invasive actions; she thoughtfully explores how teenage catcalling and sexual assault affected her breast conceptions during adolescence and early motherhood. She gives a moving personal account of the power of reclaiming one's maternal breasts and creating a healthy embodied relationship for herself and her daughter through

breastfeeding. Despite others' desire to control Cavanagh's body, she is able to reclaim her body's narrative for herself.

Early motherhood breast definitions have also been reclaimed by Canadian First Nations communities. In "A Manifesto on the Sacredness of Anishinaabeg Mothers' Breasts," Renée E. Mazinegiizhigoo-kwe Bédard uses both the teachings of elders and her personal experiences to explore how mothers from the Anishinaabeg First Nations engage in nursing. This cultural information affects how Anishinaabeg women understand their breasts once they transition into motherhood. Moreover, Bédard shows how culturally informed breastfeeding enriches mothers' connections to rich Anishinaabeg traditions through passing down stories and also through the custom of creating their personal medicine bags. With this examination, Bédard demonstrates the profound implications of culture on the lived experience of mothers' breasts.

Whereas culture can provide enriching traditions, some cultural norms can be maddening. In "The Professor's Breasts: An Alphabetical Guide to Academic Motherhood and Breastfeeding," Robin Silbergleid explores the pressures and, at times, irreconcilable differences between personal and professional aspects of her existence once she enters motherhood. Silbergleid's breasts represent a site of discord between her public persona and her role as a mother of young children; she struggles to find not only a balance for herself but also solace and understanding in the public displays of the private nursing lives of other academic mothers. She discusses how her life has been shaped by social standards, technological developments, and medical mandates; the reader comes away with a sense of how all-consuming nursing can be and, also, how Silbergleid's views changed over time. This chapter underscores how the institution and ideology of motherhood are often at odds with broader societal norms and expectations.

Although this collection primarily focuses on cisgendered mothers, it is important to complicate taken-for-granted gender assumptions and augment knowledge about trans parents' experiences. To that end, Lara America reflects on her transgendered body's possibilities as she enters into motherhood in "My Breasts, My Authenticity." She details her purposeful journey to become a biological parent, which included the temporary cessation of hormone therapy in order to produce sperm. America's breast size and breasted identity are affected by this process,

as her breasts represent an embodiment of her gender identity. After her partner becomes pregnant and Americo's own breasts reappear, she questions her personal desire to nurse their child, asking herself if she sees breastfeeding as affirming her gender identity or as child nourishment. Americo considers the presence, absence, and possibilities of her breasts, and, in doing so, she reveals the myriad ways that breasts affect individuals' self-concepts.

Jessica Whitbread and Saara Greene's "Going Beyond the Guideline: Breastfeeding with HIV" documents the extraordinary lengths Whitbread went to in order to breastfeed her twin daughters as an HIV-positive mother in Canada. It is also a call to action to protect the rights of future HIV-positive Canadian mothers to ensure they can safely and legally breastfeed their children. The authors chronicle the fear and secrecy Whitbread lived with while interacting with nurses, physicians, and public health officials. Through their discussion, Whitbread and Greene reveal how mothers with stigmatized identities must carefully navigate laws; to blunder ahead without forethought is to risk having your children removed. Whitbread and Greene call attention to the laws that characterize some mothers' breasts as unfit and, consequentially, force some mothers to go underground with their mothering practices.

State regulations and potential penalties are also explored by Debra Guckenheimer in "Breasts, Health, and Foster Adoption: When Breastfeeding Is Considered Sexual Abuse." Like HIV-positive Canadian mothers in Whitbread and Greene's essay, the maternal breasts of Gukenheimer and other American foster-adoptive mothers are judged unfit to nurse the infants these women are mothering. The very act of putting their child to their breast is illegal; for these mothers, breastfeeding is considered an act of potential sexual abuse perpetrated by foster mothers towards their infants. Gukenheimer details how her hope to nurse her baby and respond to her baby's changing needs existed in opposition to the foster care agency's condemnatory, possibly sexualized, understanding of a breastfeeding foster mom. This tension was palpable, as the agency could have removed her daughter if Gukenheimer had failed to mother her child in accordance with the agency's dictates. As with Whitbread and Greene, this chapter speaks to the power of state institutions to regulate mothers' breasted lives.

In "Breast Work: My Breasts Deserve a Trip to Hawaii for All the Work They've Done Nursing," Catherine Ma ties together the history

of biomedical control, health promotion campaigns, and the influence of feminism on breastfeeding. Ma weaves her own experiences as a breastfeeding mother into her analysis; her personal reflections are sometimes lighthearted and are sometimes painful, but they are always truthful. Through this multifaceted examination, Ma provides historical and cultural context for breastfeeding struggles, and concludes with a message of empowerment and solidarity.

Part Two concludes with Rosann Edwards's chapter, "Older First-Time Moms: Breastfeeding and Finding Their Own Paths," which examines women who entered motherhood after age thirty-five. Following these women through their first half-year of motherhood, Edwards describes how they negotiate and renegotiate their new mothering identities. Breasts and breastfeeding are essential components of their identities, and the author documents how the women shift from inexperienced outsiders to knowledgeable insiders. Over time, these mothers decrease their reliance on outside opinions and begin to recognize and prioritize their own maternal perspectives. Rather than feeling like vulnerable objects, Edwards' mothers increasingly perceive themselves to be knowledgeable, powerful, and in control of their nursing decisions.

Part Three: Breasts in Later Motherhood

The chapters in the final section of *Breasts Across Motherhood* explore women's breast satisfaction and health in the later years of motherhood. New mothers may also encounter these issues; however, the mothers profiled in these chapters are past their breastfeeding years. As with previous sections of this collection, the mothers' breasted views are rooted in their interpersonal interactions and social locations.

Patricia Drew's chapter, "Intergenerational Breasts: Breast Reduction Surgery Patients and Family Breast Talk," highlights the roles of families and motherhood in shaping women's elective breast reduction experiences. This study explores the perspectives of two mothers—first examining the breast messages they received from their families and, second, exploring the types of breast messages that these women intend to pass on to their daughters. Both women indicate reflecting upon their families' messages as they thought about their breasts and decided to undergo surgery. Moreover, both interviewees reflected on their parents'

body messaging as they decided how to frame breasts with their own prepubescent daughters. In sum, the interviewees indicate that parents' breast messages continue to influence their children's body esteem throughout the lifespan.

Body modification is also the topic of Heather Jackson's personal essay, "My Breast Reduction Surgery," where she describes her changing relationship with her breasts. As she became a mother, biological changes affected both the physical appearance and the feel of her breasts; they became larger and painful during pregnancy and after childbirth. The author also shows how having a poor body image and an eating disorder affected her breast views; she perceived her breasts as ponderous and uncontrollable. By simultaneously reflecting on her breast dissatisfaction, feminist ideals, and anarchist ideology, Jackson shows how she sought to have a better relationship with her body. Through opening her struggle, readers can witness the multiple external factors affecting breast satisfaction.

Culture and location affect health decisions in Alina Engelman's exploration of her mother's recent breast cancer experience. In "A Comparative Analysis of Breast Reconstruction Postmastectomy: German and American Perspectives," Engelman highlights the role of place in shaping standards of patient care. The author's mother, who was raised in Germany and now resides in the United States., initially assumed that breast reconstructions were unproblematic and the universal standard. However, after speaking with German relatives, Engelman's mother came to realize that breast implants carried their own set of potential problems; these reconstruction issues are more readily recognized in Germany than in the United States. Through exposing the role of place-based norms in breast care decision making, Engelman pinpoints how local medical discourses shape women's lives.

Catalina Florescu's "Unsent Letters: 1992–2020" similarly highlights the role of place in shaping women's decisions. When Florescu's mother was diagnosed with breast cancer in her native Romania, her treatment choices reflected both local and personal concerns: her suspicion that the Chernobyl nuclear plant disaster might be to blame; her reluctance to lose her breasts through mastectomy; and her frustrations with life under communism. Florescu shows how her mother's treatment decisions were influenced by the time and place in which she lived; Romanian cultural discourses about femininity and female body ideals strongly shaped her choice to decline a mastectomy. Florescu attempts

to come to peace with her mother's eventual death by "talking back" to her mother through discussing artists and writers who have shaped her cancer-related beliefs in the subsequent years. Although it is impossible for Florescu to alter her mother's outcome, the passages directed at her mother assert that it is okay to have a mastectomy and that being flat-chested represents a different form of beauty. In this, the author attempts to rebut Romanian beauty messages, which led her mother to cease cancer treatment.

The book's concluding chapter, "Future Breasts, Future Selves: Mid-life Women's Thoughts," features the voices of midlife women as they imagine their breasts in older age. Their narratives draw upon personal histories, present-day circumstances, and anticipated lives; they help to demonstrate how social locations shape current and prospective breast concerns. In this brief chapter, women highlight a diverse array of hopes for their future breasts: attractive, healthy, comforting, and pleasurable. In their statements, the featured women poignantly forecast the significance of breasts in their senior years.

When read together, the eighteen chapters featured in *Breasts Across Motherhood* demonstrate the lifelong salience of breasts in women's lives. Although women's personal perceptions and experiences vary widely by geography, age, and community, the combined chapters show how social forces shape mothers' breasted lives. Social forces exert influence over their personal breast perceptions and choices, their interpersonal, breast-related interactions, and, their socially based breast experiences. Collectively, the chapters uncover the processes by which mothers' breasts are tacitly and overtly regulated; moreover, the authors reveal the myriad mechanisms that influence women's feelings about their breasts and their breast behaviours.

Works Cited

Bartky, Susan. "Foucault, Femininity and the Modernization of Patriarchal Power." *Feminism and Foucault: Reflections on Resistance*, edited by Irene Diamond and Lee Quinby, Northeastern University Press, 1988, pp. 61-86.

Blum, Linda. *At the Breast: Ideologies of Breastfeeding and Motherhood in the Contemporary United States*. Beacon Press, 1999.

Blumer, Herbert. *Symbolic Interactionism: Perspective and Method*.

University of California Press, 1969.

Bordo, Susan. *Unbearable Weight*. University of California Press, 1993.

Conrad, Peter. "The Shifting Engines of Medicalization." *Journal of Health and Social Behavior*, vol. 46 (March), 2005, pp. 3-14.

Correll, Shelley, Stephen Benard, and In Paik. "Getting a Job: Is There a Motherhood Penalty?" *American Journal of Sociology*, vol. 112, no. 5, March 2007, pp. 1297-1338.

Edwards, Rosann, et al. "Factors Influencing the Breastfeeding Practices of Young Mothers Living in a Maternity Shelter: A Qualitative Study." *Journal of Human Lactation*, vol. 33, no. 2, 2017, pp. 359-367.

Elder, Glen. *Life Course Dynamics*. Cornell University Press, 1985.

Foucault, Michel. *Discipline and Punish: The Birth of the Prison*. New York: Vintage, 1979.

Gergen, Mary, and Kenneth Gergen. "Narratives of the Gendered Body in Popular Autobiography" *The Narrative Study of Lives*, edited by Ruthellen Josselson and Amia Lieblich, Sage Publications, 1993, pp. 191-216.

Gerson, Kathleen. *The Unfinished Revolution: How a New Generation Is Reshaping Family, Work, and Gender in America*. Oxford: Oxford University Press, 2010.

Collins, Patricia Hill. *Black Sexual Politics: African Americans, Gender and the New Racism*. New York: Routledge, 2004.

Hochschild, Arlie. *The Second Shift: Working Families and the Revolution at Home*. Viking, 1989.

Lamb, Tessa, and Louise Vincent. "When Breast is Not Best—Young Women and Breast Reduction Surgery." *Agenda*, vol. 25, no. 3, 2011, pp. 9-17.

Latteier, Carolyn. *Breasts: The Woman's Perspective on an American Obsession*. Routledge, 1998.

MacDonald, Trevor. "Lactation Care for Transgender and Non-Binary Patients: Empowering Clients and Avoiding Aversives." *Journal of Human Lactation*, vol. 35, no. 2, 2019, pp. 223-26.

Mead, George Herbert. *Mind, Self and Society*. University of Chicago Press, 1934.

Ochs Elinor, and Lisa Capps. *Living Narrative: Creating Lives in Everyday*

Storytelling. Harvard University Press, 2001.

O'Reilly, Andrea. *Maternal Theory: Essential Readings.* Demeter Press, 2015.

Reisman, Tamar, and Zil Goldstein. "Case Report: Induced Lactation in a Transgender Woman." *Transgender Health*, vol. 3, no. 1, 2018, pp. 24-26.

Rich, Adrienne. *Of Woman Born: Motherhood as Experience and Institution.* Virago, 1976.

Riska, Elianne. "Gendering the Medicalization Thesis." *Gender Perspectives on Health and Medicine: Key Themes Advances on Gender Research*, vol. 7, 2003, pp. 59-87.

Roberts, Dorothy. *Killing the Black Body.* Vintage, 1997.

Rosenberg, Shoshana, et al. "'I Couldn't Imagine My Life Without It': Australian Trans Women's Experiences of Sexuality, Intimacy, and Gender-Affirming Hormone Therapy." *Sexuality & Culture*, vol. 23, 2019, pp. 962-77.

Rubin, Lisa and Molly Tanenbaum. "'Does That Make Me a Woman?' Breast Cancer, Mastectomy, and Breast Reconstruction Decisions among Sexual Minority Women." *Psychology of Women Quarterly*, vol. 33, no. 3, 2011, pp. 401-14.

Shilling, Chris. *The Body and Social Theory.* Sage Publications, 2003.

Short, Ann Marie, et al. *Breastfeeding and Culture: Discourses and Representation.* Demeter Press, 2018.

Shuttleworth, Sally. "Female Circulation: Medical Discourse and Popular Advertising in the Mid-Victorian Era." *Body/Politics: Women and the Discourses of Science*, edited by M. Jacobus et al., Routledge, 1990, pp. 47-68.

Stryker, Sheldon. *Symbolic Interactionism: A Social Structural Vision.* Benjamin Cummings, 1980.

Sundquist, J. and S. E. Johansson. "The Influence of Socioeconomic Status, Ethnicity and Lifestyle on Body Mass Index in a Longitudinal Study." *International Journal of Epidemiology*, vol. 27, 1998, pp. 57-63.

Wang, Ya, Ching. "The Influence of Gender Identities on Body Image and Breast Health among Sexual Minority Women in Taiwan: Implications for Healthcare Practices." *Sex Roles*, vol. 78, no. 3-4,

June 2017, pp. 1-13.

Weigert, Andrew, and Victor Gecas. "Self." *Handbook of Symbolic Interactionism*, edited by Larry T. Reynolds and Nancy J. Herman-Kinney, Alta Mira Press, 2003, pp. 267-288.

Wieczorkowska, Magdalena. "Medicalization of a Woman's Body- A Case of Breasts." *Przeglad Socjologiczny*, vol. 61, no. 4, 2012, pp. 143-72.

Yalom, Marilyn. *A History of the Breast*. Ballantine, 1997.

Part One

Discourses
Surrounding
Mothers' Breasts

Chapter One

Breasts: From Functional to Sexualized

Lisa Sharik

In contemporary Western cultures, women's breasts are primarily known as visual markers of femininity and sexual objects for heter-onormative pleasure (Bartlett; Campo), which is rather amazing, given that women's breasts, biologically known as mammary glands, are not scientifically classified as sexual organs. Breasts have no role to play in reproduction, unlike ovaries, testicles, penises, and vaginas (Dettwyler; Williams). The propensity to objectify and sexualize breasts has resulted in breasts becoming the foremost female body part to be exhibited, flaunted, measured, scrutinized, inflated (Blum), and, most recently, sexted.

Many feminists have argued that when extensive sexual attention is fixated on one body part at the exclusion of others, it has become a fetish (Yalom; Young). In the West, breasts are most definitely fetishized; they are seen as sexual objects—things that others judge from afar based on preconceived notions of how attractive breasts should appear. In the case at hand, big, firm, perky breasts—objects that can be handled and man-ipulated—continue to be highly valued. The worth assigned to women's breasts is equated with women's value as sexual beings (Young). However, to assume that a singular body part should define and classify women's worth is nothing short of ludicrous. There is much more to women than the size and shape of their breasts.

Unsurprisingly, the widespread belief that breasts are linked to women's sexual appeal has figured prominently in sexuality discourses. Breasts have long been viewed as symbols of female desirability, with

the primary purpose of attracting male attention. Over time, breasts have come to be recognized as valid representations of women's sensuality and a key component of sexual pleasure—so much so that they are required to be present in order for women to be seen as sexual (Carter; Groz). This chapter details how knowledge about breasts' biological function has been usurped by the sexualization and objectification of breasts; in detailing this transformation, I argue that women should reclaim control over their breasts' definitions.

What Are These Glands For?

> "Breasts are a body part that we didn't start out with,
> whole new organs, two of them, tricky to hide or eradicate,
> attached for all the world to see, twin messengers announcing our
> lack of control, announcing that Nature has plans for us about
> which were not consulted."

—Francine Prose, *Master Breasts*, 10

Why do women have breasts? Aside from basic information such as dimension, volume, and composition, a lot remains unknown about human breasts, including how exactly they develop (Werb). Technically, breasts are referred to as mammary glands; their name stems from the class *Mammalia*, which literally means "of the breast" and is derived from the Latin term *Mammae*, which refers to the breast (Schiebinger). Although the mammary glands of human females share the same basic functions and anatomical make up as other female mammals, they are strikingly different in their appearance. To illustrate, unlike other female primates, human females' mammary glands become swollen and remain swollen even when they are not pregnant. Other female primates develop small swellings only while lactating and these shrink after weaning (Schiebinger). Anthropologist Dan Sellen, who specializes in nutrition and evolution, argues that human females' mammary glands are structurally different from other primates due to the delivery of essential nutrients that occurs during lactation and helps to sustain humans' enormous, complex brains (qtd. in Williams).

With over six thousand species-specific genes, it comes as no surprise to learn that of all the organs in the human body, mammary glands are

the only organs that are not fully developed by adulthood; they do not fully develop until a woman becomes pregnant. Remarkably, breasts build themselves out of seemingly nothing during puberty, when breast receptor cells receive signals from hormones to begin maturing. From this point on, a woman's breasts will go through the process of constructing and deconstructing a little bit each month regardless of whether she ever becomes pregnant. When a human female does become pregnant, her breasts develop in preparation for lactation. Once the child is weaned, or if a woman chooses not to breastfeed, the breasts transform once again (Williams). As noted above, unlike other primates, a woman's breasts will never actually shrink completely once lactation has ceased. Thus, whether or not a woman is pregnant or breastfeeding her breasts will continually protrude from her chest (Williams). In sum, the inner mechanisms of breasts have a complex and important role to play in the biological lives of women, with everything from their initial development to the intricate wiring and signals that take place for the purpose of lactation and breastfeeding.

From Mammary Glands to Sexual Breasts

> "So what is it about this small gland of postnatal nourishment that puts a great nation in such a dither? Perhaps it has to do with generations of men who did not get enough nipple when it really counted."
>
> —Glenn O'Brien, Playboy, 42-43

Although women's breasts are routinely scrutinized, it is the representations of women's breasts and bodies that set the cultural standards for women's appraisal (Carter). The public has been bombarded with images and representations of sexually objectified breasts for centuries; thus, it is not surprising that women's breasts have come to signify female attractiveness. From museums and art galleries to the covers of magazines, posters, and advertisements, it does not take long to notice that images of women's breasts (oftentimes titillating, highly idealized, and erotic) are everywhere. Today, representations of women's breasts in Western cultures still tend to highlight idealized, erotic breasts rather than the breasts of average women (Yalom). Objectifying, sexualized

characterizations of breasts have existed for at least six hundred years in the West.

Prior to the fifteenth century, many works of art—such as sculptures (e.g., Minoan goddesses), statues (Greek and Roman Goddesses), and paintings (e.g., the nursing Madonna)—highlighted breasts for their ability to sustain life. Cultural meanings attached to human bodies began to shift during the Renaissance, as physical pleasures were increasingly emphasized (Yalom). In this changing climate, many male artists began to highlight and eroticize breasts. The images of breasts created during this period played a powerful role in creating contemporary cultural beliefs; they helped set standards for the Renaissance body's appearance and meaning.

In art spanning the fifteenth, sixteenth, and seventeenth centuries, women's breasts can often be seen spilling out of tightly laced corsets. During the sixteenth century, paintings of nude breasts began to flourish, with women appearing either alone or in the company of another woman who was oftentimes touching her breast and nipple— something that male artists and audiences considered highly arousing (Yalom). Even in serene landscape paintings, bare breasted and/or nude females were often included as part of the landscape set among the trees and valleys. When women and men were portrayed together in paintings, oftentimes the woman was in a state of undress, whereas the man was fully clothed and either gazing longingly at her breasts or had one hand resting on her breast (Yalom).

In this climate, it did not take long before breasts came to be known and desired as titillating sexual objects. Whether in artwork or literature, the eroticized breasts were presented as a means of arousing men, not women. As art historian Linda Nochlin notes, many of the sexualized paintings of women were in no way based on the desires of the women portrayed; rather, the sexualized images were created by the male artists based on their longings and intended for the enjoyment of men (qtd. in Yalom). As sexual and eroticized breasts began to take precedence over sacred breasts, they also came to be known more as objects of male desires and the property of men.

Even today, it does not take long to notice that many of the images of women used in Western cultures' patriarchal-dominated media continue to highlight sexual breasts—with the majority being created about women, most often by men and for men (Yalom). The creation of such

images highlights the hegemonic ideology of normative heterosexuality, which has typically been defined by men and for men (Blum; Carter; Young). Hence, women's images are intended to gratify men's yearnings while simultaneously changing the meaning of breasts. The consequence of always highlighting sexual breasts rather than non-idealized and noneroticized breasts is that it produces a false portrayal of what most women's breasts actually look like (Yalom).

Modernizing Sexual Breasts

> "The mammary fixation is the most infantile and the most American, of the sex fetishes."
>
> —Molly Haskell, *From Reverence to Rape*, 105

In the nineteenth century, social and cultural changes brought forth by Western modernization and industrialization augmented transformations in the social attitudes about breasts and bodies. By the time manufactured infant formulas became available in the late 1800s, breasts had been considered sexual for nearly six hundred years. Although breasts had been vital organs capable of sustaining infants' lives, the introduction of artificial breastmilk reinforced the sexualized objectification of breasts; breasts were no longer needed for nourishment (Apple; Wolf). During this time period, Western patriarchal beliefs became linked with the ideologies of capitalism and technology, which helped frame individuals' worldviews and daily lives (Rothman). As lactation was increasingly devalued, fewer women breastfed their infants, and breasts came to be viewed in an increasingly sexualized manner.

The mass marketing of corsets and bras in the late nineteenth century and early twentieth century further cemented the eroticization of breasts. Advertisements argued that breasts needed to look a certain way in order for a woman to be sexually attractive for her husband. As sexual breasts began to take precedence over lactating breasts, not only were fewer women choosing to breastfeed, but those women who did breastfeed were becoming increasingly uncomfortable doing so in front of others for fear of exposing their (sexual) breast (Wolf).

The equation of women's breasts with sexual objects appears to have

infiltrated the public's consciousness in Western cultures to the point where not thinking of breasts as sexual became an anomaly. Over time, as more attention has been given to sexual definitions, the primary lactation function of breasts has become lesser known, with some people denying that breasts have any role to play in infant health, nutrition, and childrearing (Dettwyler). Thus, whether to attract male attention and satisfy male desires or to define and highlight a woman's sexuality, sexual breasts have come to unreservedly define women's breasts in Western cultures, which has resulted in lactating breasts being largely unappreciated.

Sexualization in Science

> "No one pays attention to mammary glands and lactation, even though it is perhaps the most significant occurrence in mammalian ascendance, because the field is dominated by men who only think of breasts as sexual objects."
>
> —Olav Oftedal, qtd. in Williams, 44-45

The sexualization of human breasts goes beyond art, cultural norms, and capitalist practices. Indeed, during the mid-to-late twentieth century, evolutionary biologists frequently drew upon sexualized conceptions of breasts when theorizing mating behaviours and, concurrently, minimizing the role of mammary glands and lactation in human evolution. Beginning with zoologist Desmond Morris, who wrote the male dominance manifesto *Naked Ape* in 1967, and Owen Lovejoy, who wrote many articles based on Morris's theories in the latter part of the twentieth century, many evolutionary biologists have argued that the prominent breasts of early hominid females helped to attract early hominid males, and this erotic attraction helped to ensure successful relationships. According to Morris and Lovejoy, early males would only have sexual intercourse with women who had big, voluptuous breasts; without them, man-the-hunter would have no reason to remain in a relationship. Morris even went so far as to equate women's breasts to swollen buttocks: "the protuberant, hemispherical breasts of the female must surely be copies of the fleshy buttocks" (67). With such elaborate conjectures, it appears that Morris began his

research by using stereotypical mid-twentieth-century biases equating women's worth to their body parts.

Anthropologist and evolutionary writer Elaine Morgan wrote *The Descent of Woman* in 1972 as a response to the theories posited by Morris and Lovejoy, among others. Morgan aptly refuted Morris's objectification: "Desmond Morris, pondering on the shape of a woman's breasts, instantly deduces that they evolved because her mate became a Mighty Hunter, and defends this preposterous proposition with the greatest ingenuity. There's something about the Tarzan figure which has them all mesmerized" (5). Despite critiques put forth by Morgan and her contemporaries, numerous introductory anthropology textbooks continue to include breast evolution theories proposed by Morris and Lovejoy as well as illustrations of early human females (e.g., Lucy) with big, bountiful breasts, even though there is a lack of fossil evidence for such fleshy breasts, since they do not leave fossils behind (Dettwyler). The theories claiming breasts had an erotic value among early humans are seldom questioned despite the absence of proof. These problematic claims have helped to perpetuate the Western belief that breasts are primarily sexual.

Conclusion

Without a doubt, the ongoing obsession with sexualizing women's breasts—which began to take hold during the Renaissance and increased exponentially at the end of the nineteenth century—had led to breasts being predominantly understood as twenty-first-century sexual objects. Through intergenerational socialization, most people have come to accept the dominant sexual meanings that have been attributed to breasts (Hausman; Yalom), without ever questioning why and how this narrative came to be. Centuries of art, media, and biased research have reinforced the predominant belief in Western cultures that breasts develop for the sake of sexual attention and pleasure.

The time has come to call for a paradigm shift in how breasts are spoken of, thought about, and imagined in Western cultures. Doing so will require decoupling the lactating breast from the sexual breast (Shaw). Perhaps through this shift, the public may begin to appreciate and know breasts for what they are: mammary glands capable of sustaining life. Such a shift is not intended to eliminate sexual breasts

but rather to decrease the infatuation that Western cultures have with sexualizing breasts. Instead of categorizing and knowing breasts as either functional organs that are capable of sustaining the lives of infants or as sexual objects that are desired by men and fetishized in Western cultures, breasts can become known as multifunctional organs that belong to women (Bartlett). It is time for Western cultures to begin to redefine breasts—to place a greater amount of importance on lactation and physiology and to unburden women's breasts from the sexual narratives that have been latched onto them for centuries.

Works Cited

Apple, Rima. *Mothers and Medicine: A Social History of Infant Feeding, 1890-1950.* University of Wisconsin Press, 1987.

Bartlett, Alison. *Breastwork: Rethinking Breastfeeding.* University of New South Wales, 2005.

Blum, Linda. *At the Breast: Ideologies of Breastfeeding and Motherhood in Late Contemporary United States.* Beacon Press, 1999.

Campo, Monica. "The Lactating Body and Conflicting Ideals of Sexuality, Motherhood and Self." *Giving Breastmilk: Body Ethics & Contemporary Breastfeeding Practices,* edited by Rhonda Shaw and Alison Bartlett, Demeter Press, 2010, pp. 51-63.

Carter, Pam. *Feminism, Breasts and Breast-feeding.* St. Martin's Press, 1995.

Dettwyler, Katherine, A. "Beauty and the Breast: The Cultural Context of Breastfeeding in the United States." Eds. Patricia Stuart-Macadam and Katherine A. Dettwyler. New York: Aldine De Gruyler, 1995, pp. 167-215.

Groz, Elizabeth. *Volatile Bodies: Toward a Corporeal Feminism.* Indiana University Press. 1994.

Haskell, Molly. *From Rape to Reverence: The Treatment of Women in the Movies,* 3rd edition. University of Chicago Press: Chicago & London, 2016, pp. 105.

Hausman, Bernice, L. *Mother's Milk: Breastfeeding Controversies in American Culture.* Routledge. 2003.

Morgan, Elaine. *The Descent of Woman.* Souvenir Press. 1972.

Morris, Desmond. *The Naked Ape*. McGraw-Hill. 1967.

O'Brien, Glenn. "Nipple Phobia." *Playboy* January, 1995, pp. 42-43.

Prose, Francine. *Master Breasts: Objectified, Aestheticized, Fantasized, Eroticized, Feminized by Photography's Most Titillating Masters*. Aperture. 1998.

Rothman, Barbara, K. *Recreating Motherhood: Ideology and Technology in a Patriarchal Society*. Norton. 1989.

Schiebinger, Linda. "Why Mammals are Called Mammals: Gender Politics in Eighteenth-Century Natural History." *The American Historical Review*, vol. 98, no. 2, 1993, pp. 382-411.

Shaw, Rhonda. "Performing Breastfeeding: Embodiment, Ethics and the Maternal Subject." *Feminist Review*, vol. 78, 2004, pp. 99-116.

Williams, Florence. *Breasts: A Natural and Unnatural History*. W.W. Norton & Company Inc. 2012.

Wolf, Jacqueline, H. *Don't Kill Your Baby: Public Health and the Decline of Breastfeeding in the 19th and 20th Centuries*. The Ohio State University Press. 2001.

Yalom, Marilyn. *A History of the Breast*. Pandora. 1997.

Young, Iris. *On Female Body Experience: Throwing Like a Girl and other Essays*. Oxford University Press. 2005.

The Madonna's Breast and the Surprise of the Real: From Ideal to Embodied

Jessica M. Rodríguez-Colón

A few years ago, I was on an elevator ride when a mother exited in an almost panicked state as her baby started crying. I exited on the same floor and noticed her desperately preparing a bottle for the baby. During this process, an elderly woman passing by commented, "This is why people shouldn't bring babies to the museum." This was during one of my visits to The Metropolitan Museum of Art in New York City when I was in the early stages of researching the tradition of Madonna representations in paintings. Little did I know that the day's biggest lessons and questions would arise from interacting with and observing other visitors to the museum. The situation in the elevator made me think about the spaces specifically determined for infants, children, and their caregivers.

As I continued walking towards the European paintings wing that displayed works from 1250 to 1800, I witnessed the same elderly woman looking at Luca Signorelli's *Madonna and Child* (Figure 1); she commented that it was beautiful and admired the way the Virgin looks at baby Jesus. When I got to my destination, I noticed a mother nursing her child while cruising through the gallery. She was shortly approached by another visitor—a young woman—who confronted her and advised her to either go to the bathroom or cover herself because it was a public space. The mother, however, ignored the comment and continue feeding while walking. A few steps away from this scene, one could see the painting

JESSICA M. RODRÍGUEZ COLÓN

of *Madonna and Child* (Figure 2) from the early fifteenth century by Bernardino dei Conti, in which—contrary to the painting by Signorelli—the Madonna is breastfeeding the child. My intention on this Met visit was to look at some of the early artistic representations of the Madonna, but as I continued to walk, I encountered more similar situations, and some questions grew in my mind. What spaces are socially determined for mothers? In particular, how has our society determined the acceptable spaces for mothers' breasts? How could the same person find the artistic representation of the Madonna (with an exposed breast) and child to be beautiful while, simultaneously, believe it's inappropriate when a mother breastfeeds in front of the same image?

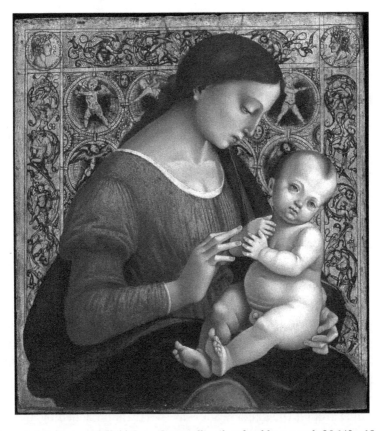

Figure 1: *Madonna and Child*, Luca Signorelli, oil and gold on wood, 20 1/2 x 18 3/4 in., ca. 1505-7, Permanent collection of The Metropolitan Museum, Public Domain Licensing

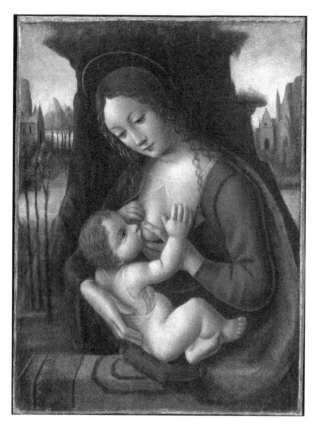

Figure 2: *Madonna and Child*, Bernardino dei Conti, oil on wood, 15 7/8 x 12 in., c.a. 1520, Permanent collection of The Metropolitan Museum, Public Domain Licensing

This chapter explores the iconography of the Madonna and child as well as the depiction of the mother's breast in these works of art. More specifically, I contrast idealized and embodied Madonna images in order to examine the contemporary feminist art and activism that challenge culturally persuasive ideas of breastfeeding and the socially prescribed spaces for the exposure of women's breasts. Contemporary Madonna portraits allow for the exposure of multiple mothers' breasts and illustrate the realness of both artistic depictions and actual nursing mothers.

In iconography from the Middle Age to early modernism, the maternal breast seems to be securely located within the frame of the

sacred image. However, today, this place is often questioned because of diverging views. In light of this, I ask whether the classic Christian iconography of the Madonna, as imagined chiefly by male artists, exemplifies the ideal of womanhood and motherhood—where the mother's breasts are reserved for that of a sacred mother in a sacred space. I also interrogate how the iconography of the contemporary Madonna, as embodied by feminist artists, creates a discourse that challenges the gaze, spaces, and signifiers of a mother's breasts.

I argue that through contemporary artists' deconstruction of this historical iconographic model, a new space for motherhood is being created—a space that is heterotopic in nature and exists at the intersection of the private and the public as well as the secular and the sacred. The contemporary sacredness of the mother no longer relies on an idealized image of Virgin Mary. Rather, this image has been appropriated by contemporary artists to create a new Madonna that surprises us with the real—a normalization of the realness of a mother's breasts.

Madonna and child-themed paintings have existed since the Byzantine era and have often held associations with mythology, folklore, and religion. As such, there has been an unspoken agreement to limit mother's breasts to such visual and literary representations—with those to be the appropriate spaces for a mother's breasts. According to the National Museum of Women in the Arts, the image of the Virgin Mary, the mother of Jesus Christ, "was the most frequently depicted woman in Western art until the eighteenth century." Generally speaking, the Virgin Mary represents the Christian ideal of womanhood and motherhood, specifically the ideal constructed by the Catholic Church. Therefore, the paintings depicting the Madonna and child became the iconography of such ideals. Accordingly, the perfect devoted mother, the Virgin Mary, is represented as an ideal within the heterotopic space of the church or the museum. By looking briefly into the meaning of those spaces, we can see why many people are comfortable with the image of the classical Madonna's breasts while they are concurrently uncom-fortable or confused when gazing at a real mother's breasts in everyday public spaces.

Philosopher Michel Foucault defines utopias as "sites with no real place" and heterotopias as "places that do exist and that are formed in the very founding society" (qtd. in Balibar 362). He divides hetero-topias into five principles, the fourth one being heterochronies or the indefinite accumulation of time:

there are heterotopias of indefinitely accumulating time, for example museums and libraries. Museums and libraries have become heterotopias in which time never stops building up and topping its own summit, whereas in the seventeenth century, even at the end of the century, museums and libraries were the expression of an individual choice. (365)

The Madonna has a constant presence within the heterotopia of archives that exists mostly within the structure of libraries and museums. However, it originated in the sacred heterotopic space of the church and, perhaps, is still identifiable within the crisis heterotopic space, as Foucault seems to have packed all female bodily cycles within such spaces:

In the so-called primitive societies, there is a certain form of heterotopia that I will call crisis heterotopia, i.e., there are privileged or sacred or forbidden places, reserved for individuals who are, in relation to society and to the human environment in which they live, in a state of crisis: adolescents, menstruating women, pregnant women, the elderly, etc. (qtd. in Balibar 363)

Although Foucault argues these heterotopias are disappearing, I believe that, in recent years, such spaces have transformed into a heterotopic idea of the public realm by challenging the gaze of those who inhabit the crisis heterotopic space. In other words, by making the other visible through artistic representation—in this case, the mother in each of its stages, including her breasts—one has to face the otherness and make a conscious decision of whether to look or not.

Contemporary artists employ the image of the Madonna to revamp the traditional meaning of the mother, motherhood, and the maternal by creating alternative images or depictions of the Madonna that embody the physical representation of a mother's body while, at the same time, demystifying the reduction of a mother's breasts to its sexualization as per the male imagination. Through their embodiment, each of these artists challenges the sacred societal prescription of the idea of the mother, her body, and the appropriate spaces for her breasts because once outside and in the realm of the real, the societal prescription of motherhood no longer accepts a mother's breasts in public space.

Embodied Madonnas Are the Real Madonnas

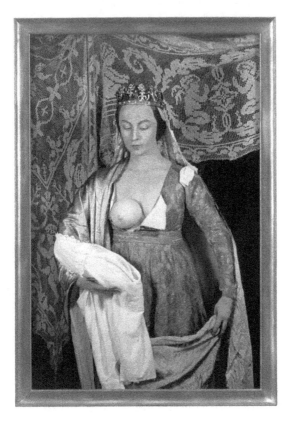

Figure 3 *Untitled #216*, Cindy Sherman, chromogenic color print, 7' 3 1/8" x 56' 1/8", 1989, © Cindy Sherman

Cindy Sherman challenges the image of the sacred Madonna in her photograph *Untitled #216* (Figure 3). She creates a spectacle and, in doing so, questions the unrealistic idealization and sacredness of the Madonna. Sherman defies the gaze of the spectator by creating a spectacle of the classical image with a prosthetic mother's breast, which comments on how we have created such ideals instead of looking at the real breast of a mother. We also find Catherine Opie confronting the idea of the sacred Madonna in her *Self-Portrait/Nursing*. Opie accomplishes this by showing the mother and child naked and establishing skin-to-skin contact while looking at each other. She challenges the motif of universal sanctification and perfection seen in the traditional

Madonna through representing the mother as the subject instead of the object in the portrait. The bareness of the Madonna in Opie's work allows us to see the representation of the breastfeeding mother rather than the image of a sacred and idealized Madonna. She presents the realness of a mother's breasts and challenges the spectators to accept them and the spaces they inhabit. We can take this as a metaphor to what should be expected of a mother's breasts—that is, a mother's breasts should exist in spaces determined by the mother and child based on need instead of societal biases.

Sherman's contemporary, alternative Madonnas challenge the traditional gaze of the sanctified Madonna and her breasts. bell hooks says, "There is power in looking" (qtd. in Jones 94). Indeed, there is power in the gaze that includes critical reflection of the images we observe. Feminist artists are aware of this; they create alternative narratives to challenge the gaze of the spectators. In other representations of the Madonna, the acknowledgement of the multiplicity of nonlinear and nonmasculine definitions of motherhood can be seen in the portrayal of the multiple maternal bodies. Therefore, in the creation of these alternative Madonnas, the gaze of the spectator is challenged and, with it, the construction of the notion of the appropriate spaces for a mother's breasts.

In *Oppositional Gaze*, bell hooks reminds us that Foucault:

> insists on describing domination in terms of "relations of power" as part of an effort to challenge the assumption that "power is a system of domination which controls everything and which leaves no room for freedom." Empathically stating that in all relations of power "there is necessarily the possibility of resistance," he invites the critical thinker to search those margins, gaps, and locations on and through the body where agency can be found. (qtd. in Jones 94)

Gloria Rodríguez-Calero creates images that challenge the dominant idea of the white Madonna and the white mother's breasts. *La Madonna Negra* (Figure 4) is an acrollage that creates an icon of the black, Latin American, pregnant Madonna, who carries the weight of her unborn child. Rodríguez-Calero's Madonna challenges traditional iconography by creating an icon that is closer to the biblical description of the poverty experienced by Mary rather than the hyperidealized Madonna image

promoted by the Catholic Church. Contrary to most of the previous images, the mother's breasts are fully covered by the extension of her veil. Once again, Rodríguez-Calero's presents a sanctification of motherhood outside of the mother's breasts.

Fig. 4: *La Madonna Negra*, Rodríguez-Calero, acrylic and collage, 54" x 24", 2004, © Rodríguez Calero

In Rodríguez-Calero's work, the sanctification of the mother is not limited to her breasts or their possible feeding functionality but includes the whole experience of motherhood. As it is witnessed in the images created by contemporary, feminist artists, the image of the Madonna and her signification as an icon undergoes a constant transformation, including the exposure of her breasts, which may be attributed to the transfer of spaces that these Madonnas inhabit. With

regards to space, Foucault says the following: "These are oppositions that we regard as simple givens: for example between private space and public space, between family space and social space, between cultural space and useful space, between the space of leisure and that of work. All these are still nurtured by the hidden presence of the sacred" (qtd. in Balibar 361).

The sacred image of the Madonna is redefined by its transfer into various spaces that challenge our societal prescriptions of motherhood, thus creating discourses that one tends to ignore. Most of these spaces are sacred heterotopias that society wants to maintain as utopic illusions because they represent the idea of the sacred space and keep the mother's breasts out of public spaces.

Through their works, Sherman and Rodríguez-Calero deconstruct the signification of the sacred Madonna in an endeavour to construct a new significance for the contemporary Madonna. They also challenge the acceptable societal spaces for the visual representation of a mother's body, including the exposure of her breasts. By positioning their Madonnas in heterotopic spaces through the embodiment of such iconography, they shift the focus to the mother that does not fit the societal prescription of motherhood or whose body challenges the ideal representations that create an illusion of a universal maternal body type. As such, their representations of the Madonna create a new heterotopic space for the mother's breasts and her body as a whole; this space that blurs the lines at the intersection between the public and the private and the secular and the sacred. In these representations, the sacredness of motherhood is redefined through the mother's reality and not through an ideal image of motherhood. Through their appropriation of the Madonna iconography, these contemporary artists open a space for understanding real mothers' bodies.

These feminist works not only challenge the classical representation of the Madonna but also invite us to think critically about the gaze and appropriate spaces for mothers and children in order to create new signifiers. These contemporary Madonnas blur the lines between sacred and real bodies, and, consequently, surprise our gaze by showing a variety of mother's breasts that utilizes embodiment to highlight a discourse that creates an alternative gaze as well as alternative spaces and signifiers for the breastfeeding mother. These Madonnas create a new space for the everyday life —the real— breastfeeding mother. In

doing so, feminist artists question and redefine the role of mothers' breasts and move the space for breasts away from sacred traditions and into everyday life.

Works Cited

Balibar, Étienne, et al. *French Philosophy since 1945: Problems, Concepts, Inventions*. New Press, 2011.

Dei Conti, Bernardino. *Madonna and Child*, 1520, *The Metropolitan Museum*, www.metmuseum.org/art/collection/search/435940. Accessed Mar. 29 2016.

Giannetti, Charlene. *Picturing Mary: Woman, Mother, Idea. Woman around Town*, Dec. 13, 2014, www.womanaroundtown.com/author/cgiannetti/. Accessed June 30 2018.

Jones, Amelia. *The Feminism and Visual Culture Reader*. Routledge, 2003.

Rodriguez-Calero, Gloria. *La Madonna Negra*. Courtesy of the artist.

Sherman, Cindy. *Untitle #216*, 1989. Courtesy of the artist and Metro Pictures, New York.

Signorelli, Luca. *Madonna and Child*, 1505-7, *The Metropolitan Museum*, www.metmuseum.org/art/collection/search/437674. Accessed Mar. 29 2016.

Chapter Three

"The Body for Someone Else": Mothers' Breasts in Brazilian Probreastfeeding Discourses

Irene Rocha Kalil and Adriana Cavalcanti de Aguiar

International organizations and public policies widely promote breastfeeding, as it reduces child morbimortality rates and positively influences long-term child health outcomes. This is not just a prerogative of so-called developing countries: England, the United States, Canada, and other developed nations also promote the widespread adoption of breastfeeding. Since the 1980s, Brazil has undertaken initiatives to increase breastfeeding rates and duration. Currently, the Brazilian Ministry of Health's National Breastfeeding Promotion, Protection, and Support Policy follows the World Health Organization (WHO) and the United Nations International Children's Emergency Fund (UNICEF) guidelines and recommends exclusive breastfeeding for the first six months of life and, then, complementary breastfeeding until the age of two. These recommendations are included in promotional materials produced by the Brazilian Ministry of Health (BMH), such as lactation manuals aimed at new mothers and their health professionals. They also affect Brazil's World Breastfeeding Week (WBW) public health campaigns, which intend to raise breastfeeding awareness and mobilize breastfeeding-related actions.

In this chapter, we analyze advertisements from the Brazilian government's 2008–2014 WBW campaigns to demonstrate that contemporary Brazilian breastfeeding discourses portray the lactating body as sacred, natural, civic minded, and beautiful. Official discourses emphasize the

nutritional and immunological value of breastmilk for the baby as well as its ability to reduce "allergic and respiratory problems, as well as diseases that might emerge later, such as obesity, high blood pressure, high cholesterol, and diabetes" (Brasil, Ministério da Saúde 11). As we discuss below, there is a great deal of "polyphony" (Bakhtin) in these official materials, but the child is consistently placed at the centre of interest. The mother's role, according to these materials, consists of optimizing the babies' physical, mental and emotional health. The campaigns use language that objectifies women and primarily presents the female body as the producer of precious breastmilk.

Analytical Contexts

Our analysis examines official breastfeeding materials produced by Brazil's WBW and aims to understand the way those materials portray breastfeeding. We wanted to uncover the types of breastfeeding messages privileged in WBW campaigns as well as the messages that were silenced. In previous work, Kalil analyzed twenty-six WBW documents, including Brazilian campaigns. Here, we present the analysis of seven posters that circulated in WBW campaigns from 2008 to 2014.

Linguist Milton Pinto's semiology of social discourses informs our theoretical framework. He understands communication as a process of meaning negotiation between and among subjects, and applies discourse analysis to understand how discourse is both constitutive of and constitutes power relations. He observes textual clues that suggest how some meanings are privileged or naturalized, according to ideological elements that consciously or unconsciously inform their production. Across our analysis, we identified several different voices, some of them contradictory. Pinto calls such voices "intertexts," composed of a discursive memory, or interdiscourse (Orlandi), and they exemplify what Bakhtin has termed "polyphony"—that is, characteristics inherent to any discourse. Different voices or discussions are triggered in the process of construction and meaning negotiation.

We apply gender studies' theories to interpret discursive memory about the female body in motherhood and breastfeeding. Aware of gender's "complex and multifaceted" social configuration (Villela et al., 1004), we turned to gender studies literature to inform our critique of

the supposedly essential elements of masculine and feminine. Those elements are not natural, though; they are forged "in the political sphere, legitimizing asymmetrical positions in the social distribution of power between genders" (Romani 65).

Throughout human history, the feminine body has been both object of reverence and appreciation, and subjected to objectification in religious, scientific, and artistic discourses. Based on his concept of "habitus"—which bridges social constraints and personal characteristics and shapes social identities as a "cultural frame that predisposes individuals to make their choices" (Setton 61)—sociologist Pierre Bourdieu sees the female body as a "body for someone else" (79) ("*corps pour autrui*," as opposed to the "body for oneself," or "*corps pour soi*," in French). Bourdieu discusses how women's habitus allows their bodies to be "ceaselessly exposed to objectivation operated by the lenses and discourse of others" (79). We believe this notion may inform how Brazilian officials' probreastfeeding campaigns portray the maternal body.

Based on this theoretical frame and through the method of discourse analysis, this paper simultaneously examines the official posters and considers the intertext elements that lie within them which originate in social, historical, and institutional contexts.

Breastfeeding Campaign Posters (2008–2014)

Every year, the World Alliance for Breastfeeding Action (WABA) convenes to define a slogan for WBW, which is then disseminated to all partner nations, which adapt it according to local circumstances. In Brazil, the Ministry of Health, in partnership with the Brazilian Society of Pediatrics (BSP), promotes campaigns adopting the figure of one "godmother"—that is, a "woman of expression" (Giugliani 117) who breastfeeds. These iconic mothers typically are beautiful, well-known actresses or singers who lend their positive images to the campaigns. These famous faces are associated with kindhearted attitudes and, thus, enhance the campaigns' appeal to the population and to the media (Kalil).

The WBW campaigns associate women and motherhood with charity, beauty, and perfection, as seen below:

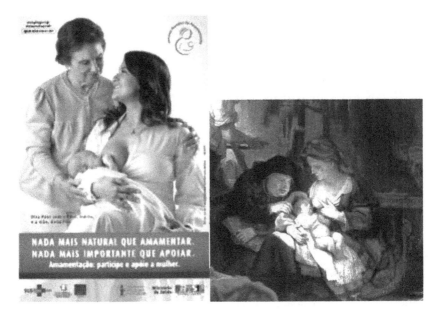

Figure 1 (left): WBW 2008 campaign poster (Source: Brazilian Ministry of Health). Figure 2 (right): Detail of the work *La Sainte Famille* (1640) by Rembrandt (Louve Museum, Paris)

The WBW 2008 poster (Figure 1) features movie and TV actress Dira Paes nursing her son under the watchful eye of her mother. Visibly well-groomed, she holds and supports the child. She looks at her mother and smiles. The actress's neck is adorned with a necklace featuring the Virgin Mary. Next to Paes, her mother embraces her daughter, and both women smile. The grandmother represents family support for the mother's decision to breastfeed her baby.

The slogan, in upper case, states "NOTHING MORE NATURAL THAN BREASTFEEDING. NOTHING MORE IMPORTANT THAN SUPPORT." In a smaller font below the slogan is the supporting text: "Breastfeeding: participate and support women." Visually, this campaign poster resembles classical paintings of the Virgin Mary breastfeeding baby Jesus. One of them is Rembrandt's *La Sainte Famille* (Figure 2), in which the artist portrays an enclosed, private environment with a small cradle made of straw and a woman calmly breastfeeding her child under the attentive and affectionate gaze of a lady, who extends her hand, caressing the head of the suckling baby. By evoking a centuries-old religious image, the WBW 2008 poster reinforces the idea that breastfeeding is traditional, admirable, and sacred.

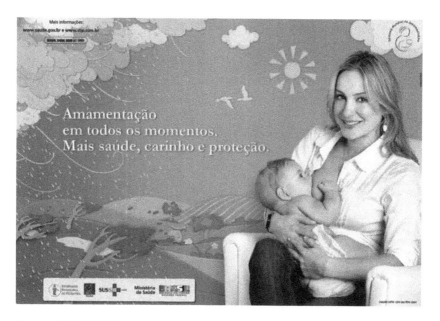

Figure 3: WBW 2009 campaign poster (Source: Brazilian Ministry of Health).

The WBW 2009 campaign's godmother was singer Cláudia Leitte, who has acted in several popular television programs. At the time of her campaign, the singer was nursing her first child shortly after he had recovered from bacterial meningitis. Nicely made-up and with a calm, rested expression, she faces the viewer. She wears a casual outfit, like many contemporary working women. The baby wears only a diaper, looks at the mother while suckling, and rests his right hand on her breast. The slogan of the campaign—"Breastfeeding at all times. More health, care, and protection"—is featured on the left side of the poster. The central message of the campaign informs us that breastfeeding is always the best option. Breastmilk—and, thus, the breast responsible for milk delivery—is crucial to the baby's health in all circumstances.

The poster additionally highlights natural images: the association of nature and breastfeeding is a recurrent theme in the campaigns. This idea of nature encourages viewers to see women as female mammals— biologically prepared and meant to breastfeed. The reference to the "nature of the act of breastfeeding" in the text is, as Eni Puccenelli Orlandi has defined it, a mark of the "historical materiality of language" (68); it is a vestige of social and discursive processes through which

breastfeeding has been seen over the centuries. From the early eighteenth century to the nineteenth century, European discourses to encourage mothers to breastfeed associated breastfeeding with nature; they promoted the notion that mammalian females' instincts would naturally lead them to nurse their young ones (Badinter, *Um Amor Conquistado*).

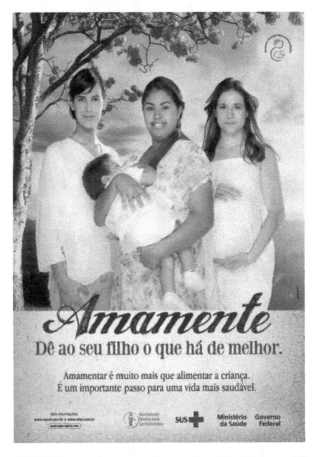

Figure 4: WBW 2010 campaign poster (Source: Brazilian Ministry of Health).

The campaign's 2010 slogan was: "Breastfeed. Give your child the best." In the poster (Figure 4), the image is comprised of a triad of anonymous women and a child. The woman on the right is pregnant and holds her belly between her hands; the woman in the centre carries a baby, probably over six months old, whose face is turned into the mother's bust; the one on the left, apparently not pregnant, has a

confident and purposeful countenance. The women are portrayed as celestial creatures; in the background, there is a bucolic, ethereal landscape. Kalil et al. observed that the scene seems peaceful, as if breastfeeding was easy "and as if their willingness to breastfeed, by itself, was enough to actually accomplish it" (10).

Although the poster's explicit message aims to promote healthy behaviour, an element of risk emerges in the supporting text (Kalil et al.): "Breastfeeding is much more than feeding the child. It is an important step towards a healthier life." The poster suggests that failure in breastfeeding would expose babies to several health risks. Although the ads are intended for pregnant or lactating women, the messages prioritize babies' needs; for example: "In their initial months, the babies have no specific breastfeeding schedules. They should suckle whenever they want. Over time, they set their schedule." The children's dominant role is highlighted, and children are depicted as controlling how women should adapt and concede their bodies and breasts to babies' needs. Such discourses portray women's bodies as public health policy tools and imply that breastfeeding is a moral and civic duty.

In Figure 5 (overleaf), actress Juliana Paes, the WBW 2011 campaign's god-mother, is depicted sitting on a bench and nursing her child as she looks at him and smiles. She has natural makeup on her face and wears sober, pastel clothes. On the left side of the poster is the slogan: "Breastfeeding is good for your baby and for you." Below it is the supporting text: "**Until 6 months** your baby only needs breast milk. Afterwards, provide the baby with healthy food and continue to breastfeed until the age of **2 or over**. Seek information, be prepared. Make this experience whole" (bold in the original). As in the WBW 2008 poster, the scene reinforces the divine realm of breastfeeding by referring to Andrea di Bartolo's *La Vierge au Coussin Vert*, which portrays the Virgin pleasantly breastfeeding baby Jesus.

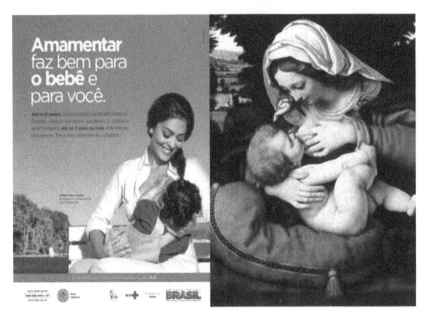

Figure 5 (left): WBW 2011 campaign poster (Source: Brazilian Ministry of Health).
Figure 6 (right): *La Vierge au Coussin Vert* (1507-1510?) by Solario (Louvre Museum, Paris).

The WBW 2012 campaign features singer Wanessa Camargo. In the poster (Figure 7), Wanessa nurses her baby, looks at the viewer, and smiles with a cheerful, calm look. Unlike Camargo's typically sensual and audacious public image, she wears conservative clothes, makeup, accessories, and hair style, reinforcing motherhood as light and sober. In the back, a large, green area surrounds her; a picnic table is set by the lake with a fruit-laden basket. These images are coordinated with the text below, which instructs the reader to supply only breastmilk until six months. Breastfeeding initiates healthy eating, which should continue after the introduction of new foods.

The slogan "Breastfeeding today is thinking about the future" stresses the importance of breastfeeding—and breastmilk—not only for the infant's early life but also to help the baby "prepare to a healthy growth." Thus, the WBW replicates the typical civic hygienist rhetoric of late nineteenth and early twentieth centuries, which proclaimed breastfeeding was a means of ensuring children's health and, consequently, the consolidation of a modern and prosperous Brazilian nation.

The text also emphasizes a current health promotion and risk discourse; it introduces the time-based concept of debt credit: present-day healthy habits will ensure future rewards, whereas failure to breastfeed could cause negative future consequences (Vaz et al.). With this perspective, maternal breasts are seen as tools to ensure both children's health and civic progress.

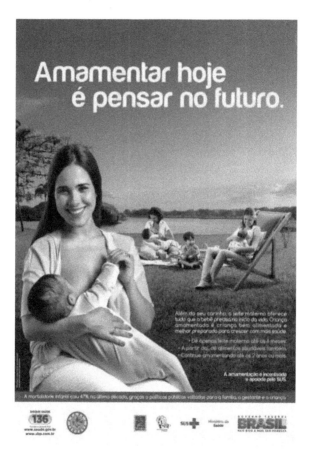

Figure 7: WBW 2012 campaign poster (Source: Brazilian Ministry of Health).

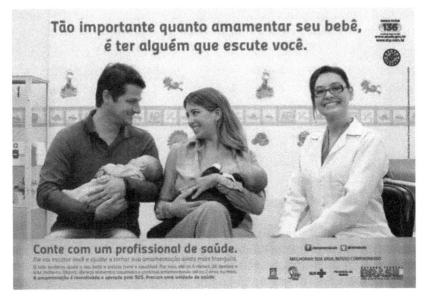

Figure 8: WBW 2013 campaign poster (Source: Brazilian Ministry of Health).

The WBW 2013 campaign features actor Marcelo Serrado and his wife, who was breastfeeding one of the couple's twins. The poster's (Figure 8) slogan is "Someone listening to you is as important as breastfeeding your baby." The supporting text is the same in all materials: "Rely on a health professional. He will listen to you and help make your breastfeeding smoother." This poster differs from other years, as it incorporates a father figure into the breastfeeding scene; Serrado is, therefore, the "godfather" of the campaign. This poster also depicts the woman as an active participant in the breastfeeding process and stresses that nursing is good for the mother's health and must be supported by the family, which is represented in the image by the partner's figure or by health services.

For WBW 2014, the chosen godmother, actress Nívea Stellman, is featured alongside her eldest son and youngest daughter. As in other years, the actress wears discreet makeup and clothing. Her daughter lies calmly on the right breast, which is partially exposed, as she watches her mother and brother. Balloons attached to vertical ribbons float above their heads, as if they were part of a children's mobile, with pictures of the baby wearing the attire of various professions: teacher, doctor, judge, and dancer. At the top of the poster (Figure 9), the slogan of the campaign

is placed in red capital letters: "BREASTFEEDING. A BENEFIT FOR LIFE." The supporting text claims the following: "You do not know what your son will be when he [sic] grows up. But with breast milk, you help him get there.... Feed your child for two years or more. During the first six months, give only breast milk." These statements promote breast-feeding as an investment in the child's future and refer to scientific studies that relate breastfeeding to a higher intelligence quotient (IQ) in later life.

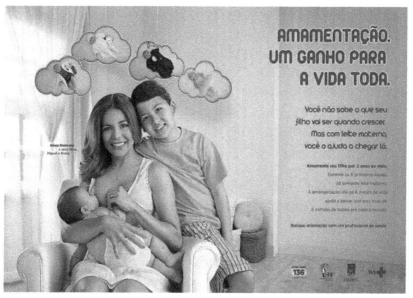

Figure 9: WBW 2014 campaign poster (Source: Brazilian Ministry of Health).

Maternal Breasts: Depictions and Dictates

Most campaign posters adopt command statements; they are written with verbs in the present tense and, in general, are in the imperative mode, as the posters seek to reinforce a "truth effect" (Pinto). Such devices aim to ensure that "in the future, the receiver adopts the be-havior expressed by the state of things to which reference is made" (Pinto 92). The statements are primarily aimed towards women— pregnant women, mothers, nursing mothers—and instruct them to discipline their bodies, especially their breasts.

Nursing researcher Dagmar Estermann Meyer has previously high-lighted this prescriptive characteristic of breastfeeding discourses in the analysis of the National Breastfeeding Incentive Program, created in 1981, which gave rise to current Brazilian breastfeeding policies and other national health programs. Reinforcing what Meyer has termed "a new politicization of feminine and motherhood," (81) these discourses, on the one hand, recall some late nineteenth-century Brazilian hygienist arguments, such as the assumption of breastfeeding as a natural, biological, and instinctive action. On the other hand, the campaign discourses represent a rupture with the knowledge that supported the medical prescriptions regarding breastfeeding that prevailed during the nineteenth and early twentieth centuries. This rupture established, for example, the so-called free breastfeeding regime, in which women should be available to breastfeed as often and as long as the child wishes.

One of the femininity images used in the WBW'S contemporary breastfeeding promotions is that of beauty as an attribute and expression of womanhood. This connection between women and beauty is old and widespread, and has permeated fields from religion to the arts. Beauty in women is, thus, part of seeing femininity as "a perceived being" (Bourdieu 79)— that is, one of the dominant social expectations that fall on women before, during, and after pregnancy. Women's bodies and breasts are a symbol of beauty; in Brazilian culture, the image of women and the image of beauty are conflated (Vilhena et al.).

One argument adopted in the breastfeeding promotion materials is the importance of the beautiful, maternal body as well as the mothers' acceptance of their new mother-woman bodies. The campaign's godmothers are always well groomed and dressed; they sport a happy expression and have no trace of dark circles around their eyes from sleepless nights. Significantly, the godmothers' beauty is disconnected from any body and breast sensuality; women who breastfeed are depicted as beautiful, but their beauty is chaste and asexual. Women's bodies and breasts are modestly shown, appearing just enough to enable the baby to suck and sometimes to touch them. Even godmothers who present sexualized media images in other contexts s are depicted as clean, pure mothers. In eliminating mothers' sensuality, a chaste and religious intertext is activated in the WBW posters.

Starting in the Middle Ages, the Virgin Mary was seen as the innocent protector of motherhood and breastfeeding; this purity belief

materialized through vast iconography depicting the suckling baby Jesus (Sandre-Pereira). Over the centuries, artistic images consolidated the ideal of sacred motherhood and sacred maternal bodies, which led to the exclusion of nursing women's sexuality in contemporary Brazilian breastfeeding rhetoric. The beautiful, sacred breastfeeding mother is not depicted as capable of sensual pleasure. Thus, the WBW ideal omits any mention of the sexual body of breastfeeding women, including, for example, the sensual feelings experienced by some women while breastfeeding as well as the maintenance of women's active sex life during the breastfeeding period (Queiroz).

The sacred is also associated with other foundational breastfeeding discourses. One is the discourse of nature. The entanglement of women and nature is, according to Sherry Ortner, a constant across diverse cultural contexts and shapes the opposition of nature vs. culture. The association of breastfeeding with nature—where breastfeeding is considered a natural behaviour that is common to all mammalian females— casts it as women's duty to their offspring. Thus, according to Fernanda Lemos, through the fusion of religion and biology, "women have been consecrated in their maternal, sublime, emotional, fragile, caring essence, and men in their authoritarian, rational, providing and strong essence" (121).

We argue that the discourse of civic service portrays breastfeeding as a moral imperative to the nation's collective health. Hygienist doctors from the early twentieth century understood that childhood health issues had far-reaching implications for Brazilian public health and national modernization. As a result, they advocated a model of maternity whose primary function was to ensure children's physical, emotional and moral health, and, thus, positively affect the future of the country. This discourse appears in materials oriented towards different audiences and mainly emphasizes economic advantages of breastfeeding, such as the reduction of public health expenses due to lower rates of illness or hospitalization among breastfed children.

One example of the discourse of civic duty is seen in the WBW 2012 slogan "Breastfeeding today is thinking about the future." In this slogan, eugenics-based ideals are evoked, namely the search for healthier and stronger individuals, since much of the Brazilian hygienic movement promoted eugenics assumptions into the first half of the twentieth century. According to Maria Izilda Santos de Matos, the eugenic

discourse supported maternology "as an initiative to promote motherhood under ideal health and hygiene conditions" (86). The social and civic function of women thus became "to ensure procreation, the survival of future generations, and the refinement and strengthening of the race" (Matos 86). The rhetoric of eugenics is present in several WBW posters, which highlight breastfeeding benefits, such as good nutrition, immune system development, and cognitive development.

Conclusion

In this chapter, we have argued that contemporary breastfeeding discourses affect present-day conceptions of maternal breasts and women's bodies. Despite feminist claims of women's rights to their own bodies (Badinter, *O Conflito: a Mulher e a Mãe*), contemporary Brazilian breastfeeding discourses reinforce a new politicization of femininity and motherhood (Meyer). Our analysis reveals considerable poliphony in these discourses, which show, in their subtextual level, a diversity of voices. Among these intertexts, we highlight four: sacred, natural, civic mindedness, and beauty. All of them help persuade women to breastfeed and, therefore, permit external regulation of their bodies by the Brazilian state and society. When women accept such externally originating body regulations a contradiction arises: on the one hand, the breast that nurses is chaste, yet, on the other, it represents the eroticism associated with the feminine. These dual meanings affect the mothers' breastfeeding experiences, as the good mother must perform her primordial biological function, remain pure, and, also, retain her sexual attractiveness.

According to political scientist Erin Taylor and sociologist Lora Ebert Wallace, questions of guilt and shame emerge from discrepancies between the hegemonic discourses disseminated by national and international organizations and the experiences of breastfeeding women. Mothers who do not breastfeed or do not comply with official breastfeeding parameters may feel guilty, sad, or inadequate (Wolf). Moreover, mothers who do not respond to hegemonic breastfeeding expectations may be seen as denying the ideal of femininity that associates breastfeeding with women's nature. Such criticisms can make a non-nursing mother feel like "an incomplete woman" (Taylor and Wallace 85).

The feminine body, as Bourdieu has pointed out, has historically been understood as a body that existed to service others. Moreover, women's views about their own bodies are affected by others' feedback. Family members, friends, and medical authorities can all provide feedback to women about the appropriateness of their breastfeeding behaviour and appearance. Cultural artifacts, such as the WBW breastfeeding posters, also give women information about how good mothers feed their children; women are persuaded to assess themselves in contrast to these campaign messages.

We believe the WBW campaigns reinforce a vision of women's bodies as objects of external regulations. Mothers have become an instrument of Brazil's child health public policy, as they are understood to be a channel for providing children with a seemingly essential food product and, also, with the responsibility of providing Brazil with a healthy, prosperous future.

Works Cited

Badinter, Elisabeth. *O conflito: a mulher e a mãe.* [*The Conflict: Woman and Mother*]. Record, 2011.

Badinter, Elisabeth. *Um amor conquistado: O mito do amor materno.* [*Mother Love: Myth and Reality: Motherhood in Modern History*]. Nova Fronteira, 1985.

Bakhtin, Mikhail. *Marxismo e Filosofia da Linguagem: Problemas Fundamentais do Método Sociológico da Linguagem.* [*Marxism and the Philosophy of Language*]. Hucitec, 2006.

Bourdieu, Pierre. *A dominação masculina.* [*Masculine Domination*]. Bertrand Brasil, 2012.

Brasil, Ministério da Saúde. *Cartilha Para a Mãe Trabalhadora Que Amamenta.* Ministério da Saúde do Brasil, 2010.

Giugliani, Elsa Regina Justo. "Papel da Sociedade Brasileira de Pediatria na Promoção, Proteção e Apoio ao Aleitamento Materno." *O Aleitamento Materno no Contexto Atual: Políticas, Prática e Bases Científicas,* edited by Hugo Issler, Sarvier, 2008, pp. 115-117.

Kalil, Irene. *De Silêncio e Som: A Produção de Sentidos nos Discursos Pró-Aleitamento Materno Contemporâneos.* Multifoco, 2016.

Kalil, Irene et al. "Da Intenção ao Gesto: Aproximações e Distancia-mentos Entre Informações Oficiais e Percepções Maternas Sobre Amamentação." *Diálogos de la Comunicación*, vol. 88, 2014, pp. 1-18.

Lemos, Fernanda. "'Se Deus É Homem, o Demônio É [a] Mulher!': A Influência da Religião na Construção e Manutenção Social das Representações de Gênero." *Revista Ártemis*, vol. 6, 2007, pp. 114-124.

Matos, Maria Izilda Santos de. "Em Nome do Engrandecimento da Nação: Representações de Gênero no Discurso Médico: São Paulo 1890-1930." *Diálogos*, vol. 4, no. 4, 2000, pp. 77-92.

Meyer, Dagmar Estermann. "A Politização Contemporânea da Matern-idade: Construindo um Argumento." *Gênero*, vol. 6, no. 1, 2005, pp. 81-104.

Orlandi, Eni Puccinelli. *Análise de Discurso: Princípios e Procedimentos*. Pontes, 1999.

Ortner, Sherry B. "Is Female to Male as Nature Is to Culture?" *Feminist Studies*, vol. 1, no. 2, 1972, pp. 5-31.

Pinto, Milton José. *As Marcas Linguísticas da Enunciação: Esboço de uma Gramática Enunciativa do Português*. Numen, 1994.

Queiroz, Telma Corrêa da Nóbrega. *Do Desmame ao Sujeito*. Casa do Psicólogo, 2005.

Romani, Jacqueline Pitanguy de. "Mulher: Natureza e Sociedade." *O lugar da Mulher: Estudos Sobre a Condição Feminina na Sociedade Atual*, edited by Madel Luz, Graal, 1982. pp. 59-71.

Sandre-Pereira, Gilza. "Amamentação e Sexualidade." *Estudos Femin-istas*, vol. 11, no. 2, 2003, pp. 467-491.

Setton, Maria da Graça Jacintho. "A Teoria do *Habitus* em Pierre Bourdieu: Uma Leitura Contemporânea." *Revista Brasileira de Educação*, no. 20, 2002, pp. 60-70.

Taylor, Erin N., and Lora Ebert Wallace. "For Shame: Feminism, Breastfeeding Advocacy, and Maternal Guilt." *Hypatia*, vol 27, no. 1, 2012, pp. 76-98.

Vaz, Paulo et al. "O Fator de Risco na Mídia." *Interface—Comunicação, Saúde, Educação*, vol. 11, no. 21, 2007, pp. 145-153.

Vilhena, Junia de., et al. "A Violência da Imagem: Estética, Feminino e Contemporaneidade." *Revista Mal-estar e Subjetividade*, vol. 5, no. 1, 2005, pp. 109-144.

Villela, Wilza, et al. "A Incorporação de Novos Temas e Saberes nos Estudos em Saúde Coletiva: O Caso do Uso da Categoria Gênero." *Ciência & Saúde Coletiva*, vol. 14, no. 4, 2009, pp. 997-1006.

Wolf, Joan B. "Is Breast Really Best? Risk and Total Motherhood in the National Breastfeeding Awareness Campaign." *Journal of Health Politics, Policy and Law*, vol. 32, no. 4, 2007, pp. 595-636.

Chapter Four

Public Breastfeeding as a Scandalous Practice

The MATER Association (Serena Brigidi, Marta Ausona, and Laura Cardús) and LactApp (Maria Berruezo and Alba Padró)

W hat's up with boobs? And what about boobs in Spain? Why is breastfeeding so provocative that it is censored in both physical and virtual contexts? Why is breastfeeding forbidden in some of Spain's public spaces, such as squares, museums, and shopping malls? There are many confounding factors that seem to influence breastfeeding behaviours. First of all, Spanish women's bodies are typically sexualized, although maternal bodies in Spanish culture are idealized as asexual and sacred. Second, Spain's overt and tacit organization of public spaces determines their usage through norms of access and formal policies. This tension between public space, sexualized bodies, and maternal bodies results in an ongoing struggle over Spain's breastfeeding policies and women's breastfeeding practices.

There are no explicit laws regarding public breastfeeding in Spain; however, tacit standards exist that are based on personal feelings, collective prejudices, and a general ignorance of babies' physiological needs. These social standards cast public breastfeeding as a taboo behaviour. For instance, a 2013 sign posted at a San Sebastián de los Reyes (Madrid) civil registry stated, "Moms are asked to refrain from feeding babies in work areas. Thank you." Clearly, this bureaucratic office wanted women to remain covered up; however, as a result of requesting women's compliance, babies could suffer.

In Spain, women are expected to breastfeed for nine to twelve months (INE). This is both expected by society and recommended by medical institutions. If women continue nursing beyond the baby's first year, their breastfeeding practice becomes a social taboo, and mothers are judged accordingly. These views are made clear through the existence of special outfits made for discreet breastfeeding—for instance, tops and covers that hide both the baby and breast. The existence of private baby feeding spaces inside of restrooms or in special bathroom-like rooms reinforces breastfeeding's marginal position. Unsurprisingly, images of women breastfeeding are generally absent in visual media, such as television and advertising.

In Western societies, breasts have a central role in heteronormative discourses; women are supposed to have breasts of a specific size and shape. This expectation objectifies and trivializes other breast functions and meanings. Yet the hegemonic social discourse about breastfeeding lacks such concepts as desire, sexuality, sensuality, and pleasure for women. These elements are only reclaimed when you talk and, especially, when you listen, to breastfeeding mothers. Moreover, the nutrition function of breasts is downplayed in public locales, as are breastmilk's numerous health benefits. Breastfeeding is often viewed as a private act that should be restricted to secluded spaces and is only appropriate for very young children.

Local breastfeeding politics are important to the everyday lives of women, as they affect women's bodies, body practices, and perceptions of freedom. In Spain, during the dictatorship of Franco (1939–1975), breastfeeding was praised as a mother's obligation, not a right or an option. In the context of Franco's pronatalist policies and his ultra-Catholic, fascist ideals, women were depicted as the angels of the house and were expected to show state allegiance through engaging in supposedly painful breastfeeding and maternity. At the same time, the ideology of the Franco regime established a clear division between masculine public spaces and domestic private spaces, which belonged to women and children. Social spaces were politically and hierarchically segregated; women were, by divine grace, destined for maternity, and fathers or husbands were meant to guard women (de Miguel).

As Spain began transitioning to democracy in 1975, breastfeeding rates started to decline. In those years, Spanish feminism was characterized by hegemonic egalitarianism and was antireproduction. It con-

sidered motherhood as a kind of slavery; this was a logical counterpoint to motherhood's definition during Franco's era. This antimaternal backlash devalued breastfeeding (Blázquez). In contrast, bottle feeding was seen as modernizing, something that would help to liberate women from the burden of maternity. Women were encouraged to limit the length and frequency of breastfeeding; they were told to nurse every three to four hours for just ten minutes on each breast. At the same time, pharmaceutical companies promoted formula feeding, which contributed to the decrease in breastfeeding rates (Ausona). In combination, these elements led to declines in the cultural value placed on breastfeeding, declines in the number of women who initiated breastfeeding, and declines in mothers' commitment to breastfeeding over many months.

Despite these antibreastfeeding sentiments, some women in Spain banded together to create breastfeeding support groups. They demanded the right to breastfeed in public spaces and, thus, attempted to break the male-public and female-private dichotomy, which was left over from the Franco era. Moreover, these women stood up to cultural standards that expected mothers to be modest and remain covered up.

In the 1980s and 1990s, Spain began to adopt the World Health Organization (WHO) guidelines regarding medical protocols supporting and promoting breastfeeding (Blázquez), which led more Spanish women to reembrace the culture of breastfeeding. They felt as if they could justifiably use their breasts to nurse in both public and private spheres (Ausona). Other women, however, did not reclaim breastfeeding, which was likely related to several variables, including maternal age and social status. One additional and unexplored factor that likely affects Spain's breastfeeding rates is the public-private sphere divisions, as public breastfeeding is still decried.

Stripped and Objectified Bodies: Dirty Milk

"I am a woman, and I feel disgusted when I see someone sticking out her boob to offer it to a baby. I am sorry, but milk pumps exist, and if you are at a restaurant I directly walk away, it is revolting.... They are always with the "this is a very natural act" nonsense; yes, but taking a piss or a dump is just as natural and more urgent, and we don't do it everywhere."

—Asdf (Internet user commenting on an article in *Revenga*)

Public breastfeeding remains controversial in contemporary Spain. Whereas some nursing mothers receive compliments from strangers, others are reproached, especially if the child is considered too old to be breastfed. A mother breastfeeding in public becomes exposed to the critical eyes of others. Some mothers describe feelings of discomfort when nursing in public, as they are aware that they are breaking a social convention by breastfeeding in an inappropriate space.

Although nonlactating breasts are often depicted as sexy and desirable, lactating breasts are frequently seen as indecent and obscene. An example of this is when in 2013, Facebook users flagged a World Breastfeeding Week photograph featuring topless, breastfeeding women as obscene. Due to the complaint, Facebook deleted the post and closed the accounts of the featured mothers. As a form of ironic protest, the users made a new image by photoshopping the censored photo (see image below).

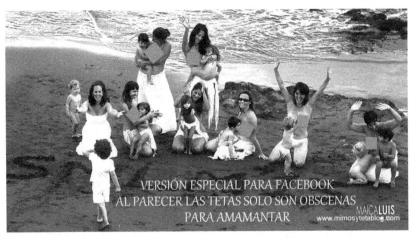

(Translation: "Special version for Facebook: Apparently tits are only obscene when it comes to breastfeeding")

The media and popular culture characterize breastfeeding as obscene while suggesting that non-nursing breasts are appropriate and desirable, which implies that women's bodies are merely sexual objects and are not suited for pregnancy, birth, or nursing. The degradation of breasts' natural function limits women's bodies and women's own beliefs about their bodies' potential (Brigidi; Ricoy). The denial of breasts' usefulness strips many women of their belief in their breasts' capacities and can diminish their self-esteem. Women who are discouraged from

frequent nursing may experience low milk supply and, consequently, may think of their bodies as defective (Scheper-Hugues; Ausona et al.). The body that does not serve to nourish supports an entire industry of child nutrition—that is, substitute formulas (Narotzky). When women compare their bodies to airbrushed, Euro-Western cultural ideals, they may feel imperfect and uncomfortable with their own bodies. This self-criticism—combined with views that nursing is commonly per-ceived as an intimate act to be performed in private spaces—may neg-atively affect the number of women willing to breastfeed in public spaces.

Thus, nursing is commonly considered taboo in spaces construed as public. Breastfeeding is seen as an intimate action between mother and baby that has to be left undisturbed. Indeed, many breastfeeding man-uals insist the mothers find a quiet place to breastfeed. But the argument that nursing should be private to protect mothers and babies is nothing more than a fallacy created to avoid public displays of breastfeeding. Consequently, women are invited to feed their children in isolated spac-es and restrooms; through this, nursing is depicted as dirty. Indeed, most lactation rooms are not separated from children's toilets or diaper chang-ing stations. The equation of nursing with uncleanliness is also used when women are discouraged from breastfeeding in public swimming pools (LactApp).

In summary, public lactation is controversial in Spain, where human milk is thought of as a dirty substance and breastfeeding as a quasi-obscene act that others prefer not to see. Consequently, mothers are forced to be careful about their lactation practices—restricting them to the toilet, to breastfeeding areas, to home—in order to protect bystanders from exposure to their obscene breasts (Herraiz and Saiz).

Freedom and Censorship

Despite the omnipresent critique of breastfeeding as being too public or babies as being too old to nurse, a countertrend exists in Spain that seeks to validate nursing mothers' lives. This form of lactation-based activism, called "lactivism," argues that breastfeeding is both an ac-ceptable and a natural act. For many mothers, breastfeeding outside the home is a way of expressing freedom regarding the use of their own bodies and the rights of their babies to be fed in any place and situation

(Ausona). It represents freedom for breasts. This vision can be summarized in the following lactivist breastfeeding video's assertion: "FREEDOM, no time limits, no measurements, no rules, anywhere, anyhow" (Colo and Medina). Freedom in lactation is linked, consequently, to the absence of restrictions regarding time, place, rules, or modesty. This freedom is what has given rise to criticisms—both from the feminist movement and more conservative sectors of society—related to excessive breastfeeding, whether in terms of time, the place chosen, or not following norms or modesty standards.

Lactivist websites gather complaints from women who have been asked to leave public locales—such as shopping malls, museums, public swimming pools, and restaurants—based on the reasoning that nursing could be offensive to others or that the place is not suitable for it. Similarly, when women in public positions bring their babies to work (for example, politicians Licia Ronzulli and Hanne Dahl Carolina Bescansa), they have been criticized for nursing. Such critiques and warnings can lead to self-censorship (Ausona) and reinforce nursing taboos. These experiences may lead women to limit their breastfeeding to private places where their breasts will not offend others. Critics of public breastfeeding are attempting to impose limits on public behaviour and are trying to determine what behaviors are professional. Additionally, these critics are attempting to construct the so-called good mother as private and modest and the so-called good breastfeeding as homebound.

Ideas about protection, access, and roles are linked with motherhood, gender, as well as public and private spaces—and the both tacit and overt regulation of such locales—limits mothers' possibilities and practices. What one can do in public as well as virtual spaces, which are reflections or extensions of public spaces, restricts women's choices and is linked to social control. Indeed, for some mothers, the rebellious act of nursing in public is a way of making breastfeeding visible and normal, thereby increasing social acceptance and educating future generations. Such breastfeeding attributes are not only linked to autonomy but also to female and maternal sexual freedom. One mother had this to say:

> Breastfeeding is related to sexuality; [it] is inherent. That is ... talking about breastfeeding and sexuality is the same. Sexuality is connected to your decision regarding joy [laughs], which is a decision made from freedom and the power to feel you own your body and you can share it, and from the relationship of feedback

of love and affection. Love without affection or fluids does not exist. When there is a relationship of love and affection there is an exchange of human fluids. What do you think? We are made out of water [laughs]. Yes, I think that this needs to be shown because what is not seen does not exist ... for our daughters and for the daughters of other mothers because we already know it. (Ausona 112)

"*Tetadas*"—or gatherings to breastfeed in public spaces—are similar to this mother's approach. Lactivists and attachment parenting proponents praise *tetadas* as necessary in raising breastfeeding visibility and awareness; however, others may view *tetadas* critically because they can create an image of breastfeeding as weird or sectarian (Padro). In this context, it is important to note that many women consider lactation rooms to be a perfectly acceptable option and many prefer to nurse in private. The main breastfeeding advocacy and support movements do not negatively judge these women's privacy desires, as long as the existence of private nursing spaces is not used as a pretext to pressure nursing mothers to give up public breastfeeding (Massó-Guijarro and Villarmea-Requejo). In a recent study of Spanish breastfeeding women carried out by LactApp, most felt that breastfeeding should be normalized and that public breastfeeding should be visible and acceptable.

Conclusion

Multiple factors can hinder breastfeeding and lead mothers to abandon nursing, to supplement breastmilk with formula, and/or to avoid public nursing (Massó-Guijarro and Villarmea-Requejo). Our study has focused on the portrayal of public and virtual breastfeeding as scandalous. We found that Spanish censorship of breastfeeding is linked to a visual culture in which lactating nipples are censored and nonlactating, sexy nipples are exhibited. Additionally, censorship is expressed through the absence of commonplace breastfeeding references in stories, textbooks, films, and medical classes for health professionals (Olza). Breastfeeding criticism is expressed through negative comments directed at nursing mothers: public breastfeeding is inappropriate and offensive; breastfeeding should remain invisible and private; and women should cease breastfeeding babies who are over twelve months old (Ausona). Many of these antibreastfeeding sentiments are

linked to Spain's history from the Franco and post-Franco eras (Herraiz and Saiz; Blázquez). When breastfeeding is relegated to private locales, mothers are pressured to return to these domestic spaces and become silenced and depoliticized; meanwhile, their breastfeeding practices continue to be the object of public and political discussion.

From the perspective of some Spanish feminists, breastfeeding represents a kind of maternity that ties women to the domestic sphere (Esteban). This connotation would likely fade away if breastfeeding were normalized in the public domain and could occur without censorship. Normalizing is about accepting, informing, and respecting, which will only happen when we understand that women's bodies are powerful and autonomous. Their bodies should not be reified, trivialized, or subjected to consternation. Women must have the right to make their own body-related decisions. Liberation is not understood in the same way by everyone, and each person follows their own path, enjoys their own successes, and makes their own mistakes. Choices surrounding breastfeeding should belong to the women who breastfeed, whether that means nursing in private or public or choosing to nurse for an extended period of time.

Works Cited

Ausona, Marta. *Lactàncies maternes de llarga duració social i altres usos de la corporalitat en la criança*. Doctoral Dissertation, manuscript, Universitat Barcelona, 2015.

Ausona, Marta, et al. "Lactancias, capital y soberanía alimentaria. La falacia de la escasez de la leche humana." *DILEMATA, Revista Internacional de Éticas Aplicadas*, no. 25, 2017, pp. 135-42.

Blázquez, M. J. "Ecología y Maternidad. Recuperando el paradigma biológico original." *ISTAS*, 2007, www.istas.ccoo.es/descarga.pdf. Accessed 15 Sept. 2015.

Brigidi, Serena. *Cultura, salud, cine y televisión. Recursos audiovisuales en ciencias de la salud y sociales*. Publicacions URV, 2016.

Brigidi, Serena. "¿Jugamos a parir? El pošlost' de la violencia entre brutalidad y trivialidad". *El concepto "violencia obstétrica" y el debate actual sobre la atención al nacimiento*, edited by Josefina Goberna and Margarita Boladeras, Tecnos, 2018, pp. 161-73.

de Miguel, J.M. *La amorosa dictadura.* Anagrama, 2006.

Herráiz, Luis, andMaría Soledad Saiz. *La via da Láctea. Historia del Amamantamiento.* Foren 2010.

INE. "Encuesta Nacional de Salud." *MSSSI,* 2012, www.ine.es/ss/Satellite?L=esES&c=INESeccion_C&cid=1259926457058&p=1254735110672&pagename=ProductosYServicios%2FPYSLayout¶m1=PYSDetalle¶m3=1259924822888. Accessed 15 Sept. 2015.

Pérez, Ma Dolores, and Moreno Hernández, Amparo. "Maternidades y lactancias desde una perspectiva de género." *DILEMATA, Revista Internacional de Éticas Aplicadas,* vol. 25, 2017, pp. 143-55.

LactApp, "Entrevista a Miryan Blázquez, recriminada por amamantar dentro de una piscina." *LactApp Blog,* 12 Aug. 2017, www.lactapp.es/blog/entrevista-miryan-blazquez-recriminada-por-amamantar-dentro-de-una-piscina/. Accessed 1 June 2018.

Massó-Guijarro, Ester, and Stella Villarmea Requejo. "Filosofía y maternidad: cuando los sujetos se embarazan." *Dilemata. Revista Internacional de Éticas Aplicadas,* vol. 18, 2015, pp. 185-223.

Narotzky, Susana. *Mujer, mujeres, género. Una aproximación crítica al estudio de las mujeres en las Ciencias Sociales.* Consejo Superior de Investigaciones Científicas, 1995.

Ravenga, Juan. "Semana mundial de la lactancia materna 2014 y amamantar en 'cualquier sitio/'" *20 Minutos,* 2014, blogs.20minutos.es/el-nutricionista-de-la-general/2014/08/01/semana-mundial-de-la-lactancia-materna-2014-y-amamantar-en-cualquier-sitio/. Accessed 1 May 2015.

Scheper-Hughes, Nancy. *La muerte sin llanto. Violencia y vida cotidiana en Brasil.* Ariel, 1992.

Van Esterik, Penny. "Breastfeeding and Feminism." *International Journal of Gynecology & Obstetrics,* vol. 47, Issue Supplement, 1994, pp. 41-54.

Villén, Colo, and Ileana Medina. "Compañía para una lactancia prolongada." *Tenemos tetas,* 2010, www.tenemostetas.com/p/compania-para-una-lactancia-prolongada.html. Accesed 12 May 2012.

Chapter Five

Tongue-Tied: Medicalization of the Mouth-to-Breast Latch

Kristin J. Wilson and Wendy Simonds

B reast and nipple pain associated with breastfeeding are common complaints of mothers in the first few weeks of nursing as mother and baby negotiate comfortable positions, the frequency and duration of suckling, as well as a viable latch. Some breastfeeding mothers who are experiencing pain avoid bottles because they are committed to the "breast is best" ideal, which is viewed as integral to intensive mothering (Hays). Enduring pain related to breastfeeding is often seen as preferable to failure, as failure has been shown to erode early maternal confidence— leading to feelings of worthlessness among mothers (Marshall et al.). Mothers also worry that bonding with their babies will be negatively affected when breastfeeding does not end up looking and feeling like the calm and intimate experience that is widely portrayed (Ryan et al.). Instead of giving up, many breastfeeders who experience discomfort or pain seek lactation support.

Many professionals now consider mothers' breastfeeding pain to be a primary symptom of infant tongue-ties and lip-ties. These conditions occur when frenulae (bits of skin that attach the tongue or lip to the mouth) are tight; it is a condition thought to hinder an optimal latch on the mother's breast. In this chapter, we analyze the rise in popularity over the past two decades of tongue- and lip-tie diagnoses and resulting medical interventions on babies' frenulae—referred to by practitioners as frenotomy, revision, division, release, and, more informally, as

clipping or snipping. We examine medical and popular literature and websites about the subject and breastfeeders' narratives collected by Wilson for her book *Others' Milk: The Potential of Exceptional Breastfeeding*.

The lack of medical consensus and absence of randomized controlled trials on the effects of tongue- and lip-tie on breastfeeding puts mothers—the primary decision makers in infant health interventions— in a difficult position. The consequences of the choice to go ahead with surgery or to leave the ties alone have yet to be fully investigated. However, based on mothers' narratives, it appears that gathering information and then choosing medical intervention can help absolve breastfeeding guilt and can enable them to see themselves as good mothers.

The Medical Gaze on the Mouth-to-Breast-Latch

Lactation support professionals tell mothers that breastfeeding should not hurt. Achieving successful breastfeeding and alleviating insecurities about babies getting enough quality milk motivate a growing number of mothers to pursue a tongue- and lip-tie diagnosis and subsequent surgical interventions. Due to this growing trend, in 2009, a diverse group of service providers united to form the International Affiliation of Tongue-tie Professionals (IATP).[1] Their professionalization and quest to produce evidence-based research has propelled the expansion of tongue- and lip-tie procedures, which were relatively uncommon before the turn of the twenty-first century. Very few mentions of these procedures appear in the medical literature before 2006.

The story of the medicalization of tongue- and lip-ties is a fairly recent one, though the condition itself has been noted since medieval times (Obladen). Alona Bin-Nun et al. conducted a systematic review of the published research on tongue-ties between 1949 and 2016 and found the following:

> The total number of yearly published articles increased in a cubic fashion...over time (0–7 per year from 1949 to 1989, and up to 27–44 in the last 5 years [2011-2016])....[M]ost articles belonged to low hierarchy categories (case reports 37.9%, reviews 15.4%, and editorials/opinions 13.4%), with only 8 RCTs [randomized controlled trials] and 10 SRs [systematic reviews] (all of them published during the last 10 years of the study period). (410)

The RCTs were not consistent with each other in terms of blinding (of investigators and mothers), point at intervention (this ranges from one day to eight years), type of intervention, outcome assessment methods, or main findings. Bin-Nun et al. lament that "most articles bring little evidence" (410), yet these authors undercut the problem of inadequate research with the tautological claim that good evidence is likely to emerge soon to point the way to a definitive standard of care because of the trend in increased research itself: "If the trend ... in the number and the quality of tongue tie-related publications continues, we speculate (and hope) that much more solid evidence should accumulate over the next few years about the diagnosis and management of tongue tie, putting an end to the controversy about this condition" (413). Similarly, in a webinar titled "Gold Tongue-Tie Symposium"—held on September 17, 2018, and summarized live on Twitter @GOLDLactation— Dr. Dan Hanson, a dentist, noted the need to "develop empirical research" to support "practice-based evidence." This tongue-in-cheek reversal of "evidence-based practice" further illustrates this proin-tervention stance even in the absence of supporting scientific data. Bin-Nun et al. show that the existing research provides no clarity on the conditions under which tongue- and lip-tie interventions are beneficial—whether, when, and how they should be performed and whether there are long-term harms or benefits from the interventions. (Examples of negative outcomes include reattachment requiring multiple procedures, scarring, and, ironically, speech and eating problems.)

Most media on tongue- and lip-tie interventions acknowledge the controversy over the recent escalation of interventions, but only a few sources are highly critical. Ruth A. Lawrence, a prominent pediatrician, states in "Tongue-Tie—The Disease du Jour" that "the attention paid to this anchoring of the tongue to the floor of the mouth has varied over the decades" (467) and that none of the interventions are currently evidence based. Lawrence continues:

> In the 1940s and 1950s, there was concern that a tight tongue would cause speech problems as the child grew up. As a result many obstetricians would inspect the mouth of the newborn... and snip the frenulum before handing the infant over to be dried and measured. Most babies were bottle-fed in this era. The speech pathologists protested, and gradually the process was abandoned. (467)

Lawrence does not explicitly acknowledge the turf war taking place around the diagnosis and ensuing interventions, yet she closes her editorial by stating that only the primary care physician, as opposed to a dentist or an ear, nose, and throat specialist, "can assess all aspects of the clinical presentation and needs to be the captain of the ship if we are to avoid the perfect storm" (467-8).

In contrast to Lawrence, most authors endorse interventions; they remark the reduction in mothers' pain and improvement in breastfeeding and note their own involvement in performing the surgeries (e.g., Griffiths, a British "general neonatal and pediatric surgeon who has been dividing tongue-ties in children since 1983 and in infants since 1998" [409]). Researchers make other positive claims about intervention—that it is "safe and easy" (Amir et al. 243); that it "does not lead to complications for the infant or mother"; and that it can prevent future "speech and dental problems" (Edmunds et al. 19). Negative outcomes are rarely mentioned.

Advocates for tongue-tie education (ATTE) are described on the organization's website as a "grass-roots [online] collective of parents and professionals" but restricts entry to the professional places on its website. Parents can join a "Tongue Tie Babies Support Group" on Facebook, but many of the links for information for parents are not active (such as the "Tongue- and Lip-Tie Support Network"). The ATTE's FAQ states the following: "Research is clear. Tongue-tie *can* cause breastfeeding problems, ranging from inadequate milk-transfer causing failure-to-thrive, to maternal pain resulting in premature weaning. Not all cases of tongue-tie cause medical issues. Current research estimates approximately 30% of tongue-tie will struggle from the effects of the condition." Again, the research is not clear, and this ambiguity unsettles breastfeeding mothers even as it opens up new niches for practitioners.

The IATP is described on the group's webpage as consisting of "Medical Doctors, Dentists, Chiropractors, Osteopaths, IBCLCs (International Board Certified Lactation Consultants), Speech-Language Pathologists, Myofunctional Therapists and others." The organization states that its "goal is to improve knowledge, education and training in this field," with the aim of "standardizing the conceptual definition of tongue-tie and other oral restrictions, classifying its types, developing protocols that optimize outcomes...across the lifetime, generating assessment processes, and issue [sic] policy statements about early

assessment, proper treatment and post-surgical therapy and follow-up." Despite its general support for intervention, IATP includes almost every aspect of frenotomy in its page-long list of "knowledge gaps."

Organizations like IATP and ATTE endorse medical interventions for tongue-tie in general, even as they acknowledge a lack of data supporting interventions. The rise in tongue- and lip-tie interventions highlights an unusual alliance among medical service providers who usually do not unite (like medical doctors and dentists—or medical doctors and chiropractors), and rifts among members of the same groups and reinscribes conventional hierarchies among service providers, with medical doctors the least likely to support intervention (Messner and LaLakea).

Tongue- and lip-tie interventions are often diagnosed by lactation consultants, who do not perform the procedures. The increase in attention to these ties further medicalizes breastfeeding and helps to legitimize the gatekeeping role of lactation consultants (Carroll and Reiger), who provide referrals to surgical practitioners. The perspective that tongue-tie correction is not a big deal (i.e., like a piercing) contrasts with the potential consequences of forgoing the procedure—a baby could potentially suffer from failure to thrive or, in a worst-case scenario, die. One such cautionary tale made the rounds on several breastfeeding-related social media sites. *People Magazine* in May 2018 reported that an exclusively breastfed baby named Lucy Eleanor Talley from Bowling Green, Kentucky, nearly died of starvation until she got her tongue- and lip-ties diagnosed and clipped. These paradoxical and frightening narratives combined with ambiguous data on tongue- and lip-tie affect breastfeeding mothers' self-efficacy and medical decision making.

Constructing a Medical Problem around Maternal Competence

Parents and practitioners construct the lip-tie and tongue-tie discourse together during in-person consultations as well as online, as they both seek help and seek to educate the public. Facebook hosts several groups (some with thousands of members) in which nursing mothers as well as practitioners—particularly dentists, lactation consultants, and myo-functional bodywork specialists—provide referrals and commentary in response to mothers' questions about tongue- and lip-ties. The

primary topics include the following: classifying the ties (there are many snapshots of infants' mouths); locating willing and knowledge-able practitioners (such as dentists who can provide access to laser treatment); getting through infants' painful healing process (which is often more difficult than expected); and preventing the unwanted re-attachment of ties by doing mouth stretches (which is, in many cases, painful to babies). Mothers sometimes call out specific providers for their apparent incompetence. For example, while those whose babies' tongues or lips reattached may attribute the phenomenon to their child's "super healing," many lament not having sought out a more experienced practitioner or not having paid extra for laser treatment. There are also frequent angry posts and comments about more ignorant medical service providers (often paediatricians) having missed or dis-missed tongue-ties and lip-ties.

Mothers are frustrated. They believe in fixing their infants' ties—which is about supporting the mother-baby relationship as well as seemingly about producing a normative body part—but they often cannot reliably obtain the supports and/or services they feel they require to achieve this objective. They often complain in their online posts about the frenotomy practitioners rather than questioning the procedure itself. In contrast to the intensive mothering phenomenon of vaccine refusal, in which good mothering means intervening with nature as little as possible, these breastfeeding mothers seem to be surprisingly prointervention. We see the tongue- and lip-tie diagnoses and surgeries as a form of medicalization masquerading as antimedicalization. Practitioners talk about the ties as if they are minor anatomical flaws that simply need to be revised to right the mother-baby breastfeeding relationship. Yet the process can become complicated and has the potential to further undermine the mothers' confidence in themselves.

Breastfeeding mothers we interviewed and observed online experience both anxiety and relief in the process of diagnosing their infants with tongue-ties and lip-ties. They want to know about the short-term and long-term consequences of them as well as the expertise of the diagnosticians and treatment providers, the severity and type of tie their children may have, and the treatment options and possible outcomes. To them, the decision requires serious mothering work involving diligent research and networking. Their peers—and some medical service providers—warn them away from doctors known to be dismissive of

tongue-ties or who seem to be ignorant about the latest techniques. Because medical research and authoritative positions on the topic are often at odds, and always ambiguous, these mothers decide to place some faith in the specialists and the stories of other mothers. For some breastfeeding mothers who think their infants may have ties, sympathetic and seemingly knowledgeable experts can help validate their intensive mothering. Mothers' stories about diagnostic and treatment experiences range from validating accounts of relief and new feelings of competence to emotionally painful second guessing about whether they did the right thing.

Many breastfeeding mothers first hear about tongue-ties and lip-ties when they consult someone—a lactation consultant, a friend, or an internet group—about their difficulties with breastfeeding. Several of the mothers we interviewed told us that their pediatricians had never heard of tongue tie—or at least did not know how it could affect breastfeeding. When a mother seeks help because breastfeeding hurts or because she worries about her baby's lack of weight gain, frequency of spitting up (and crying), and/or nursing duration, providers or other mothers may suggest that the problem is anatomical, specifically having to do with the infant's frenulae. For example, if the mother and infant cannot achieve a successful mouth-to-breast latch with positioning techniques, the support person may suspect a tongue-tie and/or a lip-tie. Aurora and Beth Ann—a Bay Area married couple of co-nursing mothers—stated that their lactation consultant told them that their breastfeeding pain and mastitis might have been the result of their newborn daughter being "inefficient at transferring milk." These mothers relayed a typical story: their infant daughter had a bad latch, causing severe breast pain. But the mothers were committed to breast-feeding. A lactation consulted observed the tongue- and lip-ties and then referred them to a well-known paediatric dentist who specializes in revision. The family of three shared a miserable "five days in tears" after the surgery, and then "a light bulb went on and everything started improving." This sort of anecdote of physical and emotional turmoil relieved by an anatomical snip that heals in a few days operates as validation for other nursing mothers on the websites. Since breastfeeding improves, the medical intervention on their infant appears to be worth the pain, the hassle, the financial cost, and the agonizing choice.

These mothers share personal evidence that the intervention worked as a way of supporting other mothers who worry about whether or not

they should have their babies' lip- or tongue-tie cut. Jessica, a forty-year-old nurse and mother of three from Atlanta, was able to compare the difference between a repaired tie and an unrepaired one with her own children. She said that she did not like breastfeeding her son who had a lip-tie but that her medical service providers told her that it would "stretch out over time" and that nothing should be done. She breastfed him for a year. With her second child, Jessica explained the following:

> I talked to a different lactation person after she was born, and she told me that she knew of an ear, nose, and throat doctor that would clip a lip-tie. And so I went and saw him when she was a couple months old, and had that clipped and it made like this huge difference in how easy it was to nurse her and she was just really easy. She was this laid-back baby. She didn't have the stomach problems that my first had. She was just easy. She was so much easier.

Once Jessica obtained better information and located a willing provider, she could have the better breastfeeding experience that earlier providers seemed to have withheld from her by dismissing the apparent lip-tie in her son. She seems to casually attribute the thin strip of skin snipped on her daughter but not on her son to a host of feeding problems, such as reflux and food sensitivities. The clip was a fix all that made her daughter an easy baby—and Jessica felt like a more successful mother.

Much is made of the breastfeeding relationship. To many, it is as idealized for emotional bonding as it is for infant nutrition (Blum). For this reason, exclusive pumping as a work around to an uncomfortable latch—perhaps due to a tongue-tie or lip-tie—remains a less desirable solution from the perspective of many lactation professionals and mothers. Tongue- and lip-tie interventions offer the hope of a fix that will restore the physical closeness and physiological connection of nursing at the breast. Straining to persist with breastfeeding through unrelenting pain does not square with the ubiquitous images of a close and cozy mother-baby tableau. Whereas past breastfeeding troubles tended to be located in the mother's body in the cases of inverted nipples, trauma history, and insufficient glandular tissue, these diagnoses of tongue- or lip-tie shift the problem to the infant's anatomical difference. The diagnoses help absolve self-doubting mothers from any perceived personal inadequacy.

Valerie, a Los Angeles–based accountant and forty-four-year-old mother of four, said her story was "a breastfeeding nightmare." She said, "I always hated nursing her. Always. We just struggled the whole time." By age three-and-a-half, her daughter had revealed herself to be "just stubborn" when it came to meals. Valerie attributed some of her breastfeeding problems to the tongue-tie and to the child's inherent personality trait, concluding, "so I know it wasn't all me." Valerie had an "overactive letdown," in which too much milk released at once, and like many breastfeeding mothers who encounter such trouble, she spent some time doubting her fitness as a mother. The tongue-tie was the first indication that she did not have to blame herself (and the stubbornness of her daughter clinched it). Even if the tongue-tie cutting does not always make breastfeeding perfect, the ritual of the intervention, from diagnosis to treatment to recovery, has metaphorical significance. There can be some conceptual distance between breastfeeding difficulties and the mother's breasts. Her body is not the problem, and she is not the problem. A quick snip can repair the relationship, as the treatment discourse suggests.

The simplicity of the procedure—the seemingly minor modification of a slightly off body part—seems almost ritualistic, somewhat like circumcision rites. Acquiring expertise on one's child is part of growing into the role of a mother in the context of intensive mothering and the ever expanding medicalization of breastfeeding. Sociologist Jennifer Reich tracks a similar pattern with vaccination decisions among middle-class white mothers. Like weighing the pros and cons of vaccination or circumcision, the identification and treatment of these tongue- and lip-ties is one more box to tick off in the practice of quality mothering. The words practitioners use to describe the procedures—"division," "release," "repair," and "revision"—sound ritualistic and obscure the surgical intervention of cutting. Similarly, doctors who perform genital surgeries on infants whose genitalia are deemed medically non-normative use the terms "reconstruction" or "correction" (Davis).

Based on Wilson's interviews and our examination of the websites where parents weigh in, tongue- and lip-tie parent advocates do not seem as if they would be likely consumers of surgery for their babies. They appear to be part of the self-identified "crunchy" population of the socially and environmentally conscious who would typically avoid and be critical of medicalization; a critique of medicalization usually goes

hand in hand with valuing natural aspects of mothering, such as idealizing noninterventionist births and breastfeeding as superior to medicated birth and formula feeding, and eschewing circumcision.

Second Guessing

Is the sudden increase in diagnosis and treatment of these ties the result of a better understanding of breastfeeding after a dark age of formula and bottles, or is it something of a moral panic? The new awareness around tongue- and lip-tie leads some parents to have tie surgeries "just in case." One woman in Northern California, Mia, asked her breastfeeding support group the following: "Have any of you had your baby's tongue or lip ties repaired? I had my baby's done today, and I keep wondering if I made the right choice. Her weight gain and breastfeeding were fine. But I wanted to avoid potential speech and feeding issues. Any good or bad thoughts?" Mia received twenty-one pages' worth of affirmations from her peers; most mentioned that the provider (a dentist) she had chosen was well regarded. Several bemoaned the aftercare tongue exercises that many found too difficult to complete, too confusing to follow, or too uncomfortable for their baby. A few warned that that the ties could reattach if the mother did not follow the routines faithfully—some of these posts offered specific tips and links to how-to videos on YouTube. Mia noted in the comments that her daughter, who was five months old, had to relearn to nurse with her newly loosened tongue. The procedure iatrogenically introduced a problem where there might not have been one to begin with. Mia was prompted to seek reassurance from others after looking at the postprocedure wound in her baby's mouth, and she repeatedly brought up her hope that it would be worth it eventually if her daughter avoided any "speech or eating issues" later in life.

Breastfeeding mothers may come to consider themselves experienced and wise. Kerry—a twenty-three-year-old mother from Texas, who nursed her friend's baby to identify the source of the other mother's pain—said the following: "She couldn't decide if her daughter had a tongue-tie. And my kids have a little bit of a tongue-tie and both are lip-tied. And she wanted to know if it felt the same. And I just offered: I can just latch and see. And we did. And it hurt really bad. 'Yeah, I would say your kid has a tie, because this hurts a lot.'" Kerry's spontaneous lay

diagnosis reassured her friend that the problem was real and that the other mother was not doing anything wrong.

This concerted navigation through the newly medicalized tongue- and lip-tie diagnosis world can be an outlet for quelling some free-floating anxieties about their breastfeeding bodies and their worthiness as mothers. Many of the mothers we interviewed, like most experts, acknowledge that every child is different and that every breastfeeding relationship is different. But breastfeeding remains normative as a demonstration of maternal competence. As they diligently check for any potential problems with their infants, these mothers find explanations for the difficulties they encounter in the work of mothering, all the while establishing themselves as good mothers. Even if clear medical guidelines around tongue- and lip-ties become established by the emerging professionalization among experts, debates and controversies will likely persist. The discursive gymnastics may be a necessary component of the initiation process into morally correct motherhood.

Conclusion

The recent surge of tongue- and lip-tie professionals, publications on the topic, and interventions to remedy the conditions demonstrates a perfect (and unusual) example of medicalization. Drawing on the work of Peter Conrad, who defines medicalization as "a process by which nonmedical problems become defined and treated as medical problems" (4), Simonds defines medicalization as "the dynamic set of processes by which medical authorities, institutions, and ideologies come to (re) organize, (re)define and (re)structure our everyday experiences, culture, and social life" (11). In this instance, we see medicalization occur through a concerted effort on the part of tongue-tie intervention professionals to spread their views to a breastfeeding public primed to accept them. In 2005, sociologists Katherine Carroll and Kerreen Eiger noted the "fluidity" in the job of lactation consultancy. These specialists attempt to bridge the gap between professionally distant, high-status, and highly trained medical service providers and the intimate, instinct-validating maternalist approaches popularized by homebirth midwifery and a culture of natural mothering (Bobel). The more recent development of tongue- and lip-tie surgeries immerses lactation consultants further into medicalized breastfeeding and away

from noninterventionist, demedicalized (or antimedical) approaches. The surgeries offer a way to diminish mothers' physical pain and enable them to keep breastfeeding, despite the lack of clear evidence of their effectiveness. Surgical resolutions validate and appear to solve mothers' vreal difficulties that otherwise may take longer to resolve or may lead to making different feeding decisions. Although the long-term outcomes of tongue- and lip-tie surgeries remain unclear, choosing surgery enables mothers to see themselves as astute decision makers and as good mothers doing the best for their babies.

Endnotes

1. In our research, lip-tie always comes second to tongue-tie, and often folded into discussions of tongue-tie or gets neglected.

Works Cited

Advocates for Tongue-Tie Education. *Advocates for Tongue-Tie Education*, 2013, http://www.tongue-tie-education.com/. Accessed 14 June 2018.

Amir, Lisa Helen, et al.. "Review of Tongue-Tie Release at a Tertiary Maternity Hospital." *Journal of Pediatric Child Health*, vol. 41, no. 5-6, 2005, pp. 243-45.

Bin-Nun, Alona, et al. "A Dramatic Increase in Tongue Tie-Related Articles: A 67 Years Systematic Review." *Breastfeeding Medicine*, vol. 12, no. 7, 2017, pp. 410-14.

Bobel, Chris. *The Paradox of Natural Mothering*. Temple University Press, 2001.

Conrad, Peter. *The Medicalization of Society: On the Transformation of Human Conditions into Treatable Disorders*. Johns Hopkins Press, 2007.

Carroll, Katherine and Kerreen Reiger. "Fluid Experts: Lactation Consultants as Postmodern Professional Specialists." *Health Sociology Review*, vol. 14, no. 2, 2005, pp. 101-10.

Davis, Georgiann. *Contesting Intersex: The Dubious Diagnosis*. New York University Press, 2015.

Edmunds, Janet, et al. "Tongue-tie and Breastfeeding: A Review of the Literature." *Breastfeeding Review*, vol. 19, no. 1, 2011, pp. 19-26.

Griffiths, D. Mervyn. "Do Tongue Ties Affect Breastfeeding?" *Journal of Human Lactation*, vol. 20, no. 4, 2004, pp. 409-14.

Hays, Sharon. *The Cultural Contradictions of Motherhood*. Yale University Press, 1998.

Lawrence, Ruth A. "Tongue-Tie: The Disease Du Jour." *Breastfeeding Medicine*, vol. 8, no. 6, 2013, pp. 467-68.

Marshall, Joyce L., et al. "Being a 'Good Mother': Managing Breastfeeding and Merging Identities." *Social Science and Medicine*, vol. 65, no. 10, 2007, pp. 2147-59.

Messner, Anna H and M. Lauren Lalakea. "Ankyloglossia: Controversies in Management." *International Journal of Pediatric Otorhinolaryngology*, vol. 54, no. 2-3, 2000, pp. 123-31.

Obladen, M. "Much Ado about Nothing: Two Millennia of Controversy on Tongue-tie." *Neonatology*, vol. 97, no. 2, 2010, pp. 83-89.

Reich, Jennifer. *Calling the Shots: Why Parents Reject Vaccines*. New York University Press, 2016.

Ryan, Kath, et al. "Moral Work in Women's Narratives of Breastfeeding." *Social Science and Medicine*, vol. 70, no. 6, 2010, pp. 951-58.

Simonds, Wendy. *Hospital Land USA: Sociological Adventures in Medicalization*. Routledge, 2017.

Wilson, Kristin. *Others' Milk: The Potential of Exceptional Breastfeeding*. Rutgers University Press, 2018.

Part Two

Early
Motherhood
Narratives

Chapter Six

The Story of My Breasts

Erica Cavanagh

When I was forty-three, I gave birth to a daughter. It was spring. On Tuesday mornings when we walked to the farmer's market, she looked about at the electric wires, cars, birds, and the crowds beneath the pavilion as I pushed her in the stroller. "Taking everything in," said a stranger. "Yes," I said and smiled, holding back my besotted gratitude for having a child so late in life. I walked along, harbouring a private glow and glancing at my daughter as she gazed at people passing by with their bouquets of kale and flowers. I bought iced tea, rhubarb, and strawberries. We passed the pink gelateria and headed home through an alley where a young man in a cook's uniform leaned against the wall smoking a cigarette. I nodded hello. He did not lift his eyes to look at me. He chuckled and leered at my breasts, saying something under his breath I'm not sure I needed to hear in order to guess he'd turned me into an object for his entertainment.

Yes, my breasts are enormous. Pregnancy and milk caused them to balloon into unprecedented proportions, what some middle-school boys would call "jugs." That cook, with his leer and chuckle, brought me right back to puberty, when at age twelve, my breasts swelled from A to C cup in a matter of months. C's are average on a woman but huge on a twelve-year-old girl. I lay in bed and tried to press them back in. Only one other girl in my class had large breasts, and hers were larger than mine. At least I didn't have the largest breasts, I told myself, as if that were consolation.

I'm thinking about how my daughter will relate to her own body—that conduit of intimacy, pain, and pleasure—and how to help her build

confidence to be intimate with others in the future. Reckoning with my own past seems to be a part of that process.

The year my breasts grew so quickly I was sexually assaulted for the first time, although it wasn't called "sexual assault" then. It wasn't called anything. A thing happened, and the girl was called a slut. End of story.

It happened to me in spring at a parent-chaperoned party. The punch was spiked. I drank one cup, felt lightheaded, and trailed two girlfriends outside where music was playing; we started dancing. Even now I try to remember what the song was. And who I was, before the two older boys came up.

"Come on, you're going to like this," said the white boy, standing so close to me, and the black boy on the other side standing so close too, as each of them took an arm and pulled me into the next yard, where they pinned me to the ground.

The memory hovers as if it happened in a parallel world behind a screen where everything is eerie, like some kind of lab where you're being experimented on. Even now I can see the black boy palming my breast, but I'm not there. My body is rigid. I've left it, I left the skin of it, left the trunk between my neck and my thighs. I'm focusing on a nearby pine tree, dreaming of escape in its dense, laddered branches. But when the white boy tries to pull off my underwear, the two worlds collide, and I'm back, trying to get up.

"Come on, it's just one more base," says the white boy.

"No, no, no," I keep saying and scramble away.

Two months later, I was on a bus to summer camp, gazing out the window, when a boy with a raspy voice sidled up to my seat. He was in the same grade as the boys who did what they did to me. He snickered as he recounted what he'd heard about that night, which amounted to two derogatory remarks about my body. I froze. I'd been trying to pretend it didn't happen, but now I'd been turned into a joke. I blurted something sarcastic. It's fine. I'm fine. But I spoke to no one about it, not even my best friend.

In 1987, "sexual assault" was not part of mainstream vocabulary, so it was not a part of mainstream consciousness either. You just didn't talk about things that happened to your body. *The Accused,* in which a twenty-four-year-old woman is gang raped in a bar as a swarm of male spectators cheer on the rapists, was a year away. I wasn't old enough to see the film, but I viscerally remember the trailers that aired on TV. I remember Jodie

Foster in court being questioned on whether she'd invited what happened to her for wearing a short skirt in a bar.

The world was on the side of men, which is why I did not say to the boy on the bus, "Your friends assaulted me, and you're an asshole for laughing about it." He had the authority—I did not—to decide my story and tell it to me. "Boys will be boys," said everybody. "The girl must have asked for it." I could not go to my own parents for help. They were at their most damning when I entered puberty. My father quoted Scripture when I disobeyed him, yelling at me about "going down the wrong path." My mother said, "Now you don't want to get a reputation for being loose." I reasoned that if I didn't talk about what happened, maybe everyone would forget and kids who called me "slut" would stop. My deepest fear was that I might be a slut. If I wasn't a slut, I would have run the moment those boys grabbed my arms; instead, I was stupid, and I'd better cover up that I was stupid so I wouldn't be taken advantage of again. My smiling, unflappable face said, "I'm not hurt." No one dragged me away from a party. If you're tough, you don't complain. If you're cool, you can take a joke.

This seemingly sensible and stoic response to trauma was a form of self-sabotage. I didn't know that then, but through recent research into trauma, I've learned that animals in the wild quickly recover from a paralyzing threat by fleeing, and if they can't flee, they freeze, and once the threat is gone, they physically shake off the fear to release it and recover. But the human animal, thanks to our highly evolved rational brains, works hard to diminish the import of terror, and the stress gets stored in our bodies.

The hazing continued through eighth grade. Boys snapped my bra and called my breasts "bodacious tatas." They hyperbolically mimicked the size of said tatas on their chests and drew cartoonish pictures of them on notes they passed to me in class. It was a new girl, one who'd quickly become popular, who told me my breasts and the other large-chested girl's D-cup breasts had been drawn in the boys' bathroom. And once, after school was out and the halls were empty, I put my ear to the boys' bathroom door, my heart pounding, and listened to be sure it was empty before I went in to investigate. The small bathroom was dusky with one grimy window for light. I squinted and scanned the grey stall until I spotted the disembodied breasts labelled with our names and then scratched them out.

Events I attempted to blot out became one of my reflexes, hyper-vigilance another. Once, I clobbered a boy with my backpack when he tried to drag me into that same bathroom. In Mr. Bobbins's math class, I slumped so the back of my chair would cover my bra strap. My cerebral cortex worked hard to rationalize, adapt, and suppress the fear and flight churning in my gut. Sometimes I even fooled around with boys just to see if I would get used to it. I was supposed to get used to it, right? Wasn't it supposed to feel good? Sometimes it did. Sometimes it was sensuous and thrilling. Other times weird and mechanical, like when a boy dared me to touch his penis, and I did not want to touch his penis, not even through his khaki pants, but maybe I could be brave. Maybe I could feel powerful. But I didn't feel powerful. I felt wrong.

Middle school was not entirely awful. I had some wonderful friends. One spring we climbed up to the roof our school, five of us girls, the wind batting our hair around as we teased my best friend, Kelly, who had a new boyfriend, asking if he was a good kisser. One girl asked how far she'd gone with him, and Kelly refused to tell, but the girl kept prodding her until finally Kelly blurted it out in Spanish: "*Dos!*" She was too embarrassed to say it in English. We all laughed. That summer at camp in the Adirondacks, I met a boy named Vic who unabashedly loved me. I can still feel his skinny, knuckly fingers interlocking with mine. He was openly expressive about his feelings, while I kept a lot to myself. I cared about him so much, yet I constantly feared losing control and falling over the edge. At dusk, I sat alone on the cabin stoop, looking through dense pine towards the lake; the night was so peacefully alive that at some point I began to believe that even if no one saw what happened to me, at least the pine did. Pine forests became my most intimate companions. They could see and not hurt me.

Our high school was not large, about two hundred students per class, making it difficult to hide. The boys who held me down and groped me were in the class just ahead of mine. For three years, five days a week from 7:00 a.m. to 3:15 p.m., I either saw or feared seeing them. If I spotted one of them down the hall, I wedged myself deeper into my crowd of friends. If my friends weren't around, I walked in the opposite direction. I didn't date a single boy from my high school for fear they'd heard the same gossip the boy on the bus had heard and would assume I was easy. I bided my time till graduation wearing baggy sweatshirts and rugby shirts, hoping roomy clothing would help. It did not. When

I got older and had money, I figured I'd have surgery to shrink my breasts. In the meantime, I contemplated taping my breasts to my chest like Joan of Arc. Sometimes I starved myself until dinner. If I were skinny, my breasts would recede into my chest.

At fifteen, I joined winter track. I could barely run a mile without halting and gasping for breath, so it didn't look promising. But day by day, my lungs opened up and my body grew more capable, running through snow plowed up on the sidewalks of Elmwood Avenue, unflinching when a passing car splashed a puddle across my calves. I barreled on. Running made me feel powerful. I hated track meets, however. Sports bras from the 1980s and 1990s were not the inelastic feats of engineering they are today, so when I stepped up to the starting line, I was mortified as I imagined boys in the bleachers jeering about my bouncing jugs. I told myself, *just stare ahead; don't think about it.*

Meets aside, running taught me I had the tools to take care of myself. Running affirmed that this body was my body to take care of—not someone else's—and I could keep taking care of myself: I just had to make the choice. Running was my fury, my life force, my endurance. Running was my flight response, too, not just from my perpetrators but also from the girl to whom shameful things had happened. I wanted her to disappear far beneath the woman I was becoming: a marathon-running warrior with a trimmed-down body and ropey arms.

This brings me to my daughter. What relationship to her body will I pass on to her? I wonder how my habits will affect her, my habit of remaining composed, even when I'm uncomfortable, even when I'm under fire. This put-together look was meant to keep the past folded away—to keep anyone from wondering whether anything untoward had ever happened to me because if anyone knew, they just may start to see me as the loose girl my mother so warned me against. Now I am a mother trying to level with this legacy of attitudes towards female bodies so that it may lose its power over me and maybe our sons and daughters, too.

Our bodies and minds are palimpsests, records of what's been etched into us, etchings that cannot be erased, so my self-censoring strategies failed. Composure failed too. Denying the past demands constant maintenance. Pierre Janet, who coined the term "dissociation" back in 1889, warned of the damage of trying to dissociate from a traumatic experience. Instead of healing, or "moving on," as we say today, a patient actually becomes "attached to an insurmountable obstacle" (van der

Kolk 182). Trying to conceal unpleasant memories only fortifies their debilitating effects. Janet advocated instead for integrating repressed experiences into a story.

We pass stories on to our children, both the ones we tell and the ones we cloak in silence. We pass on behaviors too, and I did not want a predilection for repressing painful experiences, and the attendant shame, to be one of them. What we do not heal in ourselves harms us and can damage others, so this story is for me and my daughter and everyone I love now or will love in the future. Deciding which stories to tell my daughter and how and when tell to those stories will be an ongoing process. Until recently, the thought of telling mine terrified me. Not even Audre Lorde, who said, "Your silence will not protect you" and whose writing I loved, could persuade me. I first read her now-famous call to action in college, but even as her words riveted me, I thought they only applied to other women and people of colour, not me. The dictates of my Yankee-Catholic upbringing kept me in line. No self-respecting Yankee, loyal to her family, makes private matters public unless she wants to be shunned, and no Catholic is less than self-sacrificing. I focused on helping others instead, first as a Peace Corps volunteer, then as a teacher. I also feared being retraumatized by what others might do with my stories. Any echo of what that boy on the bus said to me would be unbearable, as would any sign that someone was sizing me up and found me sullied. I had to keep secrets in order to be accepted and loved. By thirty-five, I began drinking two, sometimes three and four glasses of red wine a night. Eventually, I just felt tired. Now, I am reclaiming what happened to me without shame as my story to tell, so my daughter may understand how we got here as women, as a country and a culture, so that she may have a chance at a different future.

I was four months pregnant when the electoral college put Donald Trump, a known sexual predator, into our nation's highest office. "I don't even wait," Trump boasted on the Access Hollywood tapes. "And when you're a star, they let you do it. You can do anything. Grab them by the pussy." The host, Billy Bush, laughed beside him.

On that beautiful spring day, as I pushed my daughter in the stroller, I had temporarily forgotten about such men. I had forgotten the current headlines about Senate candidate Roy Moore, who, when he was assistant district attorney in Alabama, offered sixteen-year-old waitress Beverly Young a ride home, and, according to Young, groped her and pushed her

head into his crotch.

But the cook who leered at my breasts brought it all back. He was a relatively minor plot point in a decades-long story of males trying to take a piece of me. The minor points cumulate, and minor or not, I was with my daughter, and to have a child is to be reminded that you are at the mercy of the world. One day, my daughter could be subjected to the likes of Roy Moore, Bill Cosby, Matt Lauer, or their younger selves in Brock Turner, and the many accomplices who look away, trivialize, or condone their parasitic behaviour. And I want my daughter to know, unequivocally, that it should never be her job to take responsibility for their behaviour or reason it away.

On her first day of life, I gazed at my daughter in awe. She'd made it out of the narrow birth canal. She was so resilient already, yet at the same time, her total dependence on me for survival made my heart ache for her, and for me. Her vulnerability to us—the people in charge of providing for her and shaping her life—was stunning. She tried to feed from me, but my milk was coming in slowly, so her father and I supplemented with formula, but still I kept her close to stimulate the milk and build her sense of security. Psychiatrist Bessel van der Kolk explains that from a baby's first days of life, the ventral vagal complex, which registers strong emotions and "controls sucking, swallowing, facial expression, and the sounds produced by the larynx, helps set the foundation for all future social behavior" (86). Breastfeeding is not just about feeding a child to allay hunger; breastfeeding offers a newborn comfort and reassurance that feed the entire nervous system. My milk, breasts, and touch nourish her, and I am nourished reciprocally. She asks for my breasts, and I give them willingly. To nourish her with them, through them, gives me a sense of power and the chance to use my breasts as I want.

The body is a home, and, unfortunately, there are those who violate that home, who treat it as though it is theirs, as though they are entitled to it. A high school boyfriend used to say to me, "Mine. These are mine." Then he'd squeeze one of my breasts and let out a honking sound. "No," I say now. My breasts are mine; they are extensions of my body and myself and my one sacred life. Becoming a mother, I am once again at home in my body. I am myself, doing what speaks to me as fulfilling and nurturing. Breastfeeding is one way for my daughter and I to make a home together.

As a new mother, I was surprised at the intimacy of breastfeeding, how exposed I felt yet safe in the exposure. It made sense that Adrienne Rich in *Of Woman Born* compares suckling a child to a sexual act: "it may be tense, physically painful, charged with cultural feelings of inadequacy and guilt; or ... it can be a physically delicious, elementally soothing experience, filled with tender sensuality" (86). My daughter nurses at my breast like an acolyte praying: focused, earnest, full of longing, and also at ease. There's a physiological charge between us. During her first six months, when my daughter cried out, electric milk currents surged from my armpits into my nipples; instantly, I'd reach for her as drops of milk hit the wood floors. Once latched, her body relaxed, and I relaxed, feeling the pleasure of releasing my milk to her. I left milk drops on the floor for days, reluctant to wipe them away.

As my daughter explores how our bodies work together, she is exploring her powers. It's a process. During her first weeks, she learned how to nurse, lodging her tongue beneath my breast to get the best latch. Knowing how to draw milk from me is a kind of power. I like to think she's also gaining power through the freedom to express pleasure and frustration, pleasure when she could satisfy her hungers, frustration when she could not. If the early childhood development experts are right, this freedom will help her build a sense of security that will enable her to be attuned to herself and the signals her body gives her.

By her eighth month, she became an expert feeder. She placed my hand where she wanted it so I could prop my breast at a good angle for her. She used her own hand to do the same. Breast time was play time, too. In my arms, she sometimes rolled her head away and rolled it back, giggling. Initiating games with me suggested she felt safe to test our interplay.

To explore your own body close to another's body without being controlled, condemned, or shamed—that's what I would have wished for myself. That's what I wish for my daughter. I wish her the confidence and self-love to express how she would like to use her body and how she would like it to be used. I wish her intimacy with people she loves.

Our relationship has necessitated setting limits, too. During the winter months, when she was nine months old, my daughter was so congested her nostrils became blocked. While trying to feed, she bit down hard on my nipple. She had four teeth! I cried. Our mutually nurturing honeymoon was over! But really, a congested baby biting her

mother's nipples is not unusual, and once I came off of the weepy interlude, I sucked snot from her nostrils with a Nose Frida, googled "how to teach baby not to bite breasts," and found several techniques on parenting sites: 1) push baby's face into breast, essentially suffocating your child (I'd heard this one before and shuddered at brushing shoulders with infanticide); 2) pinch baby's earlobe, not with your nails but the pads of your fingers; 3) pull baby away from breast, look baby in the eyes, and firmly say "no." I tried number three, looked her straight in the eyes and said, "No!" She cried. I cried too. A turning point had arrived in our relationship. After a few rounds of "no," my daughter did not bite me again, not even months later when she caught a late-spring cold that clogged her nose for a week. She remembered: biting doesn't work. At first, I'd so openly given her my breasts that setting limits felt painful, even worrisome for what those limits might mean for our closeness. This could be a rookie fear that would make more seasoned moms shake me and say, you're in charge; she'll be fine. Yes, I have to remind myself that establishing trust involves setting limits, and being the grownup, I need to model for my daughter how to be clear and firm so that she will learn how to say "yes" or "no" as she names what she does and does not want in the days and years to come.

I think about mothers often; I think about the girls they were that are living inside their bodies, and how their experiences as girls and young women have shaped them as mothers. I think about the circumstances of our lives that lead us to different places in our relationship to motherhood. When I look at nineteenth-century German painter Paula Modersohn-Becker's portrait of a mother nursing her child, *The Athenaeum,* I see a woman who is inward, burdened, and trapped. The bent of her back echoes the stoop of a farm worker, exhausted from pulling up onions, potatoes, or babies. For many women, breastfeeding is not an empowering act. Low milk production, engorgement, and mastitis are just a few afflictions that can undercut a mother's confidence and produce anxiety. For some women, breastfeeding triggers memories of childhood sexual abuse. We must also recognize, honour, and respect that breastfeeding is physical labour: the average baby feeds every two to three hours for about fifteen minutes per feeding, amounting to about two hours of feeding or pumping a day, every day.

"Motherhood," as Adrienne Rich reminds us, "has a history." I was thinking about this as I looked at *The Athenaeum* and read Modersohn-

Becker's bio. She died at age thirty-one from a postpartum embolism. Her art and life are reminders of motherhood's potential mental and physical dangers. I was thinking about Rich, too, born in 1929, who began having children in the 1950s. Of her pregnancy with her first child, Rich writes the following: "I felt, for the first time in my adolescent and adult life, not-guilty." She was met with an "atmosphere of approval" (85). Prior to becoming pregnant, she felt she was failing to fulfill what was expected of her. She describes her first decade of motherhood as beginning with "a smiling young woman ... gradually she stops smiling, wears a distant, half-melancholy look, as if she were listening for something" (90). Children were foisted upon her by external forces rather than by her own personal conviction. Her unwitting children and the relentless duties of childrearing sapped her ability to discover her voice and desires, bringing on depression and resentment.

Timing significantly influenced my exuberant relationship to motherhood. As I've said, I was forty-three when I had my child. I had to fight for her. For over two years, my husband and I tried to get pregnant without success. When our first pregnancy ended in miscarriage, I was devastated. With every passing month, I felt the maw of time devouring my ability to conceive and carry a child to term. Against all odds, I now have a daughter, which leaves me so grateful that very few things strike me as a burden in relation to caring for her.

In terms of the ideal biological age to conceive, time was not on my side, but financially, professionally, and emotionally, I was ready. I have a home and a secure job. Her father shares the responsibility of caring for our child. I've also cultivated a well of acceptance for my body and the experiences that shaped me. No single step or circumstance led me to this comparatively fortunate place, but ceasing to cover up experiences that saddled me with shame helped immeasurably. Doing so enabled me to recognize and disrupt patterns in my relationship to myself and others. But as Rich points out, many women don't have the time, readiness, or resources to do this necessary work before having their first child. It's a toss-up between that and the grief a woman potentially faces if she waits until she's older to conceive and can't.

My daughter is fifteen months old now. I still breastfeed but am in the process of weaning her from feeding during daylight hours so I don't have to keep pumping milk at work. When my daughter asks for my breast and I offer her a sippie cup of whole milk instead, she takes two

gulps, puts down the cup, and points at my breast. Letting go is difficult for me too. When I hold her in my arms and she's nursing, she lifts her foot for me to kiss, eyeing me to see my lips touch her toes, her eyes jubilant. This is our little game. That this particular closeness will end is bittersweet. Occasionally, I worry I will wean her in a way that damages our bond, but this fear may be a hangover from Freud, who described weaning as traumatic with clouds of oral fixation looming on the horizon. I can't predict the future, but I do know the point of breastfeeding was not to bind my daughter exclusively to me but to give her a foundation to establish nourishing bonds with others.

For months when I picked my daughter up from daycare, she threw her hands in the air and ran straight for me. At day's end, I looked forward to these triumphal reunions. But recently, instead of getting excited when I appeared, she continued playing with the girl beside her. I felt a pang, then took a breath, and sat down beside them. My daughter shook a tambourine, the other girl struck the rainbow-colored xylophone keys, and they watched one another for the next move.

Works Cited

Lorde, Audre. "The Transformation of Silence into Language and Action." *Sister Outsider: Essays and Speeches.* Crossing Press, 2007, pp. 40-44.

Rich, Adrienne. "Anger and Tenderness." *MOTHER READER: Essential Writing on Motherhood*, edited by Moyra Davey, Seven Stories Press, 2001, pp. 81-98.

van der Kolk, Bessel. *The Body Keeps the Score: Brain, Mind, and Body in the Healing of Trauma.* New York: Penguin, 2014.

Chapter Seven

A Manifesto on the Sacredness of Anishinaabeg Mothers' Breasts

Renée E. Mazinegiizhigoo-kwe Bédard

"All the rivers of the earth are milk that comes from the breast of the Great Mother. Our breasts give the waters of life to feed the children."

—ChoQosh Auh'Ho'oh, Elder

Opening My Woman's Medicine Bundle

Boozhoo! In the language of the Anishinaabeg, I offer greetings. I am Indigenous—more specifically, Anishinaabe-Ojibwe, Anishinaabe-Nipissing, *Omàmiwinini*, and French Canadian. I am a band member of the Anishinaabeg of *Okikendawt* (Dokis First Nation) in Ontario, Canada. Anishinaabeg traditional territory stretches across Canada through the provinces of Quebec, Ontario, Manitoba, and Saskatchewan, and down along the bottom of the Great Lakes region crossing the American states of Michigan, Wisconsin, Minnesota, and North Dakota. My area of research primarily concerns Anishinaabeg motherhood.[1]

Each Anishinaabeg woman who follows the cultural ways of her ancestors builds her own woman's medicine bundle. An Anishinaabeg woman's bundle is a physical object of animal hide (e.g., deer or moose),

a cloth bag that holds sacred ceremonial items (e.g., feathers, plant medicines, beadwork, drum, rattles, copper items, etc.), as well as an example of intellectual knowledge (e.g. stories, personal experiences, teachings, songs, prayers, chants, lessons, or words of teachers and mentors). Our bundles are sacred because they are the embodiment of our identities (both cultural and spiritual) and our worldviews; they represent our connections to a specific territory. In my medicine bundle, I carry sacred items I have been given or have made myself, along with knowledge in the form of teachings received from women Elders, cultural mentors, community members, my midwives, and from Anishinaabeg scholars, who have written our stories down. Included in these teachings on motherhood is knowledge specific to the mother's breasts, which honours the breasts of women as sacred embodiments of female gifts bestowed on women. These are the gifts of life giving through our womb and the gift to sustain life with our breasts. This chapter highlights the importance of a mother's breasts within Anishinaabeg women's cultural traditions and worldview.

Aki

Anishinaabeg women's medicine bundles carry the stories of the first women as instructions of how to be a mother within Anishinaabeg contexts. Aki (Earth; Mother the Earth) is the first *kwe* (woman), and the etymology of her name is rooted in her breasts, her motherhood, and her role as the first breastfeeder. The name "Aki" is rooted in teachings of mother's breasts, and Aki is considered one of the oldest sacred words in *Anishinaabemowin* (the Anishinaabeg language) (MacIntyre). Oral storytellers identify *Aki* by using either *Shkaa-kaamikwe* or *Mazikaamikwe* in deference to her sacred place as the first woman and her abilities to create life. Both names end in *ikwe*, which is the term for woman. Within the name *Mazikaamikwe*, "mazin" refers to her female ability to create something new, whereas *Shkaakaamikwe* highlights the physical nature of the mother's breasts, breastmilk, and breastfeeding. Anishinaabeg singer Brenda MacIntyre says that within the name *Shkaakaamikwe* is the sound "*zhakaa*" which is a piece of meaning added to indicate something is soft and damp, like show or a bog." She continues: "And when we think of where old stories (and now science) tell us life began, I think it may not be too far off. *These are the names for aki, the earth, the one we know as a mother* (my

emphasis, MacIntyre 3). *Shkaakaamikwe* characterizing "something is soft and damp" describes a mother's breasts, which are soft and moist with breastmilk. Aki had just given birth, indicating it is springtime for the Earth, and during that season, the Earth is saturated and soft with water from thawing, which is indicative of new breastmilk leaking or gushing forth.

Shkaakaamikwe is an accurate description of how I saw my breasts when I breastfed my daughters, specifically, from birth to over a year old. My breasts were large and became pillows for my babies' heads. At the end of each breastfeeding session, my whole chest would be damp with breastmilk, and I would be sweating from holding a warm baby for so long. To my babies, my breasts were their postbirth world; everything we did together revolved around my breasts and breastfeeding. My breasts were their favourite place to sleep, eat, and rest.

The creation story of Aki is the most important and sacred of all the *aadizookaanag* (sacred and ceremonial stories) I carry in my medicine bundle. Indeed, Anishinaabeg women have been referencing Aki's story for thousands of years like a manual on motherhood and mothering practices. The story encompasses the first teachings of the mother's breasts. For instance, Anishinaabeg Elder *Asinykwe* Edna Manitowabi's version of Aki's story roots the primacy of womanhood and motherhood within the natural order of Creation. Manitowabi teaches us that Aki is the first woman and first mother and that her female body was formed to birth life and sustain life. Elder Manitowabi identifies Aki's gifts as creation and renewal, which manifests in her body's (the land) ability to make and sustain life. According to Elder Manitwabi, as the first woman and mother, Aki conceives, experiences pregnancy, births life, and breastfeeds from her body. She also explains that all life on earth comes from the raw elements of Aki's breasts: soil, air, water, and fire. All land formations, weather, animals, birds, fish, insects, and spirit beings were distributed across the Earth's breasts to feed, grow, and thrive. Just as a newborn is placed skin to skin to breastfeed, so were Aki's children placed upon her breasts. From Aki's breasts come all food, water, air, and resources to sustain life.

Aki's first child *was Ani niisayi'iinaabe owe akiing* (The First Human Being Who was Lowered onto the Earth; Original Man). He was conceived directly from the raw elements taken from her breasts, which is the land. After *Ani niisayi'iinaabe* was born and he was lowered downwards

to the Earth, he was placed gently and with kindness onto his mother's breasts. Like other creatures created before the first human being, *Ani niisayi'iinaabe* would also be entirely dependent on his mother as his sole source of sustenance and protection from birth to death (Manitowabi). Therefore, her status as sacred is grounded in being the originator and sustainer of life now existent on our planet.

Our grandmothers passed down her story through their medicine bundles as the first source of *gikendaasowin* about being physically and spiritually women. She is a reminder that motherhood is as ancient as the Creation of the Earth. As long as there have been women and mothers, there have been mother's breasts feeding babies. We take Aki's story out of our bundles when we need the wisdom of those grandmothers that came before us. The information specific to Aki's mother's breasts tell us about our breasts as sites for our sovereignty, agency, and power within our nations. Encoded in Aki's story is the wisdom and customs that every Anishinaabeg woman and mother needs to learn to understand the scope of feminine maternal cultural identity.

Anishinaabeg Women's Medicine Bundle and Teachings on Mothers' Breasts

Women's medicine bundle teachings on mothers' breasts contain maternal teachings, customs, ceremonies, and philosophies. At transitional periods of a woman's life, she is given teachings for her medicine bundle. The transitionary periods of a woman's life include her birth, her first menstruation, motherhood, menopause, grandmotherhood and Eldership, and, finally, death. When a woman announces she is pregnant, her mother, midwives, grandmother, and Elders will begin sharing with her the teachings connected to each stage of pregnancy, which will prepare her for her role as a mother. A pregnant woman will start learning about how she is being transformed from maidenhood to a mother, with one of her first duties being that of the *doodoom* (breastfeeding mother). Knowledge about mothers' breasts contains vital information about behaviour, ethics, responsibilities, roles, songs, prayers, medicines, sacred objects, history, and stories, including information about mothers' breasts concerning pregnancy, birth, miscarriage, breastfeeding, health, sexuality, and parenting. A woman gives birth with her body and then uses her body's breasts to produce

food to sustain that life. Only women hold these gifts; these are some of Aki's array of mothering gifts to all her female descendants. From her breasts came the template for other breastfeeders, including human females.

After I first gave birth and held my hungry baby in my arms, I quickly realized that I was the only source of nourishment for her. I had no idea what I was doing, but my body did, as it was designed or engineered to do this work, and nature was taking over. My milk came on fast and overflowing like the waters of springtime. When my milk came in, I didn't know what was happening to my breasts and was quite frightened by it; I felt like I was not in control of my body. I was flooded with milk and had a baby that knew how to get my milk flowing in a second, even if I wasn't ready or willing. I felt like the maple trees of spring, hemorrhaging *ninaatig-waaboo* (maple-tree water) from their trunks and branches. I now use that metaphor when teaching other women about how Aki's breastmilk or the waters of spring hold our teachings about breastfeeding and breastmilk. One of the first teachings given to me about breastfeeding was how it was a responsibility to the life I chose to bring into this world. Breastfeeding and producing breastmilk was now my job as a mother. Aki's story tells us that the role of breastfeeder is the nourishment of new life. For the first year of my daughters' lives, I was the source of their every meal and the vessel for their food.

In First Nation's scholar Basil Johnson's account of Aki, he describes her bosom as a bowl that refills based on the needs of her children. As a bowl (*boozikinaagan*), the Earth's breasts provide nourishment for all life equally and with great generosity and self-sacrifice. The bowl is a symbol for the attributes, ethics, and behaviours a breastfeeding mother is expected to embrace and demonstrate. These teachings become part of the mother's identity, parenting practices, her medicine bundle, and legacy for her daughters and granddaughters.

The bowl teachings are essential lessons to preserve the health of the mother's breasts, as producing breastmilk and maintaining breast health is vital to successful breastfeeding. When I was a newly pregnant woman, my midwives gave me teachings to prepare my breasts for motherhood. These women taught me to care for my breasts, including knowledge of the types of clothing to wear to encourage the growth and sustenance of milk. Also, they shared how not to cause infections or blocked ducks, the ways to keep clean by bathing my breasts regularly

with fresh water, how to protect my skin from the corrosive nature of baby saliva, and how to interpret the physical changes my breasts would undergo during pregnancy and postbirth. Furthermore, they told me about the psychological challenges, the emotional ups and downs of breastfeeding, and encouraged me to speak up when I needed help.

Before pregnancy, I did not pay much regard to my breasts' health; they were merely another part of my body, like my back or my arms. The central teaching I took from the midwives was to leave behind my prepregnancy understandings of my breasts because I was physically transforming into a new version of myself as a mother, especially as a breastfeeding mother. They taught me to witness the changes to my mother's breasts and the new normal for my body. My health and my child's life depended on me not neglecting the health of my breasts. The teachings of the bowl remind us that as new mothers, our breasts become the focus of much of our motherly identity and responsibilities for up to the first two years of our child's life. Breastfeeding was a spiritual awakening for me in my role as a mother and nurturer of new life.

The Ceremony of Breastfeeding

The next teaching I carry in my medicine bundle is the spiritual ceremony of breastfeeding. Breastfeeding is more than a physical experience; it is also a profound spiritual experience that begins while the baby is in the womb. The teachings on breastfeeding preparations started early on in my pregnancy. They required that I prepare my body with food and traditional herbal medicinal teas to make my breasts ready for milk production. After birth, I consumed other traditional herbal medicines and foods to boost my milk supply. Nurturing the environment of the body produces the best nourishment for a baby and keeps the mother's breasts healthy and providing nourishment.

At birth, whether born with midwives or in a hospital setting, the baby will be placed on the mother's chest to initiate the ceremony of breastfeeding. Anishinaabe Elder Edna *Asinykwe* Manitowabi (Wikwemikong Unceded First Nation) explains that the mother must begin the ceremony of breastfeeding in the moments after birth: "Before the cord is even cut, it's long enough that we're told to put the child to your breast. And already the mother has given the first teaching about kindness, about sharing, about being honest. She is being honest when she puts

her child to her breast. She is nurturing. She is giving life to that child. She is giving strength" (30). After my Caesarean section, I remember being sewn back up, brought into a transitional area before being delivered to my private room, and then handed my swaddled baby. I was then told by the nurses to begin trying to feed my baby. I had to remember what the midwives had told me and what I had read in my books. With my daughter less than thirty minutes old, she began breastfeeding, and we had started our ceremony.

Once my midwife arrived, she placed the ceremony more squarely in Anishinaabeg culture. She discussed not just the mechanical nature of breastfeeding but also the spiritual aspect of the breastfeeding journey we were beginning. She noted that I needed to spend time locking eyes with my baby, talking to her, and snuggling with her so that she would be encouraged to feed. Manitowabi refers to this as the first lesson of kindness.

The process of physically and spiritually connecting with babies during the ceremony of breastfeeding is *gikinoo'amaagoowin abinoojii-yensag*, which translates to "mothers teach the babies from the heart and looking into their eye," and also it can mean teaching a child to learn how to open their heart as well as their eyes. My midwives taught me to maintain eye contact with my baby so that my daughter would feel and see the love in my eyes and keep feeding. Along with these gestures, mothers perform many intimate ritual practices of bonding: singing, praying, snuggling, rocking, and so on. Not only does breastfeeding feed the body, it also feeds the spirit. These rituals root the spirit of the child to this world and its family so that it does not decide to return to the spirit realm. Until the soft spot on the top of a baby's head closes, the child spirit's hold on this world is fragile (Anderson). A mother's role in performing the breastfeeding ceremony is to ensure that the child's spirit feels connected to the world of the living—in other words, give the child a reason to live. She acts as the baby's connection to this world, and her breasts act as the anchor in this reality.

Skin to Skin

Another medicine bundle teaching I carry prioritizes skin-to-skin contact as a spiritual bonding experience between mother and baby. Like the previous teachings, skin-to-skin contact with the mothers' breasts appears in Aki's story, specifically, regarding the lowering of her son *Ani niisayi'iinaabe* to her breasts following his birth. In Anishinaabe Elder Edward *Bawdwaywidun Banaise* Benton-Banai's (Lac Courte Oreilles Reservation) version of Aki's story, skin-to-skin takes place between *Ani niisayi'iinaabe* and Aki immediately after birth with delicateness, kindness, and gentleness (Toronto Zoo). *Gizhew-Manidoo* lowered *Ani niisayi'iinaabe* to Aki's breasts and arms where he lay on her skin, connecting with her, and with the rest of Creation. Through the first skin-to-skin contact, the spiritual bond is reestablished between mother and child that birth can temporarily sever.

Skin to skin is a postbirth bonding ritual that allows the baby to connect with their mother so that they can survive and thrive in the world. "What does the baby most need at the moment of birth? Only mother," state Jill Bergman and Niles Bergman, a respected husband (public health physician) and wife (teacher, doula, and author) team who have researched the effects of skin-to-skin contact between a mother and newly birthed infant (Bergman and Bergman 9). Without skin-to-skin contact, there can be a suppression of the newborn infant's protective behaviours, leading to infant behavioural disorganization, issues with attachment and breastfeeding for mother and infant, separation anxieties, lack of bonding, maternal affective responses, and harmful maternal behaviour (Bergman and Bergman 8-10).

The postbirth ritual of skin-to-skin contact is vital to the baby's and mother's physical and spiritual well-being. In the "womb world" (Smith), an unborn baby spends nine months in constant physical contact touching the mother, listening to her heartbeat, and receiving her nourishment. After birth, the baby still needs those exact requirements. Dr. Harvey Karp was the first to coin the term "fourth trimester"—the time when a baby is still physically immature and requires the re-creation of the individual sounds and relaxation they experienced inside the womb. These experiences can include constant contact with their mother's body, rocking motions, being tightly cradled, getting the mother's nutrients, and listening to the sounds of their mother's voice, blood, and heartbeat (Karp).

To the Anishinaabeg, this fourth-trimester period is sacred because the child is still closely tied to the spirit world (Goforth; Simpson). The Anishinaabeg believe that while in the womb, a baby's energies or "sacred vibrations" (National Collaborating Centre for Aboriginal Health 9) are syncopated to the mother because her body is teaching the baby how to be a human being. Outside of the womb world, the baby continues to need that syncopation for several more months, so the baby requires skin-to-skin contact with their mother's breasts to access her field of energy to properly function until they can learn to balance their energetic vibrations.

In the womb, the baby's energies are connected to their mother's *chibowmun* and *jichaag*. Birth severs that tie, and outside the womb, a newborn has to regulate their energy, which they cannot always do just after birth. Skin-to-skin contact at the mother's breasts is spiritual education or training within a new transitional energy site called the "birth field" energies. Parenting expert and scholar Tami Kent believes that there is energy in the mother-baby connection, even after the child's birth. Mothers may send their babies motherly energy in prayer, touch, words, or mere eye contact to soothe children's frustrations or to infuse their lives with blessings in moments of need. Kent explains that in the first year or two of life, physical connections of birth energy are especially strong. For this reason, babies will cry for their mother's breasts and arms. They do not feel entirely complete without the birth energy flowing from their mother's aura and milk.

Until my second daughter was two, she was always trying to place the palm of her hand down my shirt to my breast or she would place her whole head on my neck, working her way down to my heart so that she could listen to my heartbeat. She only felt calm touching or lying on my chest. As part of my woman's teachings on mothers' breasts, I learned the power of a mother's aura, sacred vibrations, and birth energies to establish the spiritual identity of my child.

Closing Reflections

Anishinaabeg women's medicine bundle teachings focus on protecting and enhancing the emotional, spiritual, mental, and physical health of the mother and child. Mothers' vigilance in passing down these traditions and intellectual knowledge over generations is believed to be part of the training and discipline required to support Anishinaabeg women and babies in living long and healthy lives.

Today, not all our women carry the mothering culture—either the objects or the knowledge—of our ancestors. Those of us who have some of it are obligated to share it, use it, and model it for the next generation. Our grandmothers knew that mothers' breasts are sacred; without breasts, life on earth would not exist. Somewhere along the way, we have forgotten this teaching. Leanne Simpson reaffirms the importance of connecting with the older generations' repository of knowledge and traditional teachings: "Our grandmothers tell us that the answers lie within our own cultures, ways of knowing and being, and in our languages. When I listen to them talk about pregnancy, childbirth, and mothering, I hear revolutionary teachings with the potential to bring about radical changes in our families, communities, and nations" (26).

Anishinaabeg women, mothers, and grandmothers must claim the narratives of our breasts; this is an essential step in our ability to claim sovereignty and agency. We need to focus on our history and traditions so that our bodies, hearts, minds, and spirits do not become colonized by living in this contemporary world. We need to ensure that we remain connected with Anishinaabeg breast traditions to ensure that we honour mothers, babies, and our cultural identity. To close, I offer a poem describing the ceremony of breastfeeding and honouring Anishinaabeg mother's breasts.

The Ceremony of Breastfeeding

Hungry, diving little mouth.
Diving into my breast.
Rooting, searching frantically around for that nipple.
Familiar, sweet smells of baby skin and hair.
Latching, swallowing, rhythmic sounds.

Suck, suck gulp.
Suck, suck gulp.
Suck, suck gulp.
Suck, suck gulp.

Drawing out and in my milk.
Soft, curled body around my breast.
Fitting close, nuzzling closer, hypnotic sounds.
Smiling up at me from my arms.
A small loving hand is stroking my breast, then my face, in thanks.
We are thankful, *miigwech* (thank you).

Suck, suck gulp.
Suck, suck gulp.
Suck, suck gulp.
Suck, suck gulp.

Endnotes

1. I understand this language may appear to exclude those individuals who identify on or with the feminine gender spectrum in the LGBTQ2S community; however, the language I use embodies the cultural legacy of Anishinaabeg women's bodies that can give birth and breastfeed. Furthermore, I also recognize that some women may not be able to conceive, give birth naturally, or breastfeed. Regardless of our physical differences or challenges with fertility as Anishinaabeg women, we are still the descendants of Aki, and her gifts extend to a complex array of mothering practices that are not solely grounded in the physical ability to conceive, birth, or breast-feed.

Works Cited

Anderson, Kim. *Life Stages and Native Women: Memory, Teachings, and Story Medicine*. University of Manitoba Press, 2011.

Bergman Jill and Niles Bergman. "Whose Choice? Advocating Birthing Practices According to Baby's Biological Needs." *The Journal of Perinatal Education*, vol. 22, no. 1, 2013, pp. 8-13.

Benton-Banai, Edward. *The Mishomis Book: The Voice of the Ojibway*. Indian Country Communications Inc., 1988.

Goforth, S. "Traditional Parenting Skills in Contemporary Life." *Healing Words*, vol. 4, no. 1, 2003, pp. 17-19.

National Collaborating Centre for Aboriginal Health. "The Sacred Space of Womanhood: Mothering Across the Generations." *CCNSA*, 2012, www.ccnsa-nccah.ca/docs/health/RPT-SacredSpace Womanhood-Bckgrnd-EN.pdf. Accessed 29 Oct. 2018.

Johnston, Basil. *Ojibway Heritage*. McClelland & Stewart, 1976.

Karp, Harvey. *The Happiest Baby on the Block; Fully Revised and Updated Second Edition: The New Way to Calm Crying and Help Your Newborn Baby Sleep Longer*. Bantam Books, 2002.

Kent, Tami Lynn. "Healing the Birth Energy Flow Between Mother and Child." *Inner Self*. 2013, innerself.com/content/personal/relationships/parenting/9026-the-birth-energy-flow-connects-mother-and-child.html. Accessed 2 Feb. 2020.

MacIntyre, Brenda. "Shkaakaamikwe/Mazikaamikwe, Ezhi-ni'gikenimaanaan." *Earth Day Conference*, 20 April 2007, Michigan State University, pp. 1-5.

Manitowabi, Edna. "Women's Connection to Mother Earth and Grandmother Moon." *Matriart Magazine*, vol. 2, no. 1, 1994, pp. 27-30.

Simpson, Leanne. "Birthing an Indigenous Resurgence: Decolonizing Our Pregnancy and Birthing Ceremonies." *"Until Our Hearts are on the Ground" Aboriginal Mothering, Oppression, Resistance and Rebirth*, edited by D. Memee Lavell-Harvard and Jeannette Corbiere Lavell,: Demeter Press, 2006, pp. 25-33.

Simpson, Leanne. *Dancing on Our Turtle's Back: Stories of Nishnaabeg Re-creation, Resurgence, and new Emergence*. ARP Books, 2011.

Smith, Sarah Ockwell. "The Fourth Trimester—AKA Why Your Newborn Baby is Only Happy in Your Arms." *Sarah Ockwell Smith: Author and Parenting Expert,* 2014, sarahockwell-smith.com/2012/11/04/the-fourth-trimester-aka-why-your-newborn-baby-is-only-happy-in-your-arms/. Accessed 28 Oct. 2018.

Toronto Zoo. "Ways of Knowing: Ways of Knowing Partnership, Turtle Island Conservation." *Toronto Zoo,* 2010, www.torontozoo.com/pdfs/tic/Stewardship_Guide.pdf. 2010. Accessed 28 Oct. 2018.

The Professor's Breasts: An Alphabetical Guide to Academic Motherhood and Breastfeeding

Robin Silbergleid

Adrienne Pine

I have been back on campus all of six hours following maternity leave when I get the phone call about my son. I give the class some writing to do, excuse myself, and go out in the hall to listen to the message in which I am informed that he's vomited twice. I have an hour left in class. Do I let my students go early (it's the first day, I probably would anyway)? Do I let my son stay at daycare sick? Neither option seems ideal. All day I have been thinking about Adrienne Pine[1]— American University professor, now infamous for breastfeeding her sick baby while giving the introductory spiel in her sex, gender, and culture class. In September 2012, her story went viral. She was interviewed on TV. Online comments, largely negative, proliferated: Pine was wrong for feeding her daughter in front of her students; Pine was wrong for bringing a sick baby to class in the first place; Pine was wrong not to stay home with her child; and Pine was wrong for not adequately supervising her child in the classroom, letting her crawl around on the floor when not attached to her breast. Although she could not have anticipated national scandal, she undoubtedly understood this as a

feminist professor and single mother: no matter what she chose to do in this situation, it would have been wrong. See also **ZEALOTS**.

Baby, Bottle, Bra, Breast

As a child, I pretended to breastfeed my dolls, putting their cold plastic mouths to my bare chest under my cotton shirt. I did not know the terms for cradle hold, or cross-cradle, or football. I did not know the rush of milk letting down or the scrape of a toddler's tooth against my nipple. I liked copying my mother as she nursed my younger brother. When I became pregnant with my first child, it did not occur to me that I would do anything other than breastfeed. I assumed it would come easily.

In preparation for returning to work after months of baby care, I began pumping milk for the babysitter to give my daughter; in the morning, I nursed her on the right and used the electric pump to collect milk on the left. When she wasn't with me, I secured the breast shields inside the cups of my nursing bra and pumped into both bottles while I checked email from work. I resented the hours spent washing baby bottles and the innards of the pump. The night before my first class, I melted a pot of plastic baby bottles I had put on the stove to sterilize—an act that should have taught me something about the fundamental problem of multitasking as a working mom. After that, I relied on the microwave in my vigilance against germs.

Despite the **STATISTICS** for working mothers in North America, I managed to breastfeed two children: the first for ten months and the second for twenty-two (at this writing). It should be noted, however, that marital status excepting (I am single), I am in the demographic of American women who are more likely to be successful at long-term breastfeeding. Within my social class, as for Adrienne Pine, it is also expected that I do so.

Choice

In the early twenty-first century in the United States, breastfeeding is often approached as an option for a new mother, in the way that formula feeding is also presented as an option, even though biologically speaking, mammals are designed to breastfeed their young. Indeed,

the scientific classification "mammal" stems from the existence of mammary glands—that is, breastfeeding is a normal part of human reproduction. Formula feeding is not—however useful it might be. At the hospital where my first child was born, I was given both the support of a lactation consult and a diaper bag full of formula samples.

Partly because breastfeeding is considered a choice rather than a biological norm, Adrienne Pine's nursing her child on campus drew national attention. In fact, in the United States, only 24.9 per cent of mothers exclusively breastfeed at six months, one of the lowest rates in the world.[2] Pine said she didn't give her child formula because it was expensive, inconvenient, and she disliked washing bottles. Did her baby drink expressed milk at daycare, or did Pine only nurse at the breast? It should be noted, as Juliann Emmons Allison explains, that parenting styles undoubtedly have professional consequences; discussing the particular problems of mothers who choose a form of intensive mothering known as "attachment parenting," Allison suggests that "the professional cost to a mother's academic career is raised considerably if she chooses to nurse her infant" (29). Undoubtedly, Pine would agree.

Dysphoric Milk Ejection Reflex (D-MER)

The anxiety that starts the heart racing, the trembling hands: I feel it in a faculty meeting while my chair drones on about this and that, and all I know is that I need to leave *now, now, now*, and sure enough, I feel milk letting down. When I leave, I will pick up my son and feed him and only then will I be able to relax.

Or. The night my usually sleepless infant doesn't wake until 2:00 in the morning, my body is buzzing with milk. Can't sleep can't sleep can't sleep. I pull him from the crib, and he sucks with his eyes closed and threatens to wake when I'm done, when he's gumming an empty breast.

My body acts on its own sometimes. I sit here typing this essay, and it does what it wants—not an emotional response but pure physiology. It seems I am not alone. The website D-MER.org informs me that D-MER "is a physiological response (not a psychological response) that appears to be tied to a sudden decrease in the brain chemical dopamine immediately before milk let-down." Women who experience such dysphoria characterize it with a range of terms, including anxiety, dread, nervousness, angst, irritability, and hopelessness.

I do not need to look at the clock anymore; I know it is time to pump milk because I become otherwise inexplicably anxious at the same times every day. Within moments of this feeling, my breasts thrum with milk; I put on my pumping bra, let the milk spill into the collection bottles, and immediately relax. My body is primed to feed my child; I must attend to it.

Expression

Breastmilk can be expressed by hand, with a manual pump, or with an electric breast pump (double or single). The Medela Pump-in-Style, a pump commonly used by working mothers, is designed to look like a briefcase. One of my male colleagues smiled at me, knowingly, when he saw me lugging mine into the office.

Later, when the daily schlepping became impractical, I borrowed my friend's extra pump to keep under my desk at work. My pumping schedule on teaching days is different than other days to accommodate my classes. Frequently, my milk lets down in class and then, later, on the walk back to the office. I no longer schedule meetings during this hour, although pre-baby the time between my classes presented the ideal time to hold meetings and office hours. How can I explain to my students I am not being dismissive when I say I really don't have time to chat right now? If I don't pump, not only will I be uncomfortable, my son will not have enough milk to drink tomorrow. In the university classroom, we like to pretend we are all brains, not bodies.

Despite it being a natural act, breastfeeding for a working mother is undoubtedly made easier—and in some cases made possible—through the artificial means of the purchasing of well-chosen gear, including nursing bras, breast pumps, milk storage bags and bottles, breast pads, and lanolin. Indeed, feeding a child mother's milk in a baby bottle is considered in some contexts to be breastfeeding; some mothers of premature infants or those with latching problems feed exclusively by giving their babies bottles of expressed milk.

One day when I sat down at my desk to pump, having already secured the breast shields in place, I realized I had brought the caps for the collection bottles but not the bottles themselves. I panicked—no time to go home and retrieve them. Fortunately, my friend had stashed a few plastic bags, labelled "my mommy's milk" in the side pocket of the pump

bag. I secured them with a substantial amount of scotch tape and rubber bands and went about my day, feeling a bit like the MacGyver of breastfeeding moms.

This is how I managed to give my son bottles of breastmilk for a full year. The fact that I am breastfeeding undoubtedly affects my work, and my working affects my ability to breastfeed. I spend more time thinking about breasts, sterilizing pump parts and bottles, and washing breast pads than I care to admit.

Formula

A notorious image circulated in breastfeeding advocacy texts depicts a South Asian mother holding her infant twins. On the left, her son, fat and thriving, suckles, his face buried in her clothing. The girl twin faces outwards, and the mother holds a baby bottle in her mouth. It is not an exaggeration to say the girl is skin and bones. There is, frankly, no other way to describe her. It should come as no surprise to the educated reader which of the twins died shortly after the photo was taken.

The photograph is meant to shock; if one ever needed to be convinced of the expression "breast is best," it is here, in this image, generated as part of an anti-formula campaign used to pressure (white, middle-class) women to breastfeed.[3] To be sure, in some areas and in some contexts, babies die from being formula fed—from contaminated formula, from unclean water sources, and from their impoverished parents stretching the formula so its caloric content is so diluted the child doesn't receive adequate nutrition. It is also true (if rare) that in some areas and in some contexts, babies die from being breastfed. Recently, I read an article discussing a newborn baby dying from such severe dehydration that his heart stopped; his mother noted that he nursed all day long and screamed when he was taken from the breast.[4] She assumed he was getting adequate nutrition when, in fact, she was hardly producing any milk. The mother was a white woman, in North America in 2017. Being encouraged to supplement with formula could have saved her baby's life.

There is no formula to determine when to breastfeed and when to bottle feed, but there is an enormous cultural apparatus (some would say propaganda) that results in mothers' guilt about their choices. The group La Leche League proclaims "*By far* the safest, healthiest food for your

baby is your milk" (*Womanly Art* 157). By contrast, they continue, "there are *thousands* of studies to show that formula-fed babies end up with lower IQs, poorer health, and higher rates of cancer, diabetes, and heart disease than babies who breastfeed. Formula also contains environmental contaminants from cow milk and other ingredients, processing, and packaging" (157).

The guilt runs deep; despite my strong desire to breastfeed and my ability to produce voluminous quantities of milk, my daughter ended up requiring hypoallergenic formula due to food protein intolerance. Her pediatrician told me to keep nursing; despite chronic diarrhea and reflux, the baby was thriving, gaining adequate weight and meeting all developmental milestones. I spent months on a radical elimination diet, starving myself and worrying about every bite I put in my mouth. What if the pediatrician had said, "I understand breastfeeding is important to you, but you'll both be better off if you switch to formula"? I hated everything about formula, but I now understand I owe my child's health, and my own, to **WEANING** her.

Galactologues

Herbal remedies that are known to increase milk supply include fenugreek, fennel, mother's milk tea, alfalfa, nettle, and dill. Or you can make a galactologue cookie using brewer's yeast and oats (both of which are known to increase supply), which undoubtedly goes down much easier than a leafy capsule of fenugreek. Many working mothers need to use galactologues in order to increase milk supply. Although I eat oatmeal daily, I have never needed to use a galactologue—see **UNDERSUPPLY AND OVERSUPPLY**. Admittedly, the primary purpose of this section is to use the word "galactologue," which isn't used nearly enough in casual conversation.

Hormones

Far too often for a feminist, I feel I am at the mercy of my hormones. I feel unable to contain the milk leaking from my breasts or the desperation with which I need to be with my child—to sit with him in the rocking chair, nurse him, and breathe (See **DYSPHORIC MILK EJECTION REFLEX**).

Women who are not pregnant or lactating have a normal prolactin level of under 25 ng/mL; prolactin level peaks at a term pregnancy to 200 ng/mL; at six months postpartum, a normal prolactin level is about 50 ng/mL, but it is higher in women who exclusively breastfeed (Kellymom). Clinical studies indicate that elevated prolactin levels contribute to anxiety (Torner). I am at its mercy.

Immunological Benefits (Breastfeeding)

According to the American Academy of Pediatrics (AAP), "Compared to formula fed babies, breast fed babies are less likely to have ear infections, eczema, food allergies and asthma, gastrointestinal infections, pneumonia and respiratory diseases, obesity in adolescence and adulthood, type 1 and 2 diabetes, childhood leukemia and lymphoma, and SIDS" (AAP 11).

Because of these benefits, the World Health Organization encourages women to breastfeed exclusively for six months and with complementary foods for at least two years. Yet despite exclusive breastfeeding, both my children had chronic ear infections and allergies. Indeed, my daughter was one of an increasing number of children who are so allergic to food proteins passed through breastmilk that they are essentially (though not actually) allergic to their mother's milk; even after a radical elimination diet on my part (no dairy, soy, egg, beef, nuts, fish, shellfish, tomatoes, strawberries, wheat, and a whole host of other foods I can't or choose not to remember), she continued to experience haemorrhagic colitis and reflux. My own weight dropped to a low of ninety-three pounds. Eventually, the doctor prescribed prescription-only, amino-acid based **FORMULA**, which I bought directly from the manufacturer, at more than $400 per month. In some cases, breast is not best, yet because the cultural narrative is so powerful, I struggled to stop nursing her though it was literally hurting us both.

Jane Gallop

Author of an essay called "The Teacher's Breasts," Jane Gallop has written extensively on issues related to feminism and psychoanalysis, including an incident when a student accused her of sexual harassment. Like both Adrienne Pine and me, Gallop is a feminist, mother, and

professor. On the cover of one of her books is the image of an infant's head crowning at birth; the vagina belongs to Gallop herself. Although Gallop has not written explicitly about Adrienne Pine, I suspect I know what she would say. In the aforementioned essay, comparing the distinction between breast (singular) and breasts (plural), Gallop suggests that it mirrors the distinction between the phallus and the penis: "The breast—singular, symbolic, and maternal—is precisely the imaginary organ of nurturance, what the good feminist teacher proffers to her daughter-students. Refusing to nurture, [Pine], the bad, sexual teacher, brings into the discourse of feminist pedagogy not the breast, which is already appropriately there, but the breasts" (13). Within this framework, the problem arises because Pine locates the maternal not in the act of teaching but in the literal act of mothering; within the university classroom, her breasts are read only within the frameworks of the pedagogical and the erotic. Gallop continues, "A maternal pedagogy might appear utopic, but it is also subject to traditionally gendered prescription" (14). Indeed. And as Margo Culley reminds us, the feminist teacher already "come[s] to the classroom with her authority in question" (214). As a breastfeeding mother-professor, Pine was doubly penalized, once for each breast.

Kellymom.com

Kellymom is a website designed to provide evidence-based information on breastfeeding, including breastfeeding as a working parent and breastfeeding beyond infancy; it also provides resources for women experiencing problems, such as **D-MER.** As Kellymom reminds its readers, "online information is NOT a substitute for an in-person evaluation by a qualified, independent International Board Certified Lactation Consultant (IBCLC) or your health care provider." Online information is, however, readily accessible in the privacy of one's home and at the touch of a button. A simple Google search for "breastfeeding help" yields approximately 89,500,000 results; Kellymom comes in at fifth, behind Medela (a company that makes breast pumps), the March of Dimes, and two separate entries for womenshealth.gov. Conveniently for the purposes of this essay, it also begins with a "K."

Law

Currently in the United States, forty-nine states have laws protecting breastfeeding mothers; Idaho remains the exception. Discussing her situation, Adrienne Pine does not cite legal precedent, although she does reference feeding her daughter in multiple public places, including buses and cafes, as many breastfeeding mothers do. In response to the controversy in her classroom, Pine's own university claims to supply lactation rooms in support of breastfeeding mothers. This is not the same, of course, as supporting breastfeeding within the classroom itself, yet Pine's action is not, as some online commenters have claimed, equivalent to a male professor pulling down his pants and exposing his penis while lecturing, which is considered indecent exposure and illegal in all public contexts. Was Pine unprofessional in bringing her child to class or in choosing to feed her? Why are professional standards different than legal precedent, and why do men still set the standard for what is considered professional? If a male professor brought his sick child to class and bottle fed her, he would likely be supported rather than condemned.[5] The issue, of course, is fundamentally about gender. Even if breastfeeding areas are guaranteed by law, cultural acceptance is not.

Multitasking

My breasts are making milk, right now as I write. What's your super-power?

Nutrition (Maternal)

Most breastfeeding guidebooks say that nursing mothers need an additional five hundred calories per day, which is higher than the amount required during pregnancy. According to **KELLYMOM**, the exact number of additional calories required by a particular nursing mother depends upon the frequency of breastfeeding and body mass index. Lactating women need calcium and vitamin D, larger than usual amounts of healthy fats and protein, and, usually, more than sixty-four ounces per day of water. In my own experience, breastfeeding takes much more than five hundred calories in order to maintain my weight. By a year postpartum, the size-one clothes I wore before pregnancy

hang from my frame; I weigh less than I did in high school. My friends ask if I am eating. I think of Toni Morrison's Sethe, becoming smaller and smaller as the succubus Beloved feeds off her. Yes, I say to my friend, it's just the milking and not sleeping. I take my vitamins. I eat an extra dinner and breakfast when I can. And full fat ice cream.

One night, when my son is a few months old and we are travelling, I am unable to eat dinner until 9:00 at night, after the baby has gone down to sleep. I eat a rare steak, with my bare hands, out of a Styrofoam take-out container on the floor of our hotel room. There are no utensils. Ravenous, I scoop mashed potatoes with my fingers. All I can think is that I need to eat before my son wakes again to feed, probably in an hour. Exhausted, I feel my body collapsing in on itself. I am all animal.

On Demand vs. Scheduled Feeding

My children have always fed on demand, meaning that I nurse them when they are hungry. This practice is part of a parenting philosophy attributed to the paediatrician William Sears and is controversially known as "attachment parenting." In practical terms, with both my kids, that meant nursing about every two hours around the clock—sometimes more frequently because they both had reflux and could only take an ounce or two at a time. (I know this because that's how much expressed milk they would take in a bottle with a childcare provider.) With a toddler, on demand feeding means he is inclined to pull up my shirt to get what he wants, flapping his hands and saying something like "mama mil." He is old enough that I can respond, "let's have a muffin; you can have mama's milk at bedtime," but he may or may not agree. We are in negotiations over my breasts; I think I would like them back. The book I check out from the public library, a picture book for a toddler entitled *Mama's Milk*, tells him that mama gives him milk all day and all night. Indeed, it is a good night when he nurses only two or three times, more than some infants. I am frazzled from weight loss and lack of sleep, yet at barely twenty pounds, he is so small that he is not even on the growth chart for weight. How can I refuse him?

Professor/Professional

Confession: there is not a day I do not think about my breasts while I work. When I first started working from home, after my fourteen weeks maternity/disability leave, the babysitter brought him to me to nurse in the **ROCKING CHAIR**, while she straightened up around the house. Then, at ten months, my son started daycare, and I had to pump multiple times per day, as I was not yet ready to start feeding him formula in my absence. I have nursed him in front of female colleagues when meeting at their homes. I have nursed him during writing groups. I have not, would not, nurse him during class. (Frankly, I cannot imagine any circumstances in which I would bring an infant or toddler to class). But I think Adrienne Pine was right. There are bigger issues here than one professor feeding her sick baby one time while she lectured.

The first time I leave my son for a professional conference, I plan which sessions I can attend around getting back to my room to pump. Although I will not save the milk—I am not a fetishist but a pragmatist—if I do not pump, I will risk mastitis as well as losing supply. I worry that my son may decide he is done nursing in my absence and that "ba-bal" will be a fine substitute for "mama mil." I should mention that this conference publicizes the availability of a nursing room in its hefty program. But in order to access it, you have to go up to the registration desk and ask a student intern for a key. And you would have to be willing to lug your pump around all day. I find it more comfortable to walk back to my own hotel, put on my bra, pump and check email for work, and write a few sentences on an essay.

Even now, with my son deep in his second year, he nurses frequently enough that my milk will let down while I am teaching, spilling into the cups of my bra. My breasts swell. Diane Freedman and Martha Stoddard Holmes write the following in their introduction to *The Teacher's Body*: "When students think the teacher's body is clearly marked by ethnicity, race, disability, size, gender, sexuality, illness, age, pregnancy, class, linguistic and geographic origins, or some combination of these, both the mode and content of education can change" (7). I wonder sometimes if my students can tell what my body is doing when I sit with them talking about poems.

Questions

1. How long do you intend to breastfeed? See **WEANING**.

2. Do you breastfeed in public? See **ON DEMAND FEEDING**. See also **WEANING**.

3. Does breastfeeding affect your work? Does your work affect your breastfeeding? See **PROFESSOR/PROFESSIONAL**. See also **D-MER**. See also **STATISTICS.**

Rocking Chair

Before my first child was born, one of my more extravagant purchases was a top-of-the-line rocker glider. It has been used almost every day for ten years, first to nurse my daughter, then to bottle feed and read; she read on her own there as a preschooler and early elementary schooler. When her baby brother was about to join our household, I bought her a cozy beanbag chair and took the rocker out of her bedroom. The rocker is now housed in a corner of my study (the only place we have space for it upstairs), and I sit there multiple times daily, nursing and reading to my son. He knows to go there at night. For a while in his infancy, he wailed when I sat down in the rocker because he knew it meant he had to nap. We spent so many hours there—his head propped on my arm, trying to get him to fall asleep—that at six months he had a flat spot on one side of his skull. That the area where I work has been turned into a nursery with a rocking chair seems an apt metaphor for the displacement of my identity as an academic. What would it mean to be an academic-mother, both at the same time? What policies and practices could support that?

Statistics

Jessica A. Kerby outlines the following in her PhD dissertation titled *The Interface of Breastfeeding and Work: A Phenomenological Exploration of the Experiences of White Low-Income Women:*

> Overall, the research on breastfeeding rates paints a picture of the prototypical breastfeeding mother as a 30-something, middle-class, educated, married woman who has had consistent

prenatal care, is well-informed about breastfeeding, and has a positive attitude toward breastfeeding. Working mothers are less likely to initiate or persist compared to non-working mothers. Among employed mothers, increased rates of initiation and longer duration are related to greater work autonomy and flexibility, longer maternity leaves, part-time work hours, and greater access to the infant during the workday. (37)

Kerby notes that the length of maternity leave is particularly salient, as it strongly correlates with the duration of breastfeeding among working women. Naomi Baumslag and Dia L. Michels explain that "[i]n societies where women stay home with the baby for a year, most mothers breastfeed for a year. In societies where women stay home with the baby for four months, most mothers breastfeed for four months. In societies where women stay home with the baby for six weeks, most mothers breastfeed for six weeks" (189). Undoubtedly the lack of adequate maternity leave in the United States undoubtedly correlates to—if not causes—such dire breastfeeding rates.

Turkey Sandwich

When my ten-month-old son ended up in the ER for the third time in the week following outpatient surgery, the nurse asked if she could bring me anything. "A turkey sandwich," she said, "or lasagna, we have everything in the freezer"; she handed me a full menu. I must have stared at her. The day of his surgery I had to ask for a room so I could pump milk; a well-intentioned nurse taped a sign to the door for privacy. "No one," she said, "had ever asked for a pumping room before." I was stunned. This was a devoted children's hospital in a major university town; they did surgery on infants every day. "You're breastfeeding," the ER nurse said, as if it was the most obvious thing in the world; "your nourishment is his nourishment." By that point, I was so tired and overwrought I could have cried. Strike that. I did cry. Over a hospital cafeteria turkey sandwich that came with a plastic tube of mayonnaise and mustard on the side. See also **NUTRITION (MATERNAL).**

Undersupply and Oversupply

Concerns about milk production are common among working mothers who breastfeed due to the time away from the infant and difficulty of maintaining milk supply through pumping. Women who do not produce enough milk can take a **GALACTOLOGUE**, including herbal supplements, teas, and, sometimes, prescription drugs, such as Reglan. Oversupply, also known as hind-milk/fore-milk imbalance, is a lesser known but equally significant problem, which can result in breastfeeding infants experiencing reflux and diarrhea due to the extra lactose— symptoms both of my children exhibited. Whether her problem was due to oversupply or allergy or a combination, my daughter's gastrointestinal distress disappeared once she made the switch to formula. I have spent years wondering if being better educated about how to handle this phenomenon would have allowed us to sustain a breastfeeding relationship; I suspect this may be one reason I have mixed feelings about weaning my son. I want the choice to be on my own terms, in my own time.

Valium (also, Vodka)

Both are contraindicated for nursing mothers. Although I have ingested neither, I am on a steady supply of Ambien; with my internist, we do a cost-benefit analysis. Sleep wins. My son has likely also ingested a whole host of chemicals, including pesticides, dioxin, ingredients for jet fuel, and flame retardants. Sandra Steingraber's *Having Faith* details the mechanism by which nursing infants leach their mothers not only of vital nutrients but also the toxins stored in their fatty tissue; the particular toxins and their concentration have to do with simple geography. So even though I only purchase organic food to feed my children, my own milk is likely not organic according to strict USDA standards.

Weaning

The baby is crying. It's four in the morning, and his ear hurts or his belly hurts or his teeth hurt, and all he wants is "mama mil mama mil mama mil." And I hold him to my chest and tell him "The milk is gone, mama's body needs to rest, I'm sorry but the milk is gone, you drank

it, but it will come back tomorrow, it will come back with the sun," but he is pawing at me pulling up my shirt desperate to get what isn't there. My mother is visiting, thank goodness, and I hand her the baby and say "please deal with him" and straggle back to bed. He is willing to rock with her, willing to put his head on her shoulder, willing to go back to sleep. The fight over my breasts is much more complicated.

One gentle guide to weaning suggests setting a time, say 11:00 pm to 6:00 am, during which you will not feed. When the child wakes you feed them up to 10:59 and then you don't. You pick them up. You hold. You snuggle. You do not feed. Within three days, you can stop picking them up. Within three days, supposedly, the child will sleep. I have my doubts. My son is voracious. He will suck from both breasts and then take a four-ounce bottle of formula and still cry.

The American Academy of Pediatrics informs me:

> If you are still breastfeeding your child through his first birthday, you can congratulate yourself on having provided him with the best nutrition he could possibly receive.... as your child moves from babyhood toward toddlerhood, breastfeeding continues to act as a source of profound comfort and security, laying the groundwork for a confident, happy future. For this reason, as well as the continued nutritional and immunologic benefits of breastfeeding, the AAP advises mothers to continue nursing beyond the first year for as long as mutually desired by mother and child. (qtd. in *New Mothers Guide*, 183-84)

I did not actively plan to nurse a toddler any more than I did not plan to forcibly wean my first child when she was nine months old, which was already a feat compared to the statistics of working mothers. But we were still going at a year, at fifteen months, eighteen, twenty. We are weaning, to be sure, as he eats three meals of table food plus snacks and now exclusively drinks formula at daycare, but still, we nurse first thing in the morning and before naps on weekends and at bedtime and two, three, four times over night. When he is teething, I call it the "all-night-suck-a-thon," as he uses me as a human chew toy. No, he will not take a pacifier.

I didn't plan any of this. The nurse handed me my five-pound newborn, I put him to my breast, and he latched on. I have no plans to be on the cover of any magazine nursing a preschooler.[6] Yet contrary to

dominant ideas in the United States, internationally, most children wean between two-and-a-half and four years.[7] I don't mind the idea of nursing a toddler before he goes to bed; of all his feedings, that's the one I'd be more reluctant to give up. But I have a feeling it is going to be an all or nothing proposition with him. He doesn't understand not having "mil" when he wants it. I have been able to stop nursing him in public, mostly, by not sitting down and by shoving snacks and bottles at him when he seems hungry; the exception is the doctor's office, where he is perfectly happy to pull up my shirt, shove my bra out of the way, and latch on. He wants what he wants.

One of my friends, trying to wean a toddler, put lemon juice on her breasts. Yucky, her son said, yucky. But still, in the night he sucked at her. In the dark of the night, he really didn't care.

Is it about hunger? Is it about comfort? What is it that my breasts give him? And what does it give, and take away, from me? At 3:00 a.m., I have no answers. We nurse, we rock, and we make it through the night.

X-Ray

Recently, when I travelled to a conference for work, my breast pump went through the standard airport security x-ray screening. "What is that? Are you carrying any liquids?" "Ice packs," I said, although I'd already thrown out three days' worth of milk. Pump and dump to keep up supply. "Huh," he said, "I've never seen that before."

YouTube

YouTube features a number of clips of Adrienne Pine defending her choices on network TV. It also has videos of women breastfeeding with such captivating titles as "Woman with Big Boobs Breastfeeds." One might ask why. I suspect Adrienne Pine would have an answer, and it has nothing to do with actually feeding a human infant. How has the human breast become a sex object first and a food source second?

Zealots

I am not a zealot, or what is pejoratively described as a "breastfeeding nazi,"[8] despite feeding on demand, co-sleeping (otherwise known as "bed sharing"), and continuing to breastfeed beyond the first year. This is what I choose to do with my breasts and what I feel is right for my family. What is right for your family and your body, well, that's your business. You stay out of my nursing bra, and I'll stay out of yours.

Breastfeeding, especially extended breastfeeding, seems to function as a synecdoche for many of the conflicts over motherhood. Working mothers vs. stay at home mothers. Crib or co-sleeping. Sleep training or co-sleeping. Breast or bottle feed. No matter what you choose, you are wrong.

As I move towards my son's second year, I take small steps towards severing our ties. I wear a regular bra instead of nursing bra with flaps when I go to work. I return the extra pump to my friend and put my own in the closet. I spend more time cooking—our freezer is stocked with toddler-friendly muffins and pancakes. But I still think about my breasts more than I care to admit. When I am teaching and away from my son, especially after a heavy nursing weekend, my milk lets down unexpectedly, which reminds me of my primary purpose as a human mammal. As a feminist, I am shocked by this statement. I would be appalled if anyone said anything about hormones affecting a woman's ability to think and work. But there it is. The fact that I am breastfeeding undoubtedly affects my work, although arguably no more than many medical or biological issues. It is high time we recognize and support that phenomenon rather than ignore or disparage it. Maggie Berg and Barbara Seeber remind us that "The academy as a whole has been reticent in acknowledging its stress; to talk about the body and emotion goes against the grain of an institution that privileges the mind and reason" (100). (Yes, students, your professor has breasts and uses them, sometimes while she is commenting on your papers.)

I would like to believe, with Alicia Ostriker, that "Maternity, even when it drives us personally crazy, far from being a professional defect, is a resource ... we can funnel it into our work and the work of creating a better civilization" (6). Writing about academic motherhood, in all its complexities, is necessary towards this end. Perhaps, then, the only thing that distinguishes me from **ADRIENNE PINE** is that I choose paper rather than the classroom in which to expose myself.

Endnotes

1. Many articles about Adrienne Pine appeared in September 2012. One of the most astute observations comes from Amanda Marcotte in *Slate*: "The reality is that for a woman of her class and age, choosing formula means having your peers act like you're dishing rat poison into your daughter's mouth. Funny how we live in a society that both expects women, especially highly educated and ambitious women, to breast feed, but forbids them to do so while pursuing their ambitions. If I didn't know any better, I'd think pushing women out of positions of prestige and power and back into the home was a feature and not a bug of this system."

2. This statistic comes from the most recent CDC Breastfeeding Report Card. More detailed information reveals wide variation across states. The WHO Global Breastfeeding Scorecard, available online, indicates that globally 70% of babies are breastfed at one year, whereas in the United States, that figure is a mere 9%.

3. There is much more to this image than can possibly be unpacked in this essay, including the gender issues at work in the choice to breastfeed the male twin and not the female, and the arguably racist, anti-Muslim use of the Other in the figure of the Pakistani woman, as part of this probreastfeeding campaign. I use it here as a ready-made image to visualize the pressure that is placed on (white, middle-class) women in order to breastfeed.

4. This example comes from Lindsey Bever's article in the *Washington Post*: "She listened to her doctors—and her baby died" (Mar. 8 2017). I pair this example with the image of the Pakistani mother to complicate the race and class implications of that pro-breastfeeding campaign.

5. For instance, Mary Ann Mason and Marc Goulden's notorious article "Do Babies Matter? (Part II): Closing the Baby Gap" concludes that "'married with children' is the success model for men, but the opposite is true for women" (11).

6. I refer here to the *Time* cover story "Are You Mom Enough?" by Kate Pickert, featuring a mother nursing her three-year-old son, who is standing on a stool to reach her breast.

7. According to a study in *Pediatrics and Child Health*, natural weaning ages have been suggested based on anthropological theories and

studies of other nonhuman mammals; among others, they suggest natural weaning times "when the infant acquires four times his birth weight; when the infant's age is six times the length of gestation (i.e. 4.5 years); or when the first molar erupts" (249).

8. The fact that lactation consultants and other probreastfeeding individuals have been aligned with the Nazis is suggestive of how fraught discussions of breastfeeding have become. Although I am Jewish and reluctant to employ such inflammatory and anti-Semitic language, a Google search for the term "breastfeeding Nazi" yields an astonishing 1,130,000 results, including separate references to "breastfeeding Nazi" and "nipple Nazi" in the Urban Dictionary.

Works Cited

Allison, Juliann Emmons. "Composing a Life in Twenty-First Century Academe: Reflections on a Mother's Challenge." *NWSA Journal* vol. 1, no. 3, pp. 23-46.

American Academy of Pediatrics. *The American Academy of Pediatrics New Mothers Guide to Breastfeeding*. Bantam, 2013.

Baumslag, Naomi, and Dia L. Michels. *Milk, Money, and Madness: The Culture and Politics of Breastfeeding*. Bergin & Garvey, 1995.

Berg, Maggie, and Barbara Karolina Seeber. *The Slow Professor: Challenging the Culture of Speed in the Academy*. University of Toronto, 2017.

Bever, Lindsey. "She Listened to Her Doctors—And her Baby Died. Now She's Warning Others about Breast-feeding." *Washington Post*, Mar. 8. 2017, www.washingtonpost.com/news/parenting/wp/ 2017 /03/08/she-listened-to-her-doctors-and-her-baby-died-now-shes-warning-others-about-breast-feeding/. Accessed 2 Feb. 2020.

"Breastfeeding Report Card." *Centers for Disease Control*, 2018, www. cdc.gov/breastfeeding/data/reportcard.htm. Accessed 29 May 2019.

Culley, Margo. "Anger and Authority in the Introductory Women's Studies Classroom."*Gendered Subjects: The Dynamics of Feminist Teaching*, edited by Margo Culley and Catherine Portuges, Routledge, 2012, pp. 209-17.

Freedman, Diane P., and Martha Stoddard Holmes, eds. *The Teacher's Body: Embodiment, Authority, and Identity in the Academy.* SUNY, 2003.

Gallop, Jane. "The Teacher's Breasts." *Discourse* vol. 17, no. 1, pp. 3-15.

"Global Breastfeeding Scorecard." UNICEF, www.unicef.org/nutrition /index_100585.html. Accessed 29 May 2019.

Kerby, Jessica A. *The Interface of Breastfeeding and Work: A Phenomenological Exploration of the Experiences of White Low-Income Women.* Dissertation. Western Michigan University, 2010.

Ostriker, Alicia. "The Maternal Mind." *The Family Track*, edited by Constance Coiner and Diana Hume George, University of Illinois Press, 1998, pp. 3-6.

Marcotte, Amanda. "An American University Professor Breast-fed During Class: So What?" *Slate*, Sept. 12, 2002, slate.com/human-interest/2012/09/adrienne-pine-is-a-mom-the-american-university -professor-breast-fed-her-baby-in-class-so-what.html. Accessed 2 Feb. 2020.

Mason, Mary Ann, and Marc Goulden. "Do Babies Matter? (Part II): Closing the Baby Gap." *Academe*, vol. 90, no. 6, 2004, pp. 10-15.

Pickert, Kate. "Are You Mom Enough?" *Time*, 21 May 2012, content. time.com/time/covers/016641,20120521,00.html. Accessed 29 May 2019.

Torner, Luz. "Actions of Prolactin in the Brain: From Physiological Adaptations to Stress and Neurogenesis to Psychopathology." *Frontiers in Endocrinology* vol. 7, pp. 25.

Steingraber, Sandra. *Having Faith: An Ecologist's Journey to Motherhood.* Berkley Books, 2003.

"Weaning from the Breast." *Paediatrics and Child Health* vol. 9, no. 4, 2004, pp. 249-53.

Chapter Nine

My Breasts, My Authenticity

Lara Americo

It was when I reintroduced testosterone into my body. Cycling through hormone changes and gender dysphoria in an attempt to produce sperm again, I read a viral article about a transgender woman who was able to breast feed her child. I realized her NYC doctor was the same as mine. I could breastfeed too. I, a transgender woman, could achieve a milestone of womanhood that many cisgender women never experience.

I learned that the process of breastfeeding involves altering your hormone levels to match the estrogen levels of a pregnant person. You raise your estrogen levels, and then you lower your estrogen levels hormones as much as possible. This simulates the hormone changes that happen when you give birth. Your body is tricked into thinking you had a baby, and you begin to produce milk.

My breasts and I were introduced by accident. I imagined our first encounter on a princess bed with pink and white pillows. Instead, we were united by an attempt to catch a spilling soda can. As I brushed against the newly developed flesh, I felt a new pain. A sharp, gender affirming twinge—physical evidence that my body was slowly inching closer to my authenticity.

A giant outdated plasma TV cast a blue glow on my skin as plastic carpet fibers imprinted on my freshly shaven knees. Estrogen was flowing through my body, and I knew conceptually that I would gain secondary physical characteristics similar to cisgender women. I couldn't have prepared myself for the euphoria that would come from becoming myself—physically.

It was time for the women in my family to surround me and teach me all the secrets of femininity and womanhood. They take you into a room with shut doors and teach you things men were forbidden to know. I touched my newly developing nipples and wished for this experience. Instead, I was alone, clutching an old stuffed bear given to me by an ex-partner.

I cried tears of joy knowing that my body was beginning to reflect my true self. My journey into femininity would be a lonely one, and that was okay. Caterpillars in the chrysalis are alone, too. I knew I would emerge from my chrysalis with a new identity and an undeniable authenticity.

Years later, I fell in love with a human bundle of laughter, Italian food, and hand gestures. The love of my life, Joanne. We were inseparable as soon as we met. Walking together down a path of sex, activism, and rock music, we decided we wanted a child. After a grueling, year-long fertility journey, Joanne became pregnant.

To my relief, my breasts began to return after a year starting estrogen treatments again. The same gender euphoria came, but there were no tears of joy. My time on testosterone taught me lessons about myself. I learned to embrace my masculinity—parts of me that were locked away. I became a whole person.

Images of myself breastfeeding and producing milk played in my mind. An archaic book titled *The Womanly Art of Breastfeeding* returned to my memory. I could provide my child with the life lessons I learned, as a non cisgender person and give the same milk as these women. I had just as much to offer, if not more. The thoughts caused me to ask myself, did I want to breastfeed to provide for my child or did I want to breastfeed to affirm my gender identity? I didn't have an answer.

Our child came and I hadn't moved forward with treatments to produce breastmilk. My partner went through the naturally occurring stages of milk production and started to excrete colostrum. I was thankful that my mind and body were at their peak. I endured a year of waking nightmares due to hormone changes. It was nice to meet my child with the correct estrogen levels.

At three in the morning, I bottle feed my child breastmilk produced by my partner. She pumped right before going to bed. I knew I made the right decision. And if I would have decided to create supplemental breast milk, I would also have made the right decision. The challenges would

have been different, but the love for my child would be the same. What my baby needs more than breastmilk is me. My love and support. There will always be an endless supply.

Chapter Ten

Going Beyond the Guideline: Breastfeeding with HIV

Jessica Whitbread and Saara Greene

"On world AIDS DAY, at the AIDS Action Now! PosterVirus 2016 launch, I sat there on the floor, openly breastfeeding my babies as woman living with HIV. I think it was quite powerful with one twin wearing their "AIDS Action Now!" onesie and the one wearing a shirt saying "I love my HIV positive mommy." It may be a bit early to say, but maybe if there was a photo it would be quite an historical moment."

—Jessica

We met a number of years ago now, likely at a legal advocacy or community-based research meeting, where we shared our passions for supporting women living with HIV. Our relationship has shifted over the years from one of colleagues and comrades to now one including a friendship. Jessica is a queer activist and artist living with HIV, who focuses on the embodied experience and rights of women living with HIV globally. Saara is an activist academic, whose research and knowledge mobilization activities focus on the sexual, reproductive, and mothering rights of women living with HIV in Canada. Jessica is a woman and mother of twin toddlers who are both HIV negative but love their HIV community. Saara is a woman and mother of two teenagers and engages in community-based research and advocacy work alongside women living with HIV. We are palpably aware of the differences in our breastfeeding experiences, and together

we want to illuminate the sociomedical inequalities that mothers living with HIV experiences as they attempt to navigate the complex web of breastfeeding in the context of living with HIV in Canada. To be clear, we are not in the business of promoting or deterring mothers living with HIV in Canada to or not to breastfeed. Rather, we are centring Jessica's breastfeeding journey as a way to highlight a particular experience—an ascent (we use this word intentionally because it was indeed an uphill battle) into the medical, sociocultural, and emotional territory of breastfeeding in the context of living with HIV. We've been talking about this issue for years, but today is different. We are closer to home—honest and open. We are sitting at Saara's kitchen table, where Jessica is telling her story and Saara is bearing witness.

Setting the Context

We agree that there is little, if any, recognition of the social, practical, and cultural challenges that women experience when it comes to the pressure they are under to breastfeed (Schmied and Barclay). However, for women living with HIV in Canada, there is a dramatic shift in the infant feeding messages they receive; that is, these mothers are told not to breastfeed due to concerns about possible HIV transmission. At the same time that women living with HIV bump up against Health Canada's promotion of breastfeeding as the "normal and unequalled method of feeding infants" (Health Canada), they are also advised not to breastfeed their newborns because of best practice guidelines to prevent vertical transmission of HIV.

Adding to this complexity is the more recent "undetectable = untransmittable (U=U)" campaign, which states that virally suppressed individuals with HIV cannot sexually transmit the virus to others. The Women and HIV/AIDS Initiative (WHAI) in Ontario, Canada, as well as the International Council of AIDS Service Organizations (ICASO), endorse the transformative impact of U=U, as do we; however, we highlight the complexity of the U=U messaging for women and those identified female at birth. One of those areas relates to breastfeeding, since regardless of whether or not mothers living with HIV are undetectable, the transformative and liberating U=U messaging does not include the act of breastfeeding (WHAI; ICASO).

Infant Feeding Guidelines for Women Living with HIV

When precautions are taken and interventions that are made to support women living with HIV are available, there is virtually no vertical transmission of HIV from a mother to her infant in utero and during birth (Mandelbrot; Luzuriaga et al.). However, there continues to be global debates regarding the possibility of breastfeeding for women living with HIV. These debates rest on medical evidence regarding the rate of transmission of HIV through breastmilk and contradictory infant feeding guidelines that shift depending on one's geographical region. In Canada, these discussions are always hard and always morally charged; the mother who wants to breastfeed is either portrayed as a woman in need of support and understanding as she mourns the loss of being able to breastfeed or as a woman who is selfish and is not thinking about the best interests of her baby (Catholic Children's AIDS Society of Hamilton).

For many mothers living with HIV, a disconnect continues to exist between medical evidence, breastfeeding guidelines, cultural practices, and public health approaches to breastfeeding. Importantly, community discourses on breastfeeding can result in an underground network that uses anecdotal evidence and story sharing as its main source of peer review. This concerns us, given that some of this story sharing results in fear mongering; it may make mothers worry that breastfeeding could lead to their being reported to public health agencies and/or charged with child neglect. In some cases, these fears force women underground and to breastfeed their babies without any medical or social support.

In relation to this, the choice to breastfeed or not remains an area of controversy for women living with HIV globally, as their choice to breastfeed is often determined by AFASS criteria (motherchildnutrition. org/info/afass-principles.html). AFASS stands for acceptable, feasible, affordable, sustainable and safe (AFASS)—an acronym developed by the World Health Organization (WHO) that was intended to help health workers and mothers to think about the specific conditions (such as safe drinking water) needed if replacement feeding, such as formula milks, are to be given safely to infants. At the same time, medical evidence surfaced that declared that the rate of transmission of HIV through breastfeeding for women who are on antiretroviral (ART) treatment, have a low viral load, and who exclusively give their infants breastmilk was 0.3 per cent at six months and 0.7 per cent at twelve months (Flynn

et al.). The WHO responded to this research, and at the International AIDS Conference in South Africa in 2016, it recommended that mothers living with HIV should exclusively breastfeed their infants for the first six months of life; they can continue to breastfeed until twelve months as complementary foods are introduced and potentially beyond while also having access to ART and counselling support for the duration of both the pregnancy and breastfeeding period (WHO). For many women living with HIV and for others doing advocacy work, this might have felt like a small victory. These were clear guidelines supported by research that backed the anecdotal community discussions among women living with HIV that transmission rates were low enough for women to breastfeed with little risk. However, these guidelines were only directed at women living with HIV in resource-limited settings where unsafe drinking water was the cause of death for many infants. Since that time, a small Tanzanian study that was conducted among mothers living with HIV who were retained in care and who had a suppressed viral load concluded that no transmission of HIV from mothers to babies occurred (Luoga et al.); Although this study had a small sample size, the findings suggest that there is a need for more research in this area.

Infant feeding guidelines in resource rich countries, including Canada, are quite different from those in low resource countries. In Canada, ever since it was first learned in 1985 that HIV could be transmitted through breastfeeding, the exclusive recommendation has been formula feeding for all women living with HIV, regardless of ART or viral loads (Burdge). This recommendation is based on the assumption that Canadian women living with HIV can meet AFASS criteria, with the risk of HIV transmission outweighing any concerns about replacement feeding (Kennedy). Presently, the WHO upholds the suggestion that mothers living with HIV in higher resource settings continue to use the originally published national guidelines and policies that recommend women exclusively formula feed. However, the acceptability of formula feeding among some women in Canada is complicated by issues of stigma, fear of disclosure, and social and cultural ideas about infant feeding (Tariq et al.; Treisman et al.). Furthermore, although Ontario and other Canadian provinces have made formula feeding more affordable, for example through free formula programs, many women living with HIV in other resource rich settings still

struggle with the cost of infant formula (Tariq et al.; Treisman et al.; CATIE). Finally, the safety of women living with HIV and their children may be compromised not just by lack of clean water and sanitation—which some mothers in Canada do still experience—but also through disclosure of a woman's HIV status (Kennedy; Tariq et al.). These concerns along with other experiences of stigma and surveillance shape the unique experiences of mothers caring for their infants while living with HIV, which often put them at odds with official guidelines on infant feeding practices (Greene et al, "[M]othering").

It should also be noted that infant feeding guidelines in several resource rich countries recognize that support should be available for women who would like to consider breastfeeding with the availability of proper medical support and without automatic involvement of law or child protection services (AIDS*info*; EACS; BHIVA). Statements to this effect have been released by the British HIV Association Children's HIV Association, the American Academy of Pediatrics, and the Canadian Paediatric Society (IBFAN Asia and BPNI). As a response to recently collected data, the British HIV Association has revised its guidelines to talk about informed consent and support women who, despite the risks, still want to breastfeed (BHIVA). In both the UK and Canada, these official guidelines rarely translate to the lived experiences of women living with HIV in these countries. At the time this chapter was written, only two women living with HIV in Canada had been supported by their healthcare teams to breastfeed with the infants remaining HIV negative (Nashid). However, as we delve deeper in Jessica's breastfeeding journey, we find that support is complicated, since it is rarely available beyond the limits of the mother's trusted healthcare team. This story takes us on a breastfeeding trajectory that illuminates experiences of stigma in the context of attempting to breastfeed as well as the heartwarming and heartbreaking moments that Jessica has experienced along the way.

Starting the Conversation

> "I wanted to advocate as if I were going to breastfeed and then not
> breastfeed at the end ... which ended up not being the case."
>
> —Jessica

This part of Jessica's story starts in the spring of 2016 after discovering she was pregnant with twins. Her pregnancy motivated her to create changes in infant feeding and healthcare policies regarding women living with HIV in the perinatal period: "I'm a white woman who has a lot of information and a history of advocating and tonnes of connection to the most current information. If anyone can push for this, I can, and it's my duty as an activist." At the same time, Jessica also wanted to pursue her personal desire to breastfeed:

> I wanted to breastfeed. I know it's okay. I'm aware of the current
> Canadian and WHO guidelines and what women do in private. I
> wanted to work with a healthcare team that was going to support
> me to make an informed decision. I didn't want to work with
> health providers that were going to report me to public health. I
> felt like I could veto the decision to breastfeed at any time, but
> this was about starting the conversation in a very open way and
> forcing healthcare providers to take action. So that the next
> woman would tell her provider, and there would be a plan that
> they could follow.

A plan for Jessica was not that easy. It was shrouded in secrecy and only included her direct pregnancy healthcare team and her two lovers. Everyone else was excluded from the full story and was only told half-truths. This plan was based on fear that public health authorities would be notified and action would be taken against Jessica. Despite her hope to pave the way for future mothers living with HIV who want to breastfeed, she felt that revealing her actions while planning to breastfeed would put her babies at risk; however, by disclosing her carefully constructed action plan after ceasing nursing, Jessica believed she could help similarly situated mothers. Her immediate healthcare team members and partners were the only ones that knew she intended to breastfeed. There was a plan about who would know and how she would be supported:

It was quite intricate actually; we called it "the circle," and everything was to be kept there and not shared with others. We talked when nurses left the room and always behind closed doors. Too much was at risk.... My direct healthcare team created a research study around it to try to protect me—no one was supposed to know. No one. Not my therapist, my family, the babies' healthcare team... no one.

Interestingly, the emotional labour involved in creating the "circle" and of ensuring a veil of secrecy regarding her plan to breastfeed was similar to the work that women living with HIV do to keep their formula feeding a secret from family and friends. Formula feeding babies behind closed doors as well as developing response strategies and tactics are central to maintaining these secrets ("[M]othering," Greene et al.). In both situations, the cost of disclosure is too high for women living with HIV to openly breastfeed or formula feed; on the one hand, breastfeeding could lead to social work involvement or a call to public health authorities, whereas on the other hand, formula feeding could lead to the painful consequences of an unwanted disclosure. The bottom line is that women living with HIV cannot safely and publicly feed their babies due to intersecting medical, social, and cultural policies, messages, and beliefs. As a result, and similar to many mothers living with HIV who focus on how to manage their infant feeding intentions, Jessica made a plan:

A plan was created that the babies would be born, and I would have a private room and be secretly taught to have the babies latch and would continue when I went home with support. We would not tell the babies' doctors, and we would get cases of formula to not cause suspicion. We knew that with twins, there could be risks that might make it not possible to breastfeed, for instance, if I didn't have enough milk to feed them. But at this stage, I really didn't care. I was so dead set on them creating a plan for the next woman that wanted to do it.

In contrast to many women living with HIV in Canada who develop plans to conceal the fact that they are not breastfeeding, Jessica's plan was developed to support her in concealing her breastfeeding. This is not to suggest that some mothers living with HIV in Canada do not breastfeed, however, for some women breastfeeding occurs underground

due to fears of being charged with child neglect. For Jessica, developing a plan to conceal her choice to breastfeed was emotionally challenging, partly because she had always been open about who she was and what she stood for and partly because it created a barrier for her to use her breastfeeding as an advocacy tool for shifting healthcare policy in this area:

> This was all very difficult for me. I live so openly as a queer woman living with HIV, and it felt yucky and untrue to myself to not share what I was doing. To be honest, I think that I was more open than I was supposed to be, but mostly because I wanted to use it as another opportunity for social change, opposed to what was really best for myself and the babies. And while I felt that the chances of transmission were unlikely and that my own milk was better, I really wanted to use my physical body as a wrench in the current system. In relation to advocacy, this had so much potential.

Amid completing her breastfeeding plan, the twins arrived at thirty-one weeks, which was too early to have developed the ability to suck; thus, Jessica's plan became no plan. She was given medication to stop the serge of milk from coming in and in that moment she "felt ok about it."

Whose Breast Is Best?

> "They say breastmilk is best, but formula is good to—
> but not best. And I wanted to say, 'but what about my milk?'
> but I didn't, and I couldn't."
>
> —Jessica

In Canada—where the WHO infant feeding guidelines are endorsed by care providers of pregnant women and of new mothers living with HIV—breast is clearly not best. This can be heartbreaking, since similar to many pregnant women and new mothers, many women living with HIV had originally intended to breastfeed. The intention to breastfeed is founded on a number of factors for women living with HIV (as with all women), including societal and cultural expectations

and/or because of what they learned about the emotional and physical benefits of breastfeeding and of breastmilk prior to diagnosis ("[M] othering," Greene et al.). As discussed earlier, learning that breast is not best in the Canadian context is particularly challenging for women who had been advised to exclusively breastfeed in their country of origin. This was not news to Jessica, who has been an advocate on behalf of the rights of women living with HIV for many years. Even so, experiencing the "breast is not best" message firsthand had a profound impact on Jessica and heightened the realities of being othered as a result of her HIV status: "It is one thing to know how things go down—that women living with HIV are treated different from other mothers in regard to breastfeeding. [But then] all of the sudden everything you've learned about breast is best no longer pertains to you ... and this is made perfectly clear."

In an attempt to clinically and financially support women living with HIV to formula feed their babies, some Canadian provinces offer free formula programs for the first year of a baby's life. However, at the time of writing free formula programs were only available in Ontario, Manitoba, Saskatchewan, Alberta, and British Columbia. Formula is expensive and can cost hundreds of dollars, and in Jessica's case, over a thousand dollars every month. Importantly, even when free formula programs are available, this does not necessarily include the provision of emotional support that women want and need regarding the range of feelings and concerns they have about not breastfeeding. And although this kind of support may be available to women living in urban centres, for women living in rural or remote communities, accessing any kind of emotional support is challenging:

> It felt a bit lonely; no one talked to me about breastfeeding or my thoughts about it. They just assumed that I am a woman living with HIV, and, therefore, I shouldn't and probably should not want to breastfeed. No one asked how I felt about it. I often just sat there holding my babies as tears ran down my face.... Even on my first night in the NICU [neonatal intensive care unit], the nurses were like "mommy, mommy you gotta pump to get your milk in" and then they'd be like "Oh! Not you, not you" and shuffle away. It was horrible.

Although concerns about disclosure and HIV stigma are at the fore-front of many women's minds, particularly women from countries where not breastfeeding is a signal that someone may be HIV positive, feelings of loss and guilt are also prominent. Sometimes these feelings are balanced by the knowledge that formula feeding may be best for the babies born to women living with HIV; however, this is not always the case.

Despite some excellent Canadian community-based support programs for women living with HIV—and a handful of researchers, physicians, and midwives (many of whom were a part of the "circle") who support women living with HIV with their infant feeding questions and concerns—it is troubling that there continues to be a lack of institutionalized support for women who are told they can't breastfeed. Jessica's experience highlights the reality that the "breast is best" discourse resounds so prominently for all women; indeed, there is little to no room for discussing the possibility and emotional ramifications of not breastfeeding. Importantly, this discourse renders women living with HIV silent, since they are not often given the opportunity to openly discuss their feelings about not breastfeeding, nor are they provided the opportunity to talk about the possibility of breastfeeding, as was the case for Jessica. Concerns about HIV transmission are certainly not the only reason why women do not breastfeed; there are many physical and emotional reasons as well. Yet the NICU where Jessica and her babies were cared for was one environment where any sensitivity to this possibility was ignored or, perhaps, not even considered.

> In this large open space, I could hear, "Mommy, Mommy, oh that's so much milk ... good job Mommy" as the other mothers would drop off their freshly pumped milk at the nurse's station, which conveniently was what I stared at for eight hours or more a day for seven weeks. The other moms would congregate and talk in this small room. They would go in this room and pump multiple times a day, and they would put the milk on the counter for the nurses, and it would go in a fridge and it would be used for their baby.

And so it goes. Jessica, a mother who was assumed to not want to breastfeed, watched from the sidelines as those other mothers were rewarded with laudatory murmurings and were provided a sacrosanct environment to gather together to pump their milk.

Will the Circle Be Unbroken?

> "After about two weeks I was holding one of the babies and one of my nipples started to leak and I was like 'Oh! The milk is still there!' And then I realized, 'It didn't stop ... wait ... what decisions did I make? Can I still do it?'"
>
> —Jessica

Partly due to the need to focus all attention on the health of the babies post premature birth and partly due to the fact that no one ever checked in with Jessica about her feelings surrounding breastfeeding, Jessica, on her own, had to recall her breastfeeding plan and make some immediate decisions without any support. Immediately following the premature birth of the twins, medical interventions were quickly put into place in the NICU. This included giving Jessica a pill to inhibit the production of breastmilk. Given this change in birth plan, Jessica and the healthcare providers who were part of the circle believed that it would be safer for her not to breastfeed in the NICU. Presently, supporting women living with HIV to breastfeed is still a controversial issue among healthcare providers in high resource countries. Consequently, trust was elusive, and the concern of being reported to public health authorities was too great a risk to take. So when quite unexpectedly Jessica's breasts started to excrete milk, she wasn't sure where or to whom to turn to make some quick decisions about her desire to breastfeed:

> I would cry and hold the babies, and my breast would excrete milk. But I was told, "do not talk to anyone about this." And then I went to see my doctor for a regular postnatal appointment. I left the appointment without telling the truth. I spent days trying to find the strength to say that I changed my mind and needed more support from my circle or anyone really. It's actually quite hard when you feel like this is happening, and there is no one you can trust, and you are told not to trust anyone.

This narrative illustrates what we are calling "the protection paradox"—the notion that maintaining secrecy regarding breastfeeding would protect Jessica from being reported to public health authorities or

to the Children's Aid Society. In some ways, this was true; although Jessica's circle had the professional and medical capacity to support her choice to breastfeed, secrecy was critical, since other people in their shared professions would not necessarily have this same knowledge and information. Such a situation could result in attempts to prevent Jessica from breastfeeding or queries to public health and social service agencies, which have historically resulted in children being removed from their mother's care. However, as Jessica demonstrates, the need to maintain secrecy regarding her breastfeeding intentions failed to protect her emotional and mental health, which created barriers to accessing support, the consequence of which was a negative impact on her mental wellbeing:

> And then I started having conversations with the doctors about transitioning off of donated breastmilk. But knowing that I wanted to breastfeed ... but I can't tell them that. I can't talk about that. And I can't talk about possibly wanting to have them breastfeed when I get home. I was like, I don't want to give them formula and then switch them to breastmilk; they were saying they had a sensitive gut, and that could theoretically make the transmission of HIV higher. And then I just wanted them to be on donated milk. There is so much math! Like emotional math happening. The conversation that I really wanted to have was an open one saying, "I would like to give them my milk—let's talk about it."

In weighing the balance of the choices she had before her—some of them were transparent, such as transitioning from donated breastmilk and starting on formula, and some of them were kept secret, such as breastfeeding when she returned home—Jessica found herself in the position of having to figure out the emotional math on her own. Such a context raises questions about the sociomedical conditions that exist within health and social service institutions through and promote secrecy and surveillance, which can prevent women living with HIV from asking for what they truly want and need.

Breastmilk Befalls a Biohazard

"What I found out later was that this [breastfeeding] would be at the cost of significant medical intervention. In order for the doctors to sign off on me breastfeeding, the babies would need to be treated as if they were HIV+."

—Jessica

Four weeks after the birth, Jessica and her circle of care decided that she would move forwards with openly preparing to breastfeed. This process included communicating this decision to the babies' medical team within the NICU and engaging this team throughout the process. Jessica received incredible support from her circle, which included providing both natural and medical interventions to increase milk supply, engaging and educating the staff in the NICU about the breastfeeding possibilities for women living with HIV, and linking Jessica and her partners to a supportive social worker, among many other things. Nevertheless, barriers to breastfeeding continued including particularly challenging conversations with the babies' care team; however, with an agreed upon medical intervention plan that would have the babies on a strong regimen of antiretrovirals (ARVs), Jessica was given the go ahead to breastfeed. It must be noted that receiving the green light to breastfeed under the supervision of such a care team was, and still is, a new concept to most women living with HIV. The two Canadian cases of mothers living with HIV who were supported to breastfeed happened within weeks of each other. To outsiders, then, Jessica—a white, middle-class, university educated woman who is front and centre in the HIV movement in Canada—was seen as occupying a privileged position. And although in some ways this is true, what is less well known is the degree to which Jessica and her partner had to research national and international transmission rate data as well as the amount of energy she spent towards her self-advocacy work, and the trade-offs she had to make in order to receive support to breastfeed:

I knew from my research and other women living with HIV that it was highly unlikely that they would get HIV from me, but here we were, their doctors and I in a standoff, both knowing that we

all were a little right. I did not want to give the babies the same treatment that would be given to HIV positive babies because they were not HIV positive. But I felt that my hand was forced, and I succumbed to their strict, highly medicated plan, including checking the levels of medication in the babies weekly. If I wasn't under so much surveillance, I would have likely flushed it down the toilet.

Greene et al. argue that mothers living with HIV "experience a unique form of surveillance and monitoring by a range of health and social care professionals," particularly "in situations where the prevention of vertical transmission of HIV from mother to child is the primary goal of their care" ("[M]othering" 248). This argument is further evidenced through Jessica's journey in the NICU. In contrast to the initial supportive monitoring that Jessica received from her circle, the NICU was steeped in stigmatizing practices that were both ostracizing and emotionally painful:

I was given a biohazard bag to store my breastmilk in. I was humiliated; I didn't want anyone to see it [and] know that there was an issue. The first time I was passed the bag was super hard and stigmatizing. The doctors said that they were going to get me an appointment with the lactation consultant. But the lactation consultant, even when I asked to talk to her, she avoided me. I think it was because she was opposed to me breastfeeding because she was in the NICU helping everyone else.... I was in there for another three to four weeks after I started pumping, and it was never again brought up that I could work with her. And when I asked, the topic was repeatedly avoided.

It appears, then, that Jessica was made to feel like somewhat of a pariah. The surveillance of her breastmilk was just one example of a range of stigmatizing practices that she experienced during her time in the NICU:

I remember the first time I had a little (and by little I mean a few drops) of breastmilk that I pumped into a cup. I gave it to the nurse feeling a little embarrassed that there was not very much but also a little proud. "Here you go" [I said], and she said "ah?" They put it in the fridge, but then after, they advised me "we

can't put your milk in the fridge," cause it was HIV positive milk. So I had to bring my own cooler bag, and I had to put it beside the babies' bed. And it's a bit weird because all the other moms would go and put it on the nurse's station, and then the nurses would put it in the fridge and they would use it to feed the baby. But my babies weren't actually allowed to have my milk in the hospital. It was being saved for when I went home, and then I would, on my own, have to learn how to feed the milk to the babies.

The surveillance and stigma that she endured in the NICU, though not erasing the work of the partnership between her and her circle, also resulted in moments of self-surveillance:

That [breastfeeding] room was really nice. So I would go in there to pump with the other moms, but it was a bit awkward because like, they were wondering "you're just starting to pump now, why?" ... I was a bit nervous because you had to buy the tubes and pump suction thing, but overall they were communal machines ... people have minds of their own, so I was bit like, "Ok, I'm wiping it down. I'm wiping it down"; I went to this place of AIDS panic, like I'm using the same glass as you, like that kind of era of thought process because I'm sure that would have been in their minds if they knew.

Greene et al. argue that "the multiple sites within medical settings where stigmatizing practices occur illuminate the need for efforts to reduce HIV-related stigma through challenging and shifting societal and institutional policies and practices" ("Why Are You Pregnant?" 173). Indeed, it was Jessica's intention to enact this challenge for the purpose of shifting infant feeding policies in medical settings. However, in order for this challenge to be successful, there is still a need for advocacy that comes from within the medical profession and from within the institutions. Jessica's circle was made up of her strongest allies, and the support they provided her with made it possible for her to carry out her plan. And there were others, as well, who understood the need for shifts in practice and policy. That is a wonderful thing. Yet there is still so much to be done:

And I think some of the nurses were quite sympathetic.... I think the doctors in a way were, but it was definitely a first for them. There were no policies or procedures to direct them. And one in particular was understanding and kind: "I know this is not fun. But if we're going to do this, we have to do it slowly and carefully because the last thing we want is it to roll back because we didn't take the right steps to change policies." Which I understood, but it didn't mean it felt better in that moment.

The Escape Plan

"I did everything as directed, for the most part, but to be honest, dreamed of do it my own way often. But I wanted to check all the boxes in case public health came after me. And after I stopped breastfeeding, I really thought I was in the clear. Until one night in our very hot apartment in Jamaica, I got an email from my doctor's assistant reading—"Jessica, I've been trying to call you. Public health is looking for you. Call us when you get this."

—Jessica

In total, Jessica breastfed the twins for three months. It was emotionally difficult to stop, but Jessica, who was working for a not-for-profit organization that required her to travel often, only had three months of maternity leave. Her first contract was with the Jamaican Community of Positive Women in Kingston, Jamaica, to jointly develop a community quilting workshop to talk about HIV-related trauma. Jessica and her partner brought the twins to Jamaica for two weeks. After months of advocating and abiding by the strict protocols of the twins' healthcare providers, Jessica was somewhat relieved to not have to deal with the weekly doctor appointments, increasing medication, and subjecting herself and the babies to so many tests. However, this relief was short lived upon finding out that Public Health was looking for her. Not surprisingly, her first thought was that someone had told on her for breastfeeding and that she was going to get in trouble:

I was thinking of all the things that could happen. Could they take the babies away? Yes. Could I be arrested and spend time in

prison? Yes. Could there be a media bonanza? Yes. That night, I spent hours thinking of what to do to make sure the babies were alright. I was devising an escape plan for my partner to go to Bulgaria with the babies and for me to just go back to Canada and deal with what I had to deal with—including maybe going to prison.... I was laying [sic] in bed and could not sleep. For probably for like twenty-four hours, I was thinking about how to protect my babies and my partner's parental rights as best as possible. I was thinking, I should not have breastfed; it was too much. I was crying and saying my doctors need to protect me ... no one should have to feel that kind of anxiety. No one.

Jessica's worry and anxiety over the thought of her twins being apprehended as a result of her breastfeeding is not surprising, given that in 2006, Canada became the first country to prosecute vertical transmission of HIV, when an Ontario woman was convicted of child neglect as a result of the vertical transmission of HIV to one of her children (Catholic Children's Aid Society of Hamilton). Even more recently, in the child apprehension case of *A.N. (Re)*, 2017 ABPC 300 (Alberta Provincial Court), the mother's HIV-positive status (and some HIV-related myths about the nature of transmission to her infant) was one of a number of factors cited for an order to remove the child from the mother's care. These cases substantiate the ongoing existence of HIV-related stigma as well as the lack of knowledge and negative surveillance that continue to be experienced by mothers living with HIV. Luckily, the inquiries from the public health authorities were addressed by Jessica and the twins' care team. No further investigations happened, and, more importantly, her children remained in her care.

And so, as we come to the end of this chapter—but not the end of Jessica's journey—we want to close with Jessica's reflections of her experience of breastfeeding as a woman living with HIV:

Being able to breastfeed made me feel like I was normal. My body was doing the thing that it was supposed to do to nurture the babies, and it felt awesome when I was doing it. I loved the way that the milk felt spraying out of my nipples, and it was just mind blowing that my body was actually able to produce such a thing. Unfortunately, there were many parts of the experience of breastfeeding that felt far from amazing. In fact, they dug deep

into my core and sent me spiralling into long-term postpartum depression. After fifteen years thinking that I was untouchable by HIV stigma, and working through all my demons, I realized this was not true.

The Way Forwards

Jessica's story echoes previous suggestions that changes in the WHO infant feeding guidelines for women living with HIV in high resource settings are desperately needed. These changes must include considerations of the structural, gendered, and cultural factors that are pervasive in the lives of mothers living with HIV. We agree with Loutfy et al.'s recommendations for "ethical and comprehensive counselling for women living with HIV on the risks and benefits of various infant feeding approaches relevant to their social, economic and legal context." Counsellors should tell parents about the benefits of formula feeding and discuss their feelings about breastfeeding; moreover, counsellors should underline the process of medical care that both the mother and baby will experience in pursuing the possibility of breastfeeding. This approach can facilitate counselling sessions for those mothers experiencing difficulty adhering to formula-only guidelines in high income settings and open up the conversation for mothers to talk about their feelings, including about the possibility of breastfeeding. By sharing this story, we hope to contribute to this dialogue—one that has been difficult for many women living with HIV. Ultimately, women living with HIV should be given full information and support to determine what is best for their families and their infants. Such supports would include having access to health and social care providers who can and will provide accessible and up-to-date infant feeding guidelines and research data as well as having the medical care and social support women require as it pertains to their infant feeding desires.

Works Cited

A.N. (Re), 2017 ABPC 300 (Alberta Provincial Court).

AIDSinfo. "Panel on Treatment of Pregnant Women with HIV Infection and Prevention of Perinatal Transmission. Recommendations for Use of Antiretroviral Drugs in Transmission in the United

States." AIDS Info, aidsinfo.nih.gov/contentfiles/lvguidelines/ PerinatalGL.pdf. Accessed Jan. 4 2019.

BHIVA. "British HIV Association Guidelines for the Management of HIV in Pregnancy and Postpartum 2018 (2019 Second Interim Update)." *BHIVA*, www.bhiva.org/pregnancy-guidelines. Accessed Feb. 4, 2020.

Burdge, David. et al. "Canadian Consensus Guidelines for the Management of Pregnancy, Labour and Delivery and for Postpartum Care in HIV-positive Pregnant Women and Their Offspring (Summary of 2002 huidelines)." *Canadian Medical Association Journal*, 168, 2003, pp. 1671-74.

Canadian AIDS Treatment Information Exchange (CATIE). "Is Formula Good for My Baby? Free Formula Programs." *Teresa Group and CATIE*, 2015, www.catie.ca/sites/default/files/26511.pdf. Accessed 27 Mar. 2018.

Catholic Children's Aid Society of Hamilton. v. J.I., I.N. and V.I.O. (2006). O.J. No. 2299 Court File No. C-1707-04.

EACS. "EACS Clinical Guidelines Version 8.2." *European AIDS Clinical Society*, 2017, www.eacsociety.org/. Accessed 12 Sept. 2019.

Flynn, Patricia. et al. "Prevention of Hiv-1 Transmission Through Breastfeeding: Efficacy and Safety of Maternal Antiretroviral Therapy Versus Infant Nevirapine Prophylaxis for Duration of Breastfeeding in Hiv-1-Infected Women with High Cd4 Cell Count (Impact Promise): A Randomized, Open Label, Clinical Trial." *Journal of Acquired Immune Deficiency Syndromes*, vol. 77, no. 4, 2018, pp. 383-92.

Greene, Saara. et al. "(M)othering with HIV: Resisting and Reconstructing Experiences of Health and Social Surveillance." *Criminalized Mothers, Criminalizing Motherhood*, edited by Joanne Minaker and Brian Hogaveen, Demeter Press, 2015, pp. 231-63.

Greene, Saara, et al. "'Why Are you Pregnant? What Were You Thinking?': How Women Navigate Experiences of HIV-Related Stigma in Medical Settings during Pregnancy and Birth.' *Social Work in Health Care*. 55:2. (2015). pp. 161-179.

Health Canada. "Infant Feeding." *Health Canada. Government of Canada*, 2015, www.canada.ca/en/health-canada/services/canada-food-guide/resources/infant-feeding.html. Accessed 9 Sept. 2018.

International Council of AIDS Service Organizations. "Understanding U=U for Women Living with HIV: Community Brief." *International Council of AIDS Service Organizations*, 2018, icaso.org/wp-content/uploads/2018/09/Understanding-UU-for-Women.pdf. Accessed 15 Oct. 2018.

Kennedy, Logan. "Complicated Dilemma: HIV and Infant Feeding. Webinar." *CATIE : Canada's Source for HIV and Hepatitis C Information*, 2014, www.catie.ca/en/webinar-series-positive-parenting. Accessed 12 Sept. 2019.

Luzuriaga, Katherine, and Lynne Mofenson. "Challenges in the Elimination of Pediatric HIV-1 Infection." *New England Journal of Medicine*, vol. 374, no. 8, 2016, pp. 761-770.

Loutfy, Mona, et al. "Counselling Clients on Perinatal HIV Transmission Risk in the Context of U=U." *Transforming Our Practice: New Knowledge, New Strategies*," November 2017, Toronto, Ontario. Unpublished conference paper. CATIE: Canada's Source for HIV and Hepatitis C Information.

Luoga, Ezekiel. et al. 'Brief Report: No HIV Transmission from Virally Suppressed Mothers during Breastfeeding in Rural Tanzania.' *Journal of Acquired Immune Deficiency Syndromes*, vol. 79, no. 1, 2018, pp. 17-20.

Mandelbrot, Laurent. "No Perinatal HIV-1 Transmission From Women with Effective Antiretroviral Therapy Starting Before Conception." *Clinical Infectious Diseases*, vol. 61, no. 11, 2015, pp. 1715-25.

Schmied, Virginia, and Lesley Barclay. "Connection and Pleasure, Disruption and Distress: Women's experience of Breastfeeding." *Journal of Human Lactation*, vol. 15, no. 4, 1999, pp. 325-34.

Tariq, Shema, et al. "It Pains Me Because as a Woman You Have to Breastfeed Your Baby": Decision-Making about Infant Feeding among African Women Living with HIV in the UK." *Sexually Transmitted Infections*, vol. 92, 2016, pp. 331-36.

Treisman, Karen, et al. "The Experiences and Coping Strategies of United Kingdom-Based African Women Following an HIV Diagnosis during Pregnancy." *Journal of the Association of Nurses in AIDS Care*, vol. 25, 2014, pp. 145-57.

WHAI. "Living in the Asterix." *Women HIV and AIDS Initiative,* 2017, www.whai.ca/ModuleFile?id=269. Accessed 9 Sept 2018.

World Breastfeeding Trends Initiative. "HIV and Infant Feeding: Global Status of Policy and Programmes Based on World Breastfeeding Trends Initiative Assessment Findings from 57 Countries." *World Breastfeeding Trends Initiative,* 2015, www.bpni.org/infant-feeding-and-hiv-3/. Accessed 9 Sept. 2018.

World Health Organization. "Guidelines: Updates on HIV and Infant Feeding: The Duration of Breastfeeding and Support from Health Services to Improve Feeding Practices Among Mothers Living with HIV." World Health Organization, 2018.

Breasts, Health, and Foster Adopting: When Breastfeeding Is Considered Sexual Abuse

Debra Guckenheimer

I never gave birth, but I am a mom. I walked into a hospital, where after being observed to ensure proper handwashing (and after years of preparation and paperwork), I met a three-day-old baby. It was one of the happiest days of my life. With tears in my eyes, I looked into hers and said, "I'm your mama." I vowed then and there to do my best to take care of her for the rest of my life.

Like probably every mom out there, I heard that "breast is best" for babies. Not only does breastfeeding have nutritional benefits, it also facilitates attachment as well as nervous system and hormone regulation, which can be especially helpful for adopted babies (Gribble; Szucs et al.). There are many reasons why breastfeeding is not a good option, but I want to unpack the idea that adoptive moms cannot and should not breastfeed.

I had presumed that giving birth is a necessary breastfeeding pre-requisite, but I was wrong. Some lesbian moms share breastfeeding roles to allow equal parenting, responsibilities, and bonding. Women whose babies were carried by surrogates may breastfeed. Adoptive and foster moms can even breastfeed.

I was hopeful when I read online that foster adopt parents are allowed to breastfeed in California if they get a letter from their placement agency

stating approval to do so. I presumed it was just a hoop, like the many others I had to jump through, to become eligible to become a fost-adopt parent (i.e., a parent who adopts children from foster care), which included filling out forms as well as spending hours talking to a social worker about every possible detail of my life.

Background on Foster Care and Breastfeeding

Foster care is a bureaucracy that cares for about half a million children in the United States who were removed or relinquished from their birth family. Most children need temporary care until their parents are deemed fit to care for them again, whereas other children are on a path to being adopted. Foster care is not without flaws and abuses: higher rates of abuse of children as well as the racist and classist processes by which children are put into foster care. To address these flaws and abuses, numerous laws were passed and rules implemented to ensure the safety of foster children (Rymph; National Foster Parent Association; Children's Rights).

Researchers argue that foster (Gribble) and adoptive mothers (Szucs et al.; Wilson et al.) interested in breastfeeding should be encouraged and supported to do so when appropriate. Both the American Academy of Family Physicians and the American Academy of Pediatrics have statements supporting adoptive mothers to breastfeed (Bryant). Despite this, in some places, breastfeeding any foster child under any circumstances is illegal (Gribble). The actual rules about breastfeeding foster children are unclear, and information to adoptive parents about breastfeeding is rarely presented by adoption agencies and professionals.

For moms like me who fost-adopt in the United States, being able to breastfeed our babies is dependent upon two factors: the ability to induce lactation and getting permission to do so. Until the birth family's parental rights were terminated, I was considered to be a foster mother to my baby who lived in my home for six months until a judge deemed me and my spouse to be her legal parents. I was legally considered a foster mother and under the strict rule and control of my state; I was even supervised by social workers.

Women's Health and Limitations

During the process of becoming approved to be a foster parent, I curiously started my attempt to breastfeed by exploring what it means to induce lactation. I learned that with a combination of pumping, medications, and supplements, females who have not given birth can produce milk in varying amounts (Wilson et al., Szucs et al., Schnell; Denton; Bryant). I even found a local lactation doula with experience with adoptive moms and made a contact through La Leche with a local adoptive mom who was breastfeeding.

It was intimidating and exciting. I heard stories of breastfeeding mom friends who were in enormous pain and bled from their breasts! I saw my sister's breasts while she fed my niece, and without sharing too many personal details about my sister's breasts, let's just say that my response was "Oh my God! What happened to you?!?!" It was like a horror movie. I tried to imagine what it would be like to have a baby eat from my breasts and pictured not only the pain but also the pleasure of being able to sustain my child, just like any other mom.

Since I suffer from severe endometriosis, attempting breastfeeding would be risky for my health as well as scary. The medication given to promote milk production increases estrogen, and endometriosis feeds on estrogen. I had been trying to avoid estrogen at all costs, including those foods that increase estrogen, such as soy and flax seeds.

Would I have a chance of producing milk? In addition to endometriosis, I had a hysterectomy. I only have one ovary, so my hormone levels are very different than the typical woman my age. I couldn't find anything written on a case like mine. The lactation doula said that there is little research on women with hysterectomies inducing lactation, but that it would likely be more difficult.

Nothing had made me question my womanhood more than the realization that I might not be physically capable of producing milk, no matter the intervention. Before my hysterectomy, the doctor questioned how the surgery would affect my womanhood. I was a little offended by his insinuation that not having a uterus made me less of a woman, but not being able to physically produce milk felt like a slap in the face. Not only did I have issues with my reproductive organs, now my breasts might not do what I need either.

How could there be so little research? As a sociologist with a specialty in gender and having a chronic illness related to being female, I shouldn't

have been surprised that this aspect of women's health is under-researched. I was considering giving up when I found an article by an adoptive mom who successfully breastfed.

I was inspired by this mom's spirit and started getting practical. I came up with a plan with my acupuncturist and investigated breast pumps. Matching (finding the right child and being approved to become their parents) can take a long time, so I debated about when to start taking the herbs and pumping. Ideally, you should start pumping a month before you want to start breastfeeding, but I wouldn't have a month's notice before being placed with a baby. Waiting to be matched with a baby could take years.

"I have to warn you that this could cause the endometriosis to flare up," my acupuncturist warned me. "And the pain. All of that pumping is going to be painful." We made a plan that I would begin taking herbs and pumping at placement because I would need to supplement with formula probably no matter when I started. While results vary, adoptive moms who breastfeed successfully generally still need to supplement.

It would be a sacrifice, but planning for breastfeeding made me feel like a real mom. I wasn't sure that it would be worth trying to breastfeed, or at least not try the medications, given the physical cost and risk to my health, but I was ready to start the next step in my exploration to find out if I could get permission from the adoption agency.

Breastfeeding as Abuse

Suddenly, everything came to a screeching halt. I asked our social worker at our agency to give us a letter approving me to breastfeed.

"I'll have to look into it. I've never had that kind of request before," she said sounding weirded out by my request. That made me nervous. She later called to tell me: "According to the state of California, breastfeeding a foster child is considered child sexual abuse."

SEXUAL ABUSE! The words just spun around in my head. I had essentially asked permission to commit sexual abuse. Absurd! My spouse and I were introduced to each other because we volunteered at the same rape crisis centre. I had spent a decade volunteering at rape crisis centres and wrote my master's thesis about them. Being an antiabuse advocate is a huge part of my identity, so this hit me hard.

"The breast is considered a sexual part of the body," the social worker

responded firmly when I pushed back.

I was shocked and offended by the view that breastfeeding was sexual, which denied the benefits of breastfeeding, as well as the social worker's distinction between my relationship with my future child and any other mothering relationship.

"Maybe you could do it and not tell the agency," a friend suggested when I told her what the social worker had said.

"And risk having my child taken away and not be able to adopt again? No way!" I emphatically replied. I was still considered a foster mother by California, and the adoption agency made it clear that the only acceptable food for my baby was formula. I tried to let go of my desire to breastfeed and focus on becoming a mom.

The response that I received from the social worker about breastfeeding was not unique. Online, I found foster parents sharing stories of breastfeeding in hiding and some having their babies taken away when the breastfeeding was discovered. Rachel, a blogger, shared her take on being allowed to breastfeed as a foster mom:

> The general rule is this isn't my baby, so I don't have the authorization to feed this baby whatever I please. In my county, I can't even switch formula brands without pediatrician approval. The other issue we fall into is the matter of physical boundaries. We live in a culture that has re-assigned the human breast to one task: sexual arousal.

Rachel noted that the legal issues aren't just statewide but also vary by state. Even if the intention of foster parents is to adopt their baby and even if the biological parents' parental rights have been terminated, the status of being in foster care tends to deem breastfeeding not allowed and sometimes even sexual in nature ("I Always Knew").

This judgment about breastfeeding haunted me sometimes while I was bottle feeding my baby, when she would put her little fingers on my breast and nuzzle her face on my chest or when I saw other moms breastfeeding. I understand that abuse of foster children happens and that the state creates regulations to keep children safe. But it was hard to have my relationship and our bodies regulated in a way that framed my physical connection with my baby as a problem.

As much as I tried to put their judgments out of my head and just be with my baby, the problematization of my body was always there. For

most moms, the relationship between their breasts and their baby isn't sexualized. After I brought my baby home, when she baby fell asleep on my chest and rested her hand there, I noticed the duality of the sexualization that the social worker implied with the natural relationship between babies and their mother's bodies.

Breastfeeding a baby in foster care is more complicated than in private adoptions because of the issue of parental rights. When children are first placed in foster care, their biological parents retain their parental rights. Hearings take place where these rights are reviewed, and in some cases, parental rights are terminated. Only after that is a child able to be adopted. It is complicated balancing the desires of biological parents with those of foster parents, and in the end, it is often county social workers and laws that drive decision making about foster children. Arguably, biological parents should have some say (if they haven't lost their parental rights) about how their babies are fed.

Breastfeeding is clearly a good option for some babies. We should be celebrating the foster and adoptive parents who can provide breastmilk appropriately. What is inappropriate is the sexualization of breastfeeding for foster and adoptive mothers in ways that it is not for others.

Donor Milk and Becoming Supermom

After a couple of months, my baby started having severe reflux. We tried everything, but nothing worked. We tried changing formulas, and some worked better than others, but my baby reacted to all of them. The paediatrician suggested that my baby was allergic to milk and soy, and there are no formulas that I could find that didn't have at least one of those ingredients. I knew that if I could breastfeed her, she maybe wouldn't have this problem. It was heartbreaking watching her suffer; it was also draining to have her not be able to sleep well, since she was vomiting formula when laid down.

I learned that there are women who share their extra breastmilk with other moms. I found a local woman with lists of moms willing to give me their breastmilk for my baby. If I gave it to my baby, I could lose her. Feeding her formula was making her sick. She was crying, regurgitating everything, and suffering. I had to do something. I kept searching.

Finally, I found a local milk bank. They collect breast milk from donors. Some are moms who have extra milk. Others' babies died, and

the donors pump and collect their milk to donate. The donors are all tested for diseases. Usually, the milk goes to preemies whose moms don't have enough for them, but maybe, just maybe this could help my baby.

"I have to warn you, insurance can sometimes cover the cost, although if they don't, it can be thousands of dollars a month," they told me when I called. "The first step is to get a doctor's note."

The actual first thing I did was go to our social worker from the foster adopt agency. I got the same response from the social worker: "I'll have to check because I've never had this request before." She let me know that this was unusual, but after she checked, we got the okay because it would be doctor ordered and not coming from my body.

Determined, I got a note from our paediatrician. The insurance approved it. And then, like magic, it happened.

Once a week, a cooler arrived at our doorstep from Fed Ex. It was filled with frozen four-ounce glass bottles of breastmilk. We paid nothing, as insurance footed the whole bill. It was magnificent! My sister was breastfeeding at the time and would complain about how difficult it was. I knew I had it easy. The reflux immediately disappeared. I felt like a supermom—empowered and assertively caring for my child. My kid needed something, and I jumped through hoop after hoop to get it for her.

Milk bank breastmilk is magical. Because it combines milk from multiple donors, my baby didn't have the reaction that many babies do to a particular food eaten by the breastfeeding parent. Donors and the milk itself are both tested to avoid diseases. It is also extremely expensive, but we were lucky that our insurance company covered all of the costs. When I fed my baby this milk, I thought about all of those who had pumped. The milk bank shared stories of women whose babies had died but still pumped to be able to donate to babies like mine.

I became famous at the agency and our paediatrician's office. They sent requests for advice when other moms who couldn't breastfeed thought breastmilk that would be beneficial for their babies. A couple of people adopting through foster care who wanted to breastfeed or get donated breastmilk contacted me and responded in shock when I told them about the rules. Milk banks are often not promoted through the medical community outside of NICUs despite the need of donors and the potential benefit to babies like mine.

Conclusion

In the foster and adoption world, formula is almost always considered the only option. Challenging the idea that formula isn't a desirable option can be taken as a challenge to the whole idea that adoptive parents can't provide everything that a biological parent can. I'm in no way arguing that all babies must be breastfed or that all foster parents should do it. I'm merely suggesting that the foster system framing the breast as merely sexual and not also as a healthy option for feeding babies should be reevaluated. It felt absurd that these other women's milk was okay to feed my baby, but that if I produced the milk, it wouldn't be. And at this point, it seemed too late to pursue this avenue further.

Once we finalized the adoption, there were a couple of times when the milk bank didn't have enough milk to give us. Friends and community members shared their milk to make up the difference, so my kid didn't need to go back on formula. I was free to feed my child whatever I wanted and parent however I saw fit. After not having cow's milk and soy in her diet for some time, her body tolerates them just fine.

The foster care system's rules and regulations are in place to ensure children's safety, as well as out of respect to birth families who may not approve of having their babies breastfed by a foster mom However, it is absurd that these other women's milk was okay to feed my baby, but that if I produced milk, it wouldn't be. Breastfeeding is beneficial to all babies, especially those in foster care and who are adopted (Bryant; Gribble; Szucs et al.). Foster and adoptive moms are moms, and we should be empowered to take the best possible care of our babies. Babies in foster care deserve to be breastfed, or at least to have breastmilk, when appropriate and available.

Works Cited

Bryant, Cathy. "Nursing the Adopted Infant." *Journal of the American Board of Family Medicine,* vol. 19, no. 4, 2006, pp. 374-79.

Children's Rights. "Foster Care," *Children Rights,* 2020, www.childrens rights.org/newsroom/fact-sheets/foster-care/. Accessed 3 Feb. 2020.

Denton, Yvonne. "Induced Lactation in the Nulliparous Adoptive Mother." *Midwifery,* vol. 18, no. 2, 2010, pp. 84-87.

Gribble, Karleen. "Breastfeeding of a Medically Fragile Foster Child." *Journal of Human Lactation*, vol. 21, no. 1, 2005, pp. 42-46.

Gribble, Karleen. "Mental Health, Attachment and Breastfeeding: Implications for Adopted Children and Their Mothers." *International Breastfeeding Journal*, vol. 1, no. 5, 2006, pp. 1-15.

"I Always Knew I Wanted to Breastfeed: My Adoptive Breastfeeding Story." *The Breastfeeding Mother*, 2010, thebreastfeedingmother. blogspot.com/2010/10/i-always-knew-i-wanted-to-breastfeed-my. html. Accessed 3 Feb. 2020.

National Foster Parent Association. "History of Foster Care." *NPA*, 2019, nfpaonline.org/page-1105741. Accessed 3 Feb. 2019.

Rachel. "Can't You Just Breastfeed Your Foster Baby?" *She Rocks the Cradle*, 2017, sherocksthecradle.com/2017/08/09/cant-you-just-breastfeed-your-foster-baby/. Accessed 3 Feb. 2020.

Rymph, Catherine. *Raising Government Children: A History of Foster Care and the American Welfare State.* University of North Carolina Press, 2017.

Schnell, Alyssa. *Breastfeeding without Birthing.* Praeclarus Press, 2013.

Szucs, Kinga, et al. "Induced Lactation and Exclusive Breast Milk Feeding of Adopted Premature Twins." *Journal of Human Lactation*, vol. 26, no. 3, 2010, pp. 309-13.

Wilson, Erica, et al. "The Intricacies of Induced Lactation for Same-Sex Mothers of an Adopted Child." *Journal of Human Lactation*, vol. 31, no. 1, 2015, pp. 64-67.

Breast Work: My Breasts Deserve a Trip to Hawaii for All the Work They've Done Nursing

Catherine Ma

B reasts are an important part of the journey into motherhood, as many mothers grapple with the decision of whether to breastfeed or formula feed their infants. During this period, they are often confronted with the "breast is best" mantra, which dictates that breastfeeding is the optimal form of nutrition for a human infant. For women who are able to nurse their infants, breastfeeding can be an empowering experience. However, many mothers find their nursing journey riddled with obstacles. For these women, breasts can become the antithesis to successful mothering. Sociologist Linda Blum has identified the irony of this situation, in which breastfeeding is often glorified as the ultimate maternal experience, but systemic obstacles create difficulties for mothers to successfully nurse their infants (291). This chapter explores the role of breast work through my perspectives as a mother and researcher in breastfeeding. My personal breastfeeding struggles transformed the way I view breasts and fuelled my passion to challenge the dominant breastfeeding paradigm. Through my personal experiences and research with first-time mothers, I examine how breastfeeding can transform the way mothers view themselves to see their maternal bodies as powerful and empowered entities.

Sometimes I begin my conference presentations by divulging to the audience that I did not wake up one day and decide to devote my research to breastfeeding. That usually elicits a few chuckles, and I share a little about how I became interested in this topic. During my first pregnancy, I was not initially concerned with breastfeeding. I read popular maternity books and decided that I would try it. If breastfeeding worked out, that would be great, but if it did not, I would not bat an eyelash. Fast forward to the day my daughter was born, and I found myself desperately trying to get her latched on. We were one hot mess with both of us crying. I had unknowingly internalized the mantra "breast is best," and to be a good mother, I had to give my daughter the best by breastfeeding her. The association between being a good mother and breastfeeding is common in maternal narratives (Burns et al. 208). I was wracked with guilt that I could not nurse her directly from my breast and became alarmed when my nipples began to bleed; I never knew nipples could bleed like that. All of these difficulties made me question who I was not only as a mother but also as a woman. I felt like a failure for not being able to nurse like the mothers depicted in La Leche League (LLL) brochures or hospital posters. When I sought help, I was repeatedly told that a proper latch does not hurt; no other assistance was offered. When I called LLL, the woman on the other end of the line chastised me for pumping and feeding my baby expressed milk from a bottle. She did not offer any remedies and criticized me when I was desperately at the end of my rope. It was a dark time for this first-time mother. I was angry at the lack of support, but my anger fuelled my passion to change the breastfeeding paradigm for all women. Expressing milk for my daughter for sixteen months taught me that there was an unspoken flexibility in how an infant can be exclusively breastfed, and that was the beginning of my empowerment. This is how I became interested in breastfeeding research, and this love continues to grow in ways I never anticipated.

Some may question the value of personal experiences and focus solely on the physical, measurable benefits of breastfeeding. Before I became a mother, there were times when I felt the same. It was only through experiencing motherhood and breastfeeding that I realized I could not—and should not—separate the breast from breastfeeding. My experiences shaped my definition of a good mother and taught me that breastfeeding was more than mere nutrition. Somehow I had fallen into the trap of measuring my worth based on my ability to successfully breastfeed. At

the beginning of my motherhood journey, I had already learned how to unsuccessfully breastfeed with my latch all wrong, bleeding nipples, clogged milk ducts, mastitis, and pumping every two to three hours for six straight months. I often wondered if I should write a book on how not to breastfeed. At that point, I felt like an utter failure. But as I took a more critical look at breastfeeding, I began to understand how my failures were related to the medical community's desire to control women's bodies.

Biomedical Control of Breastfeeding

Prior to the development of the medical model, pregnancy and childbirth were handled by midwives, matriarchs in the community, or women who themselves were experts based on their personal experiences. The biomedical model first exerted its control over women's bodies during the eighteenth century when physicians decided to take an interest in pregnancy, birth, and breastfeeding (Palmer). From those origins until our present time, male physicians have continually sought to control women's bodies. As increasing numbers of women began to rely on this so-called expert scientific advice, physician-dominated childrearing became a status symbol; only wealthy families could afford formula and costly paediatric visits (Litt). Eventually, paediatricians began to suggest that infant formula was superior to breastmilk, which swayed mothers to embrace scientific mothering (Artis). Still, until the late 1960s, breastfeeding was common with over 70 per cent of firstborn infants having been breastfed, but that number soon dropped to less than 30 per cent by the early 1970s (Hirschman and Hendershot). The marketing of formula had become synonymous with infant feeding, and breastfeeding rates began to fall. Formula manufacturers were quite influential in changing infant feeding norms; their marketing strategies often planted seeds of doubt in mothers' heads regarding the quality and quantity of their breastmilk. Ya-Yi Huang et al. found that formula feeding highly correlated with mothers' views that their bodies were unable to produce enough milk, resulting in insufficient milk syndrome. Sadly, the effects of this gaslighting are powerful and can also affect breastfeeding researchers. When my maternity nurse compared her daughter-in-law's plentiful and quick milk supply with my newborn son's constant hungry cries,

I doubted my body's ability to make enough milk. It didn't matter that this was my third nursling and certainly not my first rodeo; I was still vulnerable to feelings of doubt. Little did I know about the historical influence of artificial formula on infant feeding trends.

Human but Not Human

Physicians in Western and colonial societies portrayed artificial formula as a safer, more convenient and nutritionally superior way to feed infants; they convinced many women to embrace such scientific motherhood (Sasson; Apple). This trend continues today: infant formulas are marketed to parents as having synthetic and state-of-the-art ingredients that match breastmilk components. However, biomedical research comparing breastmilk to artificial formulas has repeatedly demonstrated breastmilk's nutritional superiority. Current studies have examined the role of human milk's oligosaccharides, which are a group of sugars unique to human breastmilk. Formula manufacturers attempt to replicate these oligosaccharides in their formula to tout having similar benefits as breastmilk, but paediatrics professor and breastmilk researcher Lars Bode has found that oligosaccharides derived from animals or plants are not as beneficial to infants as those found in human breastmilk (Institute of Medicine). With skillful marketing tactics, major infant formula manufacturers, such as Similac and Enfamil, often advertise the benefits of "2-L human milk oligosaccharide" (found in Similac Prof-Advance) to strengthen a baby's immune system or "milk fat globule membrane" (found in Enfamil), which claim to support cognitive development in brain structure and function similar to breastmilk. What consumers may not realize is that although Similac refers to their supplement as "human," their website states in fine print that the formula is not derived from human milk. Although milk processing labs have created oligosaccharides from chemical reactions and enzymes, human or bovine milk extractions, or through genetic engineering, these sugars are unable to match the naturally occurring flux in human breastmilk (Ravindran). Few realize that human milk is a living substance and changes to match the nutritional needs of infants (Ballard and Morrow). This match is quite intricate, and researchers are still far from understanding the complexities of how breastmilk is responsible

for a host of health and psychological benefits for a nursing mother and her nursling. What we do know about breastmilk is that it constitutes an ever changing dynamic process benefiting the numerous stages of infant health (Witkowska-Zimny and Kaminska-El-Hassan); for instance, breastmilk can increase the numbers of its leukocytes in response to maternal or infant infections (Hassiotou et al. 2). As medical research revealed the increasing benefits of breastfeeding, infant feeding rhetoric began to change.

During the late 1970s, mothers began to revert back to breastfeeding, as feminism highlighted the misogyny of the medical community's continual attempts to control women's bodies (Blum). At that time, Nestle, one of the biggest formula manufacturers, fought to sustain their multibillion-dollar industry by aggressively marketing their products to the public, developing countries, and impoverished families. This led to a global boycott of the Nestle Corporation in 1977, which heralded the beginning of consumer and shareholder activism, where individuals and corporations sought to control the evils of multinational companies (Palmer; Sasson). The world had gained a glimpse of the dangers of formula and formula manufacturers' questionable ethics. Consequently, research regarding breastfeeding benefits continued to grow, public health campaigns promoting breastfeeding were developed, and breastfeeding rates rose accordingly. The U.S. Department of Health and Human Services now touts the advantages of breastfeeding and the World Health Organization recommends that infants nurse until two years of age. As research on breastfeeding benefits increased, judgment towards mothers who fed their infants formula also grew. At the height of the breast versus bottle debates, mothers who fed their infants formula were told they were poisoning their babies. Although this threat sounds extreme, the use of infant formula does carry certain health risks such as increased infectious morbidity, otitis media, gastrointestinal infections, lower respiratory tract infections, and necrotizing enterocolitis. Such views have resulted in many mothers finding little middle ground between breastfeeding and formula feeding. Sadly, these debates disempower and blind women to real injustices, including unpaid maternity leave, inadequate childcare policies, and lack of equal pay. If mothers are too busy judging each other's infant feeding practices, they are too preoccupied to battle the true wars lodged against them.

Breastlike but Not Breasts

From June 2004 to April 2006, the U.S. Department of Health and Human Services (DHHS) teamed up with the Ad Council to create the National Breastfeeding Awareness Campaign (NBAC). Rather than showing actual nursing mothers' breasts, the campaign used images of two dandelion puffs or two scoops of ice cream with cherries. These depictions of breastlike nonbreasts trivialize nursing, highlight society's unease with mammary glands, and discourage the normalization of breastfeeding. Such cultural discomfort reflects maternal lived experiences. For example, I recall a time that my daughter's grammar school friend was playing at our house, and my younger son needed to nurse. I proceeded to feed him as the older children played. My daughter's friend was fascinated and proceeded to ask all sorts of questions about what I was doing. I simply explained to her that some babies drink milk from their mamas. We had a nice conversation about breastfeeding until her mother came to pick her up. Her mom was so embarrassed; she refused to make eye contact with me while I nursed and rushed her daughter out. Having exclusively breastfed all three of my children, whether through expressed milk in a bottle or directly from my breast, I take great pride in normalizing breastfeeding. Unfortunately, I cannot singlehandedly nullify society's squeamishness with breasts. What chance do we have to normalize breastfeeding when awareness campaigns are too embarrassed to show real breasts?

Other researchers have similarly criticized the NBAC breastfeeding campaign's effectiveness. Bioethics expert Rebecca Kukla has critically examined the lack of intersectionality of race, income, and social support in breastfeeding advocacy campaigns and found the resultant effects scapegoated individual mothers as unwilling to breastfeed their infants. African American and Hispanic women often face numerous breastfeeding obstacles that include inflexible work schedules, lack of time to devote to breastfeeding, and inadequate community and familial support (Jones et al.). In addition, African American mothers often work in environments that do not support breastfeeding and must return to work sooner than white women; these factors are significant barriers to their short- and long-term breastfeeding goals (U.S. Department of Health and Human Services). Such difficulties are disproportionately experienced by women of colour and have resulted in consistently low breastfeeding rates among these groups.

The DHHS and Ad Council's breastfeeding campaigns aimed to educate mothers about the benefits of breastfeeding, although previous research found that women were already aware of these benefits (Kukla). The issue at stake was that mothers were not reaching the breastfeeding recommendations created by the American Academy of Pediatrics (AAP) and the Healthy People 2010 campaign, which aimed to have 75 per cent of all mothers initiate breastfeeding, 50 per cent to continue to six months, and 25 per cent to continue to one year ("Healthy People 2010"; Eidelman). Sadly, little seems to have changed, as the Healthy People 2020 campaign has not addressed the obstacles nursing women face but has simply increased their goal numbers to have 81.9 per cent of all mothers initiate breastfeeding, 60.6 per cent to continue to six months and 34.1 per cent to continue to one year ("Healthy People 2020"; "Breastfeeding Report Card"). Increasing percentage goals without providing adequate support only results in a sense of failure when nursing women are unable to reach these breastfeeding objectives. In many ways, the simplification of breastfeeding awareness into a one-size-fits-all model is continually perpetuated by these campaigns. Although these agencies have acknowledged the existence of external factors that make it difficult for some women to breastfeed, the bureaucratic solutions ignore complexities inherent in women's breastfeeding experiences (Ma). Breastfeeding is a unique process that does not fit a general model. One-size-fits-all campaigns encourage a dichotomous view of breastfeeding as having right and wrong paths, where compliance with the generalized model is viewed as correct and any deviation from this model is viewed as incorrect.

In my research on first-time mothers, many women felt stressed and anxious when their breastfeeding experiences differed from what they had been taught prior to their child's birth, and they often felt they were breastfeeding the wrong way, which resulted in premature weaning (Ma). The singular depiction of breastfeeding promoted by the DHSS and Healthy People campaigns led women to believe that they were nursing incorrectly, which lowered their maternal self-esteem and became a major obstacle in achieving their breastfeeding goals. Ironically, the women who chose to breastfeed in the way that suited them best were more likely to listen to their infant's feeding cues, adjust what they learned to better fit their situations, and were flexible in how they breastfed. All of these factors led to more positive breastfeeding

experiences. These women did not try to fit their experiences into the narrow confines of breastfeeding as dictated by medical professionals; rather, they focused on their own needs and what worked for them. As these mothers were able to personalize breastfeeding to better suit their life circumstances, they nursed their infants longer. These mothers' experiences provide evidence that women can resist the current, generalized breastfeeding model (Ma, "I'm MY Breastfeeding Expert").

I Don't Know about Yours, but My Breasts Cannot Read

As a first-time nursing mother and researcher, I noticed how breast-feeding literature often depicted nursing in a dichotomous nature. Many suggestions for new mothers seemed black and white and reminiscent of a recipe. I believed that if I did what those books suggested (e.g., nurse on each breast for twenty minutes to prevent soreness or get a good latch, so nursing does not hurt), breastfeeding would be a breeze, and I would look like the ethereal Madonna nursing her baby. What I did not anticipate was that my breasts did not read those same books, and they had their own ideas about how breast-feeding would turn out. It was not pretty. My sore nipples felt like they were on fire, and I often angrily stated, "Why can't the milk come out of my elbows?!" Hearing physicians and lactation consultants repeat-edly tell me that a proper latch does not hurt was demoralizing at the least and infuriating at the most. Although their words implied that I was breastfeeding the wrong way, they did nothing to help me find the right way. Through my own suffering, I found ways to alleviate the pain. While researching for a chapter I was writing on breastfeeding, I came across an article that discussed a variety of effective ways to deal with sore nipples, which is one of the most prevalent reasons why women prematurely wean (Joanna Briggs Institute). This nonjudg-mental article discussed effective tools for alleviating nipple pain that included applying warm water compresses, nursing-safe pain-relieving sprays, hydrogel dressings, or glycerin gel therapies. Once I discovered glycerin gel pads, my sore nipples became a thing of the past; I bought extra sets to keep in the freezer for a touch of heavenly, cooling bliss on my blazing hot nips. I also realized that newborns have small mouths, and it took time for their mouths to grow bigger, which made nursing

less painful for me. Rather than dismissing my very real pain—the pain that planted seeds of doubt in my head—it would have been helpful if someone had addressed the multiplicity of ways to breastfeed. Since women's bodies are different and breasts come in all shapes and sizes, why would experts assume that a singular model of breastfeeding would fit all women? Rather than taking an individualized approach to identify the support each mother-infant dyad needs, the current hegemonic approach to breastfeeding continues to centre on the needs of policymakers, who seem out of touch with the mothers they purportedly serve.

Based on the analyses of the narratives of first-time mothers, the pressure women face to breastfeed their infants can have a contradictory effect and lead to premature weaning (Ma, "Dodging Booby Traps"). I had unknowingly fallen into the trap of trying to nurse according to what others had dictated as the best way (e.g., breastfeeding classes, books, the Internet, and lactation consultants) instead of listening to myself. Ironically, it never occurred to me that maybe I was not doing anything wrong. Maybe my infants had small mouths that needed to grow larger before nursing became less painful. Maybe nursing is painful at the beginning when both mother and newborn are still learning how to breastfeed. I recall taking my second newborn back to the hospital and pleading with the lactation consultant to evaluate our latch. She mentioned that I had used so much Lansinoh (i.e., a purified form of lanolin secreted by the skin of sheep used topically to treat sore nipples) that it looked like my baby ate a greasy pork chop without his hands. I can laugh about that now, but fifteen years ago, that was not funny. I finally figured out that the first three weeks of nursing my babies were always difficult and painful because their mouths were so tiny. It still enrages me when I hear physicians, lactation consultants, or medical professionals say that a good latch should not hurt. Apparently, my nipples refused to listen and cannot read. When women hear these generalizations, it negatively affects their breastfeeding experiences and dismisses their pain. When I returned to my doctoral program six-weeks postpartum, a well-meaning male colleague asked me how I felt. In my sleep-deprived stupor, I told him that breastfeeding felt like putting a staple gun to his penis. He stopped asking me questions after that. Pain is very real for nursing mothers, and disregarding this pain can result in a downward spiral where mothers feel ignored and purposefully

silenced. In many ways, the silence regarding ways to alleviate pain while breastfeeding sends a detrimental message to women, as it implies that they are nursing in the wrong manner and any pain they experience is because they are at fault. This rhetoric is quite robust and resistant to change, which indicates the importance of alternative voices to counter this view.

I'll Nurse My Baby in the Bathroom When You Start Eating Your Meals in There

A mother's decision to breastfeed her infant entails changes in her lifestyle that include stressors that formula-using mothers do not have to contend with. One of the greatest stressors for nursing mothers is having to breastfeed their infant in public. Some mothers are ostracized for whipping out their breasts while nursing, and others are told to nurse their infants in public bathrooms. For many mothers, the fear of nursing in public, feeling embarrassed or offending others results in bottle feeding (Burns et al.). Worries about potential social censure create additional stressors that no new mother needs when travelling with her nursing infant (Giles). I was initially self-conscious about public nursing, but experience (e.g., a screaming, hungry baby) taught me to nurse quickly and efficiently. I also became bolder in asking complete strangers if they had space for me to breastfeed my baby because I refused to use a restroom to do so. I even had a snarky reply in mind if anyone made the grave mistake of asking me to nurse there: I looked forward to telling people that I would breastfeed my child in the bathroom when they were ready to eat their meals there. The consensus that breastfeeding is the ideal way to feed an infant, and the concurrent harassment that ensues from mothers simply trying to abide by such new momisms, sparked a fire in me to help people see this irony.

In addition to dealing with these contradictions, my adventures in breastfeeding transformed the way I view my breasts and body. Despite overcoming such numerous challenges, nourishing my babies with my breasts taught me how powerful and strong maternal bodies are. This was a lesson I could only learn through breastfeeding my children. I also wanted to use my breastfeeding difficulties to help other mothers see that their self-worth should not be tied to their ability to nurse. This is

why I take the time to listen to what each woman wants for her child and herself. I share my breastfeeding experiences with other women in the hopes that those who suffer similar difficulties will feel less marginalized. My research on first-time mothers showed me how empowering breastfeeding can be when women listened to their own needs and those of their children (Ma, "I'm MY Breastfeeding Expert"). When women paid attention to their own needs—as opposed to following bureaucratic organizations' suggestions, formula companies' biased advice, or medical professionals' directives—they were able to foster their maternal self-confidence, which extended their breastfeeding duration. Numerous researchers support this finding, as maternal confidence was a significant factor in breastfeeding duration (Blyth et al.; Brown). When nursing is personalized rather than prescribed, it becomes an intimate act that centres on the needs of a mother and her child. This type of individualized nursing, where mothers learn to trust their inner voice, is an important act of resisting the biomedical model that permeates women's health. Breastfeeding in this fashion can help mothers learn to validate what they feel is true and see themselves as experts about their own children's needs. Clearly, the power of breastfeeding needs to be returned to the mother and infant dyad.

Conclusion

As I look back on the difficulties I experienced breastfeeding my little nurslings, I realized how fleeting that time was, even though it often felt like an eternity during the darker days. I feel fortunate that my old view of breastfeeding as the only way to be a good mother has expanded into a definition that is more encompassing and accepting of differences. Ironically, the slew of difficulties I experienced nursing my children provided fertile ground to sow the seeds of my very own empowerment, as I learned about corporealism, maternalism and the biomedical control of women's bodies. Having a touch of saltiness and sass was also helpful in reclaiming my power on days where I felt I should just suck it up and do what others thought was best for me. In hindsight, I am grateful that I chose to listen to my inner voice to do what I felt was right. That alone was probably the greatest lesson I learned from breastfeeding, and it was something only my breasts and nurslings could have taught me. In speaking with first-time and more seasoned

mothers, I have discovered that mothers are resilient and strong. Maternal bodies never cease to amaze me because we do so much with so little. Nursing may be a rocky journey initially, but mothers should know that they are not alone, and their struggles are never in vain. Finally, I want you to know that my breasts did enjoy their well-deserved trip to Hawaii and are looking forward to a return trip.

Works Cited

Apple, Rima. "Constructing Mothers: Scientific Motherhood in the Nineteenth and Twentieth Centuries." *Social History of Medicine: The Journal of the Society for the Social History of Medicine*, vol. 8, no. 2, 1995, pp. 161-78.

Artis, Julie E. "Breastfeed at Your Own Risk." *Contexts: Understanding People in Their Social Worlds*, vol. 8, no. 4, 2009, pp. 28-34.

Ballard, Olivia, and Ardythe L. Morrow. "Human Milk Composition: Nutrients and Bioactive Factors." *Pediatric Clinics*, vol. 60, no. 1, 2013, pp. 49-74.

Blum, Linda M. "Mothers, Babies, and Breastfeeding in Late Capitalist America: The Shifting Contexts of Feminist Theory." *Feminist Studies*, vol. 19, no. 2, 1993, pp. 291-311.

Blyth, Rosemary, et al. "Effect of Maternal Confidence on Breast-feeding Duration: An Application of Breastfeeding Self-Efficacy Theory." *Birth*, vol. 29, no.4, 2002, pp. 278-84.

Bode, Lars. "Human Milk Oligosaccharides: Every Baby Needs a Sugar Mama." *Glycobiology*, vol. 22, no. 9, 2012, pp. 1147-62.

Brown, Amy. "Maternal Trait Personality and Breastfeeding Duration: The Importance of Confidence and Social Support." *Journal of Advanced Nursing*, vol. 70, no. 3, 2014, pp. 587-98.

Burns, Elaine, et al. "A Meta-Ethnographic Synthesis of Women's Experience of Breastfeeding." *Maternal & Child Nutrition*, vol. 6, no. 3, 2010, pp. 201-19.

Centers for Disease Control and Prevention. *Healthy People 2010. Maternal, Infant, and Child Health*, www.healthypeople.gov/2010/Document/HTML/volume2/16MICH.htm#_Toc494699668. Accessed 21 June 2018.

Eidelman, Arthur I., et al. "Breastfeeding and the Use of Human Milk." *Pediatrics*, vol. 129, no. 3, 2012, pp. e827-e841.

Enfamil NeuroPro Infant, *Enfamil*, www.enfamil.com/articles/enfamil -neuropro-baby-formula-nutrition-and-ingredients. Accessed 21 Mar. 2018.

Giles, Fiona. "Images of Women Breastfeeding in Public: Solitude and Sociality in Recent Photographic Portraiture." *International Breast-feeding Journal*, vol. 13, no. 1, 2018, p. 52.

Hassiotou, Foteini, et al. "Maternal and Infant Infections Stimulate a Rapid Leukocyte Response in Breastmilk." *Clinical & Translational Immunology*, vol. 2, no. 4, 2013, e3.

Hirschman, Charles, and Gerry E. Hendershot. "Trends in breast feeding among American mothers." *Vital and Health Statistics. Series 23: Data from the National Survey of Family Growth*, vol. 3, 1979, pp. 1-39.

Huang, Ya-Yi, et al. "Factors Related to Maternal Perception of Milk Supply While in the Hospital." *The Journal of Nursing Research: JNR*, vol. 17, no. 3, 2009, pp. 179-88.

Institute of Medicine. *Infant Formula: Evaluating the Safety of New Ingredients*. The National Academies Press, 2004.

Joanna Briggs Institute. "The Management of Nipple Pain and/or Trauma Associated WithwBreastfeeding." *Australian Nursing Jour-nal*, vol. 17, no. 2, 2009, pp. 32-35.

Jones, Katherine M. et al. "Racial and Ethnic Disparities in Breast-feeding." *Breastfeeding Medicine*, vol. 10, no. 4, 2015, pp. 186-96.

Kelishadi, Roya, and Sanam Farajian. "The Protective Effects of Breast-feeding on Chronic Non-communicable Diseases in Adulthood: A Review of Evidence." *Advanced Biomedical Research* vol. 3, no. 3, 2014, doi:10.4103/2277-9175.124629.

Kukla, Rebecca. "Ethics and Ideology in Breastfeeding Advocacy Campaigns." *Hypatia*, vol. 21, no. 1, 2006, pp. 157-80.

Litt, Jacquelyn. "American Medicine and Divided Motherhood: Three Case Studies from the 1930s and 1940s." *The Sociological Quarterly*, vol. 38, no. 2, 1997, pp. 285-302.

Ma, Catherine. "I'm MY Breastfeeding Expert": How First Time Mothers Reclaimed their Power through Breastfeeding." *Bearing the*

Weight of the World: Exploring Maternal Embodiment, edited by Alys Einion and Jennifer Rinaldi, Demeter Press, 2018, pp. 203-20.

Ma, Catherine. "Dodging Booby Traps: How the Breast is Best Ideology Undermines Maternal Breastfeeding Efforts." *My Day Job: Politics and Pedagogy in Academia, Eastern Sociological Society,* 19 March 2016, Boston Park Plaza Hotel, Boston, MA. Conference Presentation.

National Center for Chronic Disease Prevention and Health Promotion. *Breastfeeding Report Card: Progressing Toward National Breastfeeding Goals, United States, 2016,* Aug. 2016, www.cdc.gov/breastfeeding/data/reportcard.htm. Accessed 27 Mar. 2018.

Office of Disease Prevention and Health Promotion. *Healthy People 2020: Maternal, Infant, and Child Health,* www.healthypeople.gov/2020/topics-objectives/topic/maternal-infant-and-child-health/objectives. Accessed 27 Mar. 2018.

Palmer, Gabrielle. *The Politics of Breastfeeding. When Breasts Are Bad for Business.* Printer & Martin, 2009.

Ravindran, Sandeep. "Producing Human Milk Sugars for Use in Formula." *International Milk Genomics Consortium,* Oct. 2015, milkgenomics.org/article/producing-human-milk-sugars-for-use-in-formula/. Accessed 21 Mar. 2018.

Sasson, Tehila. "Milking the Third World? Humanitarianism, Capitalism, and the Moral Economy of the Nestlé Boycott." *The American Historical Review,* vol. 121, no. 4, 2016, pp. 1196-224.

Similac Pro-Advance. *Similac,* similac.com/baby-formula/pro-advance?gclid=EAIaIQobChMI_uXztMX2QIVjVuGCh0N2wt3EAAYASAAEgL4S_D_BwE&gclsrc=aw.ds. Accessed 21 Mar. 2018.

Stuebe, Alison. "The Risks of Not Breastfeeding for Mothers and Infants." *Reviews in Obstetrics & Gynecology,* vol. 2, no. 4, 2009, pp. 222-31.

United States Department of Health and Human Services. *The Surgeon General's Call to Action to Support Breastfeeding.* U.S. Public Health Service, Office of the Surgeon General, 2011.

Witkowska-Zimny, Malgorzata, and Ewa Kaminska-El-Hassan. "Cells of Human Breast Milk." *Cellular & Molecular Biology Letters,* vol. 22, no. 11, 2017, p. 13.

Chapter Thirteen

Older First-Time Moms: Breastfeeding and Finding Their Own Paths

Rosann Edwards

In Canada, nursing students are taught about the transition to motherhood, how it should happen, and what stages women should go through. It's all very much about textbooks and videos. After the lectures, the students are immersed in the real world of clinical rotations, labour and delivery and mother-baby unit practicums, which is a chance to put theory into practice with real mothers and infants. Most aspiring nurses learn a lot in that semester of maternal-child nursing. And once they are practicing nurses, they will continue to gain tacit knowledge and to move from novice to expert (how student nurses, according to seminal nursing theorist Patricia Benner, should transition to being professional nurses).

As a nurse who has practiced for over a decade in the field of maternal-child nursing, my experience was really no different. In my clinical practice as a nurse and lactation consultant, I worked in hospital childbirth units and in the community, conducting home visits with at-risk mothers. During my years of frontline nursing, I encountered many older first-time mothers who expressed feelings of grief, guilt, anger, resentment, disappointment, and anxiety when discussing their experiences of breastfeeding and early motherhood. There was a noticeable disconnect between the expectations these mothers had of early motherhood and breastfeeding, and their lived realities.

This essay is based on findings from a constructivist grounded theory

study on the breastfeeding experiences of older first-time mothers. The discussion presented below is centred on analysis of findings focusing on participants' transition to motherhood as informed by Ramona Mercer's theory of becoming a mother (BAM). Between July 2016 and September 2017, I interviewed twenty-three first-time mothers over the age of thirty-five about their breastfeeding expectations and realities during their first six months postpartum. It is often difficult to disentangle breastfeeding from early mothering, and, as such, the mothers also focused heavily on their experiences, expectations, and realities related to becoming a mother during the interviews. It should be noted that all the names used for the mothers who participated in the study in this essay are pseudonyms.

Becoming a Mother and Breastfeeding—In Theory

Mercer's theory of BAM is widely taught in Canadian schools of nursing. The theory is also used in nursing research as a theoretical framework for studies focusing on motherhood, maternal-child care, and breastfeeding. BAM was originally developed in 1986 as the theory of maternal role attainment to serve as an alternative framework to the predominately bio-medical view of childbirth and the early postpartum period that dominated the practice of healthcare professionals at the time (Meighan; Noseff). BAM asserts that women transition to the maternal role on biological, psychological, and social levels. The three levels exert influence on each other, while acting within the context of each individual woman's past experiences and their expectations of motherhood (Meighan; Mercer, *Becoming a Mother*).

In *Becoming a Mother*, Mercer identifies four stages women work through while internalizing their newly forming maternal identity: 1) commitment, attachment, and preparation (during pregnancy); 2) acquaintance, learning, and physical restoration (two to six weeks postpartum); 3) moving toward a new normal (two weeks to four months); and 4) achievement of maternal identity (around four to six months). BAM is based on the central assumption that within each woman there exists a relatively stable core self which evolves over a woman's lifetime and is shaped both by individual experiences and cultural context. This core self determines how a woman defines new situations and, in turn, how she reacts to these situations (Meighan; Mercer, *First-Time*

Motherhood, Becoming a Mother).

In *First-Time Motherhood*, Mercer addresses breastfeeding as one of many variables to be studied under the context of the acquisition of maternal identity. This analysis positions breastfeeding as a central variable influencing the transition to motherhood. The literature clearly identifies breastfeeding as an important component of maternal identity that is used by mothers as a marker to validate their successful (or not) transition to the maternal role. Breastfeeding is a caregiving act that mothers do with their babies typically every two to four hours every day, every night, and it largely dictates the ebb and flow of early mothering. Many breastfeeding dyads will continue breastfeeding into the toddler years and beyond. It is a pivotal piece of early motherhood, and for those who cannot breastfeed or chose not to breastfed, breastfeeding still influences how they move into their new role as a mother. Breastfeeding is a central component of the culturally pervasive ideal of attachment parenting, which is a standard of mothering many women are striving, and struggling, to achieve (Avishai; Charbrol et al.; Choi; Crossely).

Moreover, breastfeeding is both a private act between mother and infant as well as a public act that provides validation, or judgment, of the mothering practices within the cultural context of the time (Avishai; Brouwner et al.; Knaak; Lee; Leeming et al.; Shaw). Breastfeeding practices demonstrate conformity to social standards of mothering that are consistent with the assumptions of role theory, on which Mercer heavily based BAM. Role theory assumes that an individual's (in this context a new mother's) behavioral responses reflect their perceptions of others' responses to their performance in the role (Mercer, *First-Time Motherhood*). New mothers can be highly cognizant of others judging them as mothers. It is important to many new mothers' sense of self that not only do they view themselves as good mothers but also that others perceive them to be good mothers as well (Avishai; Cooke et al.; Ludlow et al.; Lupton). There is the risk of role strain when women judge themselves against the idealized, and, at times unattainable, traits they have been socialized to believe make a good mother.

It is unlikely that nurses remember the intricacies of BAM after completing their academic training and transitioning into clinical practice. But nurses do know that women prepare psychologically and physically during pregnancy for motherhood. Nurses know that in the first six weeks postpartum, women grow into their new role as mothers,

including figuring out their breasts' new role as the source of all food for their new "role partner" (as Mercer would put it). Amid the chaos of caring for an infant, new mothers are trying to find a new normal: being able to shower, eat, and occasionally get out of the house. By the time new mothers reach six months postpartum, they are starting to feel increasing confidence and ownership over how they are mothering. Nurses know what this normal transition looks like. Nurses also know on a professional, an instinctive, and a tacit level that the transition to motherhood rarely occurs this neatly and cleanly.

The First-Time Mothers Over Thirty-Five and Breastfeeding Experiences Study: Becoming a Mother and Breastfeeding—In Practice

The experiences of the mothers examined in this essay come from doctoral research titled *The Breastfeeding Experiences of Older First-Time Mothers: A Constructivist Grounded Theory Study*. The research question explored was "What factors affect how first-time mothers ≥ thirty-five years of age make decisions about breastfeeding, and how do these factors affect the decisions they make related to breastfeeding in the first six months postpartum?" Twenty-three women of diverse ethnic backgrounds—all first-time mothers over the age of thirty-five, with infants under three months of age—graciously volunteered their time to be interviewed by me twice. The first interview was when their baby was under three months of age; the second was three to four months later to follow up on their breastfeeding experiences and journey into motherhood. All of the women lived within the bounds of a major Canadian urban centre, they were well educated, remarkably articulate, and skilled in the art of critical thinking. Every woman in the study, now a new mother, at some point in the interviews openly questioned expectations, the agendas of healthcare providers, and challenged the idea of conforming to cultural norms in relation to their breastfeeding and/or infant feeding practices and becoming a mother.

The dominant cultural narrative on breastfeeding and intensive mothering, or the so-called rules, imply that good mothers only do what is absolutely best for their babies. Breastfeeding is considered the best way to feed an infant, thus good mothers happily breastfeed (Avishai; Charbrol et al.; Choi; Crossely). If they are having issues, good mothers are expected to go to whatever lengths they need to in order to continue

breastfeeding. For many, rejecting the rigid definitions of exclusive breastfeeding and practicing infant feeding on their own terms were important parts of feeling satisfied with their breastfeeding experience, even when they were not exclusively breastfeeding or feeding expressed breast milk (Andrew and Knaak; Labarere et al; Spencer et al.; Symon et al.). These mothers were able to find their own definitions of successful breastfeeding to fit with their unique circumstances and needs (Baerug et al.; Labarere et al; Spencer et al.; Symon et al.). The mothers in this study were no exception to this. They found ownership over breastfeeding by relaxing the rules they had internalized from health promotion campaigns, popular cultural narratives on good mothering, as well as family and friends. They found themselves at times actively questioning these rules and giving the figurative, and literal, middle finger to those they viewed as judging them. They ultimately found satisfaction in how they were choosing to breastfeed, feed breast milk, and/or formula feed. For example, Sonya said the following:

So, basically the experience has gone very well because I've been baaad, I don't know who told me, just like "drop the book." So just drop the book, and just watch the baby, and things like that. So I guess that's what I've done and since then it's been going well—It's not black and white anyways [on breastfeeding].

In the first three months postpartum, the mothers in this study were blindsided by the challenges of early breastfeeding. These mothers simply did not know what they needed to know in relation to their new infants (including normal newborn behaviour and development) or their own breasts (including the basic physiologic processes involved in lactation). Of the twenty-three women who volunteered to be interviewed for this study, twenty-two had graduate degrees, and every one of them had a self-described successful career. All had made it to this point in their lives as independent and productive women who were used to handling problems they could solve. In the first six to eight weeks postpartum the mothers reported finding themselves caught in a cycle of reactive decision making, desperately trying to find solutions to their breastfeeding challenges. In some cases, the mothers would literally change their breastfeeding behaviours on a day-to-day basis; they went from following the often conflicting advice of one health care professional to the next. The mothers described experiencing levels of vulnerability, loss of control, and dependence that most of them had never experienced before.

Every time, that's like a wall … I smash into a wall and feel completely defeated and then like, I'm back at square one even though I'm not, but in that moment that's what it feels like, nothing is going to work to make this work. And I obviously really want to make this work, so at one point I tried to bottle feed him myself in the morning and pump right after and being like okay worst case scenario I could still pump full time and give him breastmilk.

The idea that real mothers, good mothers, breastfeed and failure is simply not an option pushed most of the mothers to continue this early cycle of solving a problem only to be met by another one. Amanda spoke for many of the mothers when she said, "We've worked. We've persisted the fuck out of this [breastfeeding]." In the first three months postpartum, mothers persisted through loss of control and autonomy as well as physical pain. They breastfed because they wanted to be good mothers. The mothers are just a few examples of the sentiments voice by all the participants linking breastfeeding to good mothering.

I think as a mom I think, um, I want to do that [breastfeed] I think it's part of being a mom. (Harpreet)

I'm just like okay, I have to do this. For me, it's like there's no choice in the matter. Like some things you have a choice in life and some things you don't. And this is one thing that I just have to do. (Jennifer)

When it came to breastfeeding supplies and stuff, he kind of said, "Well, it's your choice. You're the one choosing to breastfeed, you don't have to." And I said, "It's not a choice. It's the best thing to do." (Susan)

In early postpartum period, the mothers were moving through Mercer's second stage of acquaintance, learning, and physical restoration (birth to six weeks postpartum) as well as the third stage of moving toward a new normal (six weeks to four months). During this time, the mothers viewed their breasts as the source of becoming not only a mother but also the kind of mother they wanted to be. As Angela put it, "this was our identity; we were going to be breastfeeding." Kim also said the following "I definitely had this idea of myself as like the semi

granola-y, carry my baby everywhere, breastfeed him on the go, no problems mom, and that's not what's happening, yah, that we would be living a, like a normal looking life for me and there's a baby with me."

This internal pressure to continue no matter what the odds was both a driving force to seek solution after solution to issues that arose (everything from sore nipples, to thrush, to tongue tie releases, and physiotherapy for baby) as well as a form of self-policing to keep reminding themselves that failure was not an option. Many of the mothers recounted self-talk they employed to motivate themselves to keep going, as the following examples show.

> Just kind of focusing on okay this is for a good reason. I'll get through this because it's worth it for him and it's not every day like this. I keep reminding myself. (Jane)

> I guess just like you kind of realize how dependent one little child is on you and how when he needs to feed he needs to feed. You know you don't have any other options. You do obviously, but if you want to exclusively breastfeed you don't. (Evaya)

By the time of the second interviews, the mothers were firmly entrenched in Mercer's fourth stage of BAM, actively internalizing the maternal role. This period is characterized by Mercer as a developmental process in which maternal-infant attachment occurs, and the new mother feels competence in care-taking tasks and feels happy in her new role. By the follow-up interviews at three-six months postpartum, the mothers were moving into ownership of their new maternal role. An integral part of this was taking ownership over their unique breastfeeding, breast milk feeding and formula feeding experiences. These mothers were now more comfortable doing this on their own terms and in their own ways, as Lu explained:

> I mean, clearly there's no instruction manual for dealing with a baby. But I think I just have to live it once at least to see that everybody has an opinion and clearly I'm not doing what I'm supposed to be doing according to 95 percent of the population. So okay if that's the case then I'm doing it anyways and I am well and she's well and everybody's happy on my end and, hey, I'll probably carry that over to other things too.

Consistent with Mercer's fourth stage of BAM, the relationship between mother and child is clearly present in the second round of interviews. What began for many as a near adversarial relationship with the infants' needs pitted against the mothers' eventually turned into a relationship between two unique people with a growing balance between the baby's and mother's needs. The following are a few examples of the mothers talking lovingly about the relationship with their infants in the second interviews, something that was almost entirely absent in the first interviews:

> Just the connection is really lovely, where she just kind of looks up at you, and she kind of like massages my chest with her hand at the same time, like she has this rhythmic kind of; it's really sweet when she does it. It's nice little moments like that which I really like. (Erin)

> I think the bonding is when, if I look at him and he puts his little hands on my face, he looks right at me, or if he's crying and then I smile, I'll just look at him and he'll smile right through his tears, yea, that did it. (Jennifer)

Political scientist James C. Scott explores the idea of small acts of everyday anarchy in his collection of essays, *Two Cheers for Anarchism*. Scott's central tenet is that by engaging in small acts of resistance against who we are supposed to be, and how we are supposed to act, we keep our ability to think critically and protect who we are as autonomous human beings. For these new mothers, their breasts and breastfeeding had begun as the locus of a loss of control and vulnerability but then became a site of quiet rebellion and a locus for regaining control. This allowed them to reconnect with their core self in the new reality of being a mother. Such reconnection and ownership occurred through the acceptance of good enough mothering, the active questioning of the agendas of both official health promotion and breastfeeding advocates, and doing things their own way, as the following examples attest:

> I'm not really a "trouble-maker" but here I was just like "I'm gonna do what I need to do, too bad. I am surprised actually. I feel like oh, if I had thought about doing it in a decision I probably wouldn't have, but because it's just following my child's more important than cultural norms. (Chantal)

I'm just like "aarrr," but you know what? I do right by my kid as much as I can. You know, I'm not perfect, but it could be worse. I'm sure, like people looking into what it is people do, and another thing, I used to do was to compare myself to a lot, especially compare and despair and you know. I got over that. I don't do that anymore. (Asha)

These mothers were women in their mid-thirties to mid-forties, with their sense of self firmly established before their baby. The need to reconnect with, and redefine, their core self—who they were before baby—seemed to come through in small acts of resistance or every-day anarchism focused on breastfeeding, breast milk feeding, and weaning. These small acts of taking back control around feeding their babies helped the mothers work though the guilt at deciding to not live up to the ideal and integrate motherhood into their lives in order to begin mothering on their own terms. The acts of going against the advice of healthcare professionals to regain a sense of control and order occurred primarily around practicing co-sleeping and giving bottles to allow their infant (and themselves) to sleep longer, or giving bottles to allow the mother freedom to leave her infant with a secondary caregiver. The eventual rejection of the good mother ideal was the overarching act of resistance which allowed the mothers the space take control of feeding their babies and to begin mothering on their own terms. The following examples speak to this reclamation of control:

Initially I even felt guilty giving it [the bottle] to her thinking "I'm doing this just so I can sleep longer" but if I gave her a bottle before bed she would sleep for five hours. I decided that this is silly. I'm not gonna be as effective as a parent; it's not bad for her. She's happy and being fed and she's thriving. So almost like 80 or 90 percent of the time she is being breast fed, so I figured, no, this works for us. (Erin)

I remember, my husband, saying "you know, it's not rocket science. Why do you need a book to tell you how to do things in a certain way and a roundabout way of doing it? It just doesn't make sense to me." And then it dawned on me "you're right. It's so stupid. I'm making everything harder." (Alyssa)

One of my biggest concerns was becoming one of those moms that I see lots of, including my sister—their life just becomes being a mom. When we were struggling with breastfeeding it became just about being a mom and that was extra hard. And to figure out is that because I'm not wanting to formula feed [chuckles] or what? And so to me it's like that's the balance, and I need to be healthy for my child and I want to be a good model for my child, and the only way I can do that is to sometimes put my needs before my kid's. (Kim)

Shelton and Johnson found that stories from older first-time mothers often reflect resistance and ambivalence towards the dominant discourse of the good mother and what they *should* be doing in during early motherhood. These seemly imposed ways of mothering often resulted in their sense of identity as a person being undermined. The mothers in this study struggled with threats to their autonomy through loss of control and freedom brought on by the demands of early motherhood. The mothers underwent an active process of working to regain their autonomy and control through knowledge and skill building, finding like-minded mothers for support (both in person and online), and learning to trust their own judgment and their baby's cues. The mothers often asserted their own independence by rejecting the discourse of the all-giving mother and allowed themselves space for themselves and their needs. By the time of the follow up interviews, the majority of the mothers reported feeling like themselves as persons, not just mothers.

In summary, the first six weeks postpartum for the mothers in this study were characterized by feelings of vulnerability, dependence, and a lack of ownership related to breastfeeding and mothering. The combination of not knowing what they needed to know and the surprise at the intensity and skill required for early breastfeeding left the mothers feeling out of control and in a position of relative powerlessness, resulting in the participants acting primarily as passive agents which led to cycles of early reactive decision making. The mothers came to breastfeeding as true believers in the value breastfeeding and had internalized both sociocultural expectations of intensive mothering and attachment parenting. The internalized ideology drove these mothers to continue the cycle of reactive decision making.

From six weeks to three months there is a noted shift from early vulnerability and dependence towards active skill building. During this

period, there was a growing mistrust of healthcare professionals and health promotion messages, as the mothers begin to question the lack of clear, practical, nonjudgmental, and consistent information they had received to date related to breastfeeding. The mothers began resisting and redefining the ideal of the intensive, breastfeeding mother that limited their freedom as individuals who also happened to be mothers.

By the time of the follow-up interviews, between three and six months postpartum, the mothers had moved away from indiscriminate taking of advice and information to being active researchers and consumers of information on breastfeeding (and all other forms of infant feeding); they internalized and put into practice in their everyday lives only those practices that fit with their lifestyle, their beliefs systems, and the temperament of their individual baby. The mothers had gained knowledge, control, trust, and ownership, leading to their active agency over their breasts, breastfeeding, and mothering. By three months post-partum, the mothers' own needs and desires had overridden the need to live up to the ideal of the good, breastfeeding mother. The influence of the ideology of the good mother had rescinded into the background, and through small, everyday anarchistic acts the mothers regained a sense of themselves, now as mothers.

Conclusion

Breastfeeding is a foundational aspect of the transition to motherhood for many women. The mothers in this study used their breasts and breastfeeding experiences to frame the construction of their own unique narratives of motherhood. This quiet rebellion found these new mothers tailoring, reframing, questioning, and finding their own way to mother.

It is worth noting that the mothers in this study were middle class, well educated, and had supportive partners; they were living in a cultural context of tolerance towards questioning norms. The mothers were admittedly in a privileged position to negotiate how they would on their own terms transition to motherhood. This study repeated in a different context, with different demographics of mothers would probably look very different. For this group of women becoming a mother did in many respects follow the expected course from the theory of BAM but not in an orderly and passive manner. It was through active questioning of, and

small everyday acts of resistance against, the ideal of the good breast-feeding mother that this group of older first-time mothers redefined successful breastfeeding, good mothering, and, ultimately, came back to who they were, only now as mothers.

Works Cited

Andrews, Therese and Knaak, Stephanie. "Medicalized Mothering: Experiences in Breastfeeding in Canada and Norway." *The Sociological Review,* vol. 61, 2013, pp. 88-110.

Avishai, Orit. "Managing the Lactating Body: The Breast-feeding Project and Privileged Motherhood." *Qualitative Sociology,* vol. 30, 2007, pp. 135-52.

Baerug, Ann., et al. "Effectiveness of Baby-Friendly Community Health Services on Exclusive Breastfeeding and Maternal Satisfaction: A Pragmatic Trial." *Maternal & Child Nutrition,* vol. 12, no. 3, 2016, pp. 428-39.

Brouwner, Marrissa A., et al. "Using Goffman's Theories of Social Interaction to Reflect First-Time Mothers' Experiences with the Social Norms of Infant Feeding." *Qualitative Health Research,* vol. 22, no. 10, 2012, pp. 1345-54.

Charbrol, Henri, et al. "Influence of Mother's Perception on the Choice to Breastfeed or Bottle-Feed: Perceptions and Feeding Choice." *Journal of Reproductive and Infant Psychology,* vol. 22, no.3, 2004, pp. 189-93.

Choi, Pricilla, Y, L, et al. "Supermom, Superwife, Supereverything: Performing Femininity in the Transition to Motherhood." *Journal of Reproductive and Infant Psychology,* vol. 23, no.2, 2005, pp. 167-80.

Cooke, Margaret, et al. "An Exploration of the Relationship between Postnatal Distress and Maternal Role Attainment, Breastfeeding Problems and Breastfeeding Cessation in Australia." *Midwifery,* vol. 23, 2007, pp. 66-76.

Knaak, Stephanie. "Contextualizing Risk, Constructing Choice: Breastfeeding and Good Mothering in Risk Society." *Health, Risk & Society,* vol. 12, no. 4, 2010, pp. 345-55.

Labarère, José, et al. "Determinants of 6-Month Maternal Satisfaction with Breastfeeding Experience in a Multicenter Prospective Cohort Study." *Journal of Human Lactation,* vol. 28, no. 2, 2012, pp. 203-10.

Lee, Elliej. "Living with Risk in the Age of Intensive Motherhood: Maternal Identity and Infant Feeding." *Health, Risk & Society,* vol. 10, no. 5, 2008, pp. 467-77.

Leeming, Dawn, et al. "Socially Sensitive Lactation: Exploring the Social Context of Breastfeeding." *Psychology & Health,* vol. 28, no. 4, 2013, pp. 450-68.

Ludlow, Valerie, et al. "How Formula Feeding Mothers Balance Risks and Define Themselves as 'Good Mothers'." *Health, Risk & Society,* vol. 14, no. 3, 2012, pp. 291-306.

Lupton, Deboraha. "'The Best Thing for Baby': Mothers' Concepts and Experiences related to Promoting their Infants' Health and Development." *Health, Risk & Society,* vol. 13, no. 7-8, 2011, pp. 637-51.

Meighan, M. "Maternal Role Attainment-Becoming a Mother." *Nursing Theorists and Their Work,* 7th ed., edited by Martha Alligood Raile & Ann Marriner Tomey, Mosby Elsevier, 2010, pp. 581-98.

Mercer, Ramona. *First-Time Motherhood: Experiences from Teens to Forties.* Springer Publishing Company, 1986.

Mercer, Ramona. *Becoming a Mother: Research on Maternal Identity from Rubin to Present.* Springer Publishing Company, 1995.

Noseff, Jerried. "Theory Usage and Application Paper: Maternal Role Attainment." *International Journal of Childbirth Education,* vol. 29, no. 3, 2014, pp. 58-62.

Scott, James, C. *Two Cheers for Anarchism,* Princeton University Press, 2012.

Shaw, Rhonda. "Performing Breastfeeding: Embodiment, Ethics and the Maternal Subject." *Feminist Review,* vol. 78, 2004, pp. 99-115.

Shelton, Nikki, and Sally Johnson. "I Think Motherhood for Me was a Bit like a Double-Edged Sword": The Narratives of Older Mothers." *Journal of Community and Applied Social Psychology,* vol. 16, 2006, pp. 316-30.

Spencer, Rachael. "Research Methodologies to Investigate the Experience of Breastfeeding: A Discussion Paper." *International Journal of Nursing Studies,* vol. 45, 2008, pp. 1823-30.

Symon, Andrew, et al. "Infant Feeding in Eastern Scotland: A Longitudinal Mixed Methods Evaluation of Antenatal Intentions and Postnatal Satisfaction—the Feeding Your Baby Study." *Midwifery,* vol. 29, no. 7, 2013, pp. e49-e56.

Part Three

Breasts in Later
Motherhood

Chapter Fourteen

Intergenerational Breasts: Breast Reduction Surgery Patients and Family Breast Talk

Patricia Drew

In 2018, over 534,000 women worldwide underwent breast reduction surgery, also known as reduction mammaplasty (ISAPS). Although this number is significantly smaller than the 1,862,000 women who had breast augmentation (ISAPS), it is a growing trend and reflects longstanding cosmetic and medical interventions on women's bodies. Women reduce their breasts for myriad reasons, including the desire to alleviate breast-related pain, to increase athleticism, or due to aesthetic preferences (Rodrigues). Women who choose surgery for cosmetic reasons report their large breasts had caused them emotional difficulties, as their bodies did not fit with their own personal preferences and/or cultural ideals (Reardon and Grogan); this discord may be related to the ongoing objectification of women's bodies (Fredrickson and Roberts). Regardless of motive, women who reduce their breast size often wait until their breastfeeding years have concluded, as some surgical techniques negatively affect successful lactation (Kraut et al.).

This chapter's narratives highlight the role of families and motherhood in shaping women's breast reduction experiences. Existing studies reveal that parents', and particularly mothers', body messages have an impact on children's body satisfaction (Rogers et al.). Mothers who criticize their own bodies are likely to produce children who engage in similar

self-criticism (Neumark-Sztainer et al.). Not surprisingly, children are also likely to have low body esteem if their appearance is critiqued by their parents. In contrast, when mothers express supportive, body validating sentiments, children report higher body esteem (Ogle et al.). While most body talk research focuses on the impacts and interactions between parents and youthful children and/or adolescents, adults can still be influenced by their parents' views. Women may continue to be affected by the body messages that they received when young and/or they may continue to receive parental feedback about their bodies in adulthood (Clarke and Griffin). As women enter motherhood, they may either repeat or reject the body messages they received and internalized as children (Arroyo et al.). Although previous studies have highlighted the significant impact of parents' body messages, we do not know how this plays out among women who have undergone breast reduction surgery. This chapter begins to address this absence by examining, first, the types of breast messages that large-breasted women received from their families of origin and, second, the types of breast messages that these women intend to pass on to their daughters.

This case study explores the perspectives of two mothers who chose to undergo breast reduction surgery. In using a small sample, I aim to provide a detailed contextual analysis of the role of families in women's body ruminations. Even though these narratives are not generalizable to the wider population of women who go through reduction surgery, the interviewees' stories reveal the deep meanings attached to their bodies and families. The featured women were recruited through personal networks and snowball sampling. "Diana" was interviewed over the phone, and "Anya" was interviewed in person; with both, I used a semi-structured interview schedule. The interviews were comfortable and candid; however, Anya was more forthcoming and expressive than Diana, and that loquaciousness is reflected in the length of her story. Both interviews were recorded and professionally transcribed. Interviewees' names, as well as the names of their family members, have been replaced by pseudonyms. A cross-case analysis was used in order to examine common themes in the interviewees' experiences.

Diana's Story

Diana is a forty-seven-year-old biracial (African American/Caucasian) woman who underwent elective breast reduction surgery three years prior to our interview. She is divorced from her first wife, with whom she has two children, an eleven-year-old son and a seven-year-old daughter; she currently lives with her children and her new partner. Diana comes from a long family line of large-breasted women: "They are all fairly heavy-chested [and] very proud of their breasts." One aunt underwent breast reduction when Diana was young; however, the remainder of the women in her family are either accepting of or pleased with their large breast size. Diana's family— including her mother, father, and sister—never criticized her large breasts; instead, her breast size was characterized as unremarkable and normal.

In contrast to her body-affirming family, Diana never enjoyed her breasts, either in adolescence or adulthood. She said, "I was born into a family with the genetics of saggy boobs, so they were never really pretty to me." Moreover, she avoided highlighting her chest area, preferring conservative clothes, turtlenecks, and high-cut shirts. Although Diana was something of a family outlier, in that she did not appreciate her big breasts, no one in the family criticized her personal views. Diana's disdain for her breasts was seen as completely acceptable; it was her body, and they were her views.

Diana began to think about breast reduction surgery in her thirties, when she was a 34DD: "I think for the first time, I had a professional job and I really didn't like the fact that my breasts were so big that certain kinds of work shirts didn't fit right, or people—I caught people looking at them in a professional setting, and it just made me uncomfortable." This workplace discomfort led her to reflect more on her embodied identity and how her breasts had become an object to be noticed and perceived.

Despite her interest in reduction, Diana delayed undergoing surgery for a decade because of the purely aesthetic nature of her body complaint and the cost of the surgery. Diana also delayed surgery because she wanted to breastfeed her future babies. By the time she was forty-four, Diana's breast size had increased to a 34G, and she was done having children. She was able to pay for the surgery out of pocket, which was necessary, as her reduction was cosmetic and would not be covered by her private health insurance.

Although Diana's personal breast opinions differed from her family members' positive views, her family was uniformly supportive of her surgical decision. Her large-breasted mother and sister both believed that Diana was making a fine choice for herself: "I felt like they supported me because they knew that that would make me happy. And it completely was not an issue.... I didn't have any negatives—anything negative at all." Her family's positive, accepting attitude was an asset, as Diana reflected upon her body and went through the surgery process. She did not feel the need to make excuses to her family or state justifications because her family had always allowed its members to have a broad range of feelings about their bodies.

Diana was still in her first marriage at the time of her surgery, and she described her ex-wife as being very neutral about breast reduction. When they discussed the possibility of reduction her ex-wife said, "Fine ... if that what makes you happy, fine." Postsurgery, her ex remained blasé: "She didn't much care." Overall, Diana depicted her ex-wife as having little interest in or impact on her surgery decision. She was more concerned about their children's perceptions than her ex's. The kids were young when she went through surgery; her son, Samuel, was seven and her daughter, Esme, was three. Diana never mentioned her surgery to her toddler daughter, as she thought that Esme would not be able to comprehend the surgery's purpose, her hospital stay, or her recovery. She gave her son a relatively brief explanation in order to assuage any potential fears he might have related to his mother's health: "And so, basically, I was home in bed and just said, 'Oh, Mommy had a little...'—I think I told him Mommy's breasts were too big, and so I wanted them smaller. And so, somebody helped me do that, and he was fine with it. As long as I was okay, he was fine with it. He didn't have any reactions whatsoever." By intentionally framing her surgery as inconsequential, Diana helped Samuel to understand her surgery as a normal, standard occurrence. He accepted her explanation, and their regular life moved forwards. Her purposefully nonchalant characterization reflects her attitude that it is fully acceptable have a wide array of feelings about your body and, also, that it is permissible to modify your body to bring it into alignment with your wishes.

At the time of our conversation, Diana's seven-year-old daughter, Esme, had not yet developed breasts; however, Diana had begun thinking about how she will approach the topic. Esme is adopted, and the two

have no genetic ties; still, Diana believed that Esme may develop large breasts during adolescence:

> Diana: She might because her birth mother I know, and we stay in contact, and she has very large breasts. I think it might actually happen for my daughter because her genetic sister also has very large breasts. So, I'm very prepared for that to come up and to be a topic of conversation for us.
>
> Patricia: So, how would you approach that with your daughter?
>
> Diana: My daughter is beyond athletic. She's got a very athletic body, and I think that what I would probably try to do is just support her athleticism. But if it ever got to a certain point, I would support it after a certain age if she ever wanted to have a breast reduction.... I would support it but only after a certain age. But I guess that's the only thing I would say is I completely support you if you want to do this, but you have to do it when your body's ready. And I feel like she has a lot of people around her that—I mean, my partner now has very large breasts. My sister does. Pretty much half of my family does. So I feel like my daughter has a lot of company in how she might feel, and if I can't support her in a way that she needs, I feel like she could talk to somebody else who could.

In this dialogue, Diana indicates that she aims to be understanding of her daughter's future breast attitudes. If Esme embraces her potentially large breasts and wants to relate to similarly large-breasted women, Diana is happy to foster her daughter's connection to her sister and her partner. If Esme wants to undergo breast reduction surgery, Diana is willing to support that desire once her daughter's body fully matures. Diana intends to validate her daughter's breast attitudes, regardless of what those attitudes may be.

Diana's plan to accept Esme's future breast beliefs mirrors her own childhood experiences. Diana's mother and sister acknowledged her desire to reduce her breast size, despite the family's widespread approval of large breasts. Diana is continuing her family's legacy of acceptance. Just as her mother, sister, and other family members accepted and celebrated Diana's decision to change her body, Diana anticipates that she will validate her daughter's own breast attitudes, regardless of what they might be.

Anya's Story

Anya, forty-six, is a Jewish, Caucasian woman who underwent breast reduction surgery in 2017, two months prior to our interview. She and her wife, Megan, have a six-year-old daughter, Jessea. Like Diana, Anya came from a family of large-breasted women; her mother and her sister both have large breasts. In stark contrast to Diana's experience growing up with the women in her family being accepting and positive towards their breasts, Anya's mother did not like her own breasts and broadcast her distaste through "a lot of negative comments about her own body." Anya easily recollected her mom's decades-old self-critiques; she believed they resulted in a legacy of family eating disorders, Anya's feelings of sadness about her mom, and, concurrently, Anya's childhood revulsion for her mom's body:

> I remember thinking her body was gross. I remember really disliking the size of her breasts, and I didn't have them at that point, but I just remember thinking they were so big.... She would wear these awful, the most granny-like, old-school bras of just the worst tan, super fabric, not cute at all minimizers. I would always watch her shoving them into the cups, and I just remember there was something about it that was so off-putting.

In addition to the criticism focused around her mother's body, Anya's father routinely made remarks objectifying women's breasts. For instance, when watching television sitcoms, her dad loudly reacted when large-breasted or scantily clad women appeared: "He'd always go, 'Whoa!' and he'd make some lecherous, piggy comment. Yeah. So from very early on, there was definitely that connection of when you have a voluptuous body, you get responded to like that. It's gross."

As Anya and her sister reached adolescence, their mother began to make disparaging comments about their bodies, too. Anya had been an athletic child, and her mother started commenting on her supposedly unsuitable body: "Because I was a gymnast and I was a dancer and so I was muscular ... and she would pat me on the butt and tell me what a big butt I had or say my butt was getting big." Her mother's critiques of her daughters led Anya to feel that her strong body and her own newly large breasts were inappropriate:

We both had really big boobs, just like my mom, and we were both in ballet where everyone was tall and slim and not curvy. And here we were ... short and zaftig is what you would call it. We were curvaceous, short Jews, not statuesque Aryan ballerinas. So, we both struggled with our bodies in differing ways, yeah.... That was the other thing ... we all had to minimize our breasts— the ones [bras] that smoosh your boobs to make them look smaller—because that's the goal.

Anya's sister underwent cosmetic rhinoplasty as a teen, a common procedure at the time in her Southern Californian Jewish community. Seeing this, Anya hoped that her mom would allow her to undergo breast reduction surgery; at the time, Anya was 5'3, 100 lbs., and a D cup size. Her mother denied her request, as she believed Anya should not undergo surgery in case she wanted to breastfeed later in life. Although Anya reluctantly understood her mother's rationale, she still did not feel that her large breasts were attractive or valued. Rather her mother's body attitude communicated the message that Anya's breasts were distasteful yet needed to be tolerated.

Anya's aesthetic discomfort became increasingly acute in her twenties and thirties. During her first career as a high school teacher, students and parents would be distracted by her breast size. One student repeatedly made comments about her, and in a subsequent letter of apology, he mentioned having conversations with classmates about Anya's breasts and her occasionally visible nipples. A colleague of Anya's similarly approached her to talk about "getting padded bras to give my nipples more privacy while I'm at work"; such interactions made her feel incredibly self-conscious, and she became "so tired of my nipples being a subject of people's conversation."

Anya's desire to become a mother and to breastfeed led her to put breast reduction on the backburner. She had a child at age forty, took time off of work, and breastfed until her daughter's third birthday. Once she ceased nursing Anya's breast unease returned. She struggled with this discomfort, though, as she strongly identifies as a feminist and feels that women should love their bodies regardless of cultural norms:

I feel like ... a feminist should celebrate and embrace womanhood in all its forms, so a feminist should be at peace with her body no matter how it's shaped ... Like that self-acceptance should be a given if you're a feminist ... is my belief structure ... because that's embracing all the many forms and manifestations of womanhood.

Despite Anya's deeply held belief that women should accept their bodies, she could not shake her personal distaste for her breasts. She wanted her breasts to stop being the object of other's appraisals and, even more strongly, she wanted to like her body. Anya felt that she would be unable to appreciate her own body so long her breasts were unsatisfying:

Anya: I think it was also a lot of just my body image—when I would get dressed and look in the mirror and see how my clothes fit because of the shape of my breasts or when I would take my clothes off and I would take my bra off and they'd go "thunk." Then, I'd lift them up and I'd be like, "I'm okay with this part, but then when you layer these ginormous boobs on top of it ..." See, I hate that I have that—you can even see on my face—I have this ... I look like those old goddess fertility abundance dolls that are just two huge boobs and a big stomach and the triangle legs?

Patricia: Yup.

Anya: I felt like that's how I looked, and it didn't feel fertile and abundant to me. It just felt fat. It felt ugly. I didn't like it, and I hate saying this out loud because again, I feel like I would never, ever say these things about a friend of mine. I would never want another woman to feel this way about herself, but the reality is that's how I felt about myself, and I just felt like my breasts ... I can do something about my weight. I can start working out. I can eat better, and I know my body will trim back down, but it didn't matter how much weight I lost, I was still with ginormous boobs, and I was like, "The only way this is gonna go away is to remove it surgically."

With these remarks, Anya reveals how her personal desire to modify her body stood in stark contrast to her belief that all types of women's bodies are acceptable. She was unable to reconcile these contradictory views, and as a result, both coexist in her narrative.

Throughout our interview, Anya clearly, repeatedly stated that her decision to undergo breast reduction surgery was due to appearance as well as personal and aesthetic body satisfaction. She felt no breast-related body pains, and although she had a slipped back disc six months prior to her surgery, she did not believe that this malady was related to her breast size. In contrast to Anya, many women who undergo breast reduction surgery state that their presurgical breasts caused back or other body pains, or negatively affected their ability to engage in exercise. Such accounts are accurate depictions of many women's embodied lives and, concurrently, may help to reduce some women's guilt over cosmetic surgery.

When Anya finally decided to undergo surgery, her mother, surprisingly, was "incredibly supportive": "I was expecting some blowback, and she just said, 'I completely understand.' She basically was saying, 'I get it,' like she would love to do it too, and she's sick and tired of hauling hers around as well. She knows how it is." In Anya's estimation, her mother's change of heart was related to Anya's successful breastfeeding experience—that is, once her breasts fulfilled their utilitarian value, it was acceptable for Anya to modify them.

Anya's wife, Megan, was thoughtful and empathetic during the reduction process. Before surgery, Megan provided reassurance by validating her wife's feelings; she knew Anya was dissatisfied with her body, and she wanted her spouse to be happy. After surgery, Megan thought Anya looked happy and "great": "She's like, 'You know, they're still your boobs. They're just smaller.'" Such consistent messages of encouragement eased her surgery journey:

> I think if I was married to someone who was really opposed to it, it would have been a steeper hill to climb for me. I would have had to overcome more internal barriers to do it because I was really scared that when I started telling people I'm thinking about this, I was really nervous about the reaction I was gonna get. So, I think if I had gotten pushback from my peer group or from my partner or my family, I might have paused more. But the fact that there was such ... I was so clear internally, and then

there was such an absence of pushback and so much support that it just cleared the path very easily to happen as quickly as it did.

The only presurgical opposition that Anya encountered was from her young daughter. Jessea, who was six at the time, has a fond and proprietary relationship with her mother's body.

> So, I talked to her. I said, "Mommy is going to go to the doctor. I'm gonna have surgery, and the doctor's gonna make my boobies smaller." ... "Why?" ... "Well, because I'm having pain in my back, and it's been hard for me because they're this size. So, we're gonna make them smaller, so I can be more comfortable in my body." I said, "How do you feel about that?" ... "I don't want you to."

Jessea has a "very effusive" relationship with Anya's breasts and body. She loves to snuggle close to her mom, and she did not want anything to change her access to her mother's body. Anya indicated that, when younger, Jessea liked to cuddle with her mother's body almost as if her mom was a beloved stuffed animal. Jessea was opposed to Anya's surgery, as it meant a transformation of the object that seemingly belonged to her.

When Anya explained her breast reduction to her daughter, she was careful to frame her decision in terms of pain reduction. She avoided mentioning her own aesthetic preferences, as she did not want to let Jessea think that personal appearance was significant to her. Moreover, Anya did not want her daughter to anticipate that her future, postpuberty breasts would be problematic. Recalling her own mother's constant negative body comments, Anya did not want her personal feelings of body inadequacy to be passed down to her daughter. She thoughtfully ruminated on how she could discuss her daughter's body with her:

> I really struggled with that because one of my biggest fears in doing this is ... What if Jessea has the same body I have, and I'm sending the message inadvertently that there's something wrong with her body because it looks like how my body used to look and I wanted to change mine. So, by extension, that's sending the message that if her body looks like that, there's something not right about it.... I send a lot of messages about how strong her body is. We just talk a lot about, "God, you're so strong. Let me

see your muscles," and we do muscle checks. So, that to me, is the focus is that she's healthy, and she's strong. Her body's smart, and we take care of our bodies. That's the messaging. Hopefully, she'll talk with me enough that we can talk about how the world interacts with the changes we undergo.

Anya hopes that Jessea's adolescent body esteem will be lightyears better than her own. She suspects that Jessea may develop similarly large breasts, and she believes that there are varied possibilities for her daughter's breast-related thoughts: acceptance, self-objectification where large breasts may be a "currency of power," or dislike. Anya strongly hopes Jessea will accept her body and be happy with it and will be sad if her daughter's story mirrors her own: "Because I don't want her to feel about herself the way I've always felt about myself. I would want her to feel happier in her body than I was.... It would be painful for me if I knew that the world was treating her the way it treated me or if she was feeling about herself the way I was feeling. I would understand it. I'd be understanding, for sure." Anya's hopes for Jessea represent a sharp break from her own mother's breast and body messaging: that large breasts are an unattractive burden to endure and that curvy bodies were unattractive. As an adult, Anya has tried hard to reject these internalize, self-deprecating messages. She recognizes that her personal vision of acceptable appearance remains rooted in the beauty scripts she was taught in girlhood; this is evidenced when Anya struggles to reconcile her own self-critiques with her feminist view that all body types are permissible and wonderful. As a mom herself, Anya grapples with the contradiction of, on the one hand, having undergone an aesthetic-based surgery and, on the other hand, wanting to raise a daughter who will have high body esteem.

Contrasting the Stories

In many ways, Anya and Diana are similar: they are both middle-aged women who chose surgery after becoming mothers. Both had been dissatisfied with their breasts since adolescence and finally felt able to proactively change their bodies in midlife. Both women identify as racially or ethnically mixed, although only Anya mentioned race as significant. She felt her presurgical breasts led her to feel more commonalities with other nonwhite women; it was a point of bonding

"having tits and not being this skinny little J. Crew model." Moreover, both interviewees are lesbians in committed relationships: Anya had been married for nine years at the time of the interview, and Diana was living with her relatively new girlfriend. Both women indicated that their current partners were not particularly concerned with breasts; their significant others just wanted the interviewees to be happy in their bodies. When asked about the role of sexual orientation in their experiences, both interviewees believed male partners may be more breast centric and, thus, object to reduction. Diana mentioned that a male partner might have been "grossed out" by the scarring, and she felt "more of a comfort that women would be way more forgiving of any kind of smaller breast or scarring." Despite their beliefs about men's aesthetic breast preferences, both felt that their actual male friends were supportive and nonjudgmental, regardless of the men's sexual orientation. Anya perceived her heterosexual male friends as universally kind, though cautious in bringing up the topic of surgery.

Notwithstanding their many commonalities, the two interviewees had significantly different breast reduction attitudes. Diana displayed calm determination: she had always been discontented with her breast size, she had completed her breastfeeding years, and she had the ability to pay for surgery out of pocket. Anya, in contrast, wrestled with her decision: she did not like her breasts but hated that she wanted to look different. In undergoing surgery, she was able to satisfy her aesthetic preferences yet felt that she was reinforcing the objectification of women's bodies. Anya is, by no means, the first cosmetic surgery patient to struggle with the meaning of body work. Previous research has long-documented how women negotiate objectifying cultural norms when deciding to engage in body transformations (Davis; Gimlin). Even after her reduction, Anya remains ambivalent about whether her choice has larger meanings for her daughter or other women: she does not want to reinforce homogenizing, oppressive gender norms.

Both interviewees enjoyed the support of their families at the time of their surgeries, and both identified this as key in their decision-making processes. However, their family's breast conceptions during adolescence differed widely. Diana's family had been unwavering in their acceptance of Diana's personal breast feelings—whatever she felt was acceptable and permissible. Anya's family—and, in particular, her mother—was critical of her body and breast size. When a teenage Anya asked to

change her breasts, her mother said "no" and characterized her breasts as an unpleasant, unattractive burden that needed to be endured. There are clear, sharp attitudinal differences between Anya's and Diana's families, and the families' viewpoints helped to shape the women's perspectives on appropriate breast conceptions. Moreover, their mothers' messages influenced the women's personal levels of body satisfaction and also helped to frame the women's ideas of appropriate and inappropriate body interventions. These findings support Analisa Arroyo et al.'s assertion that parental body messages persist in later life and indicate that childhood breast messages can continue to shape adult women's breast experiences.

As mothers of young daughters, Diana and Anya each discuss the ways that they plan to frame potential large breastedness to their daughters. They both think about how their breast discussions may affect their own daughters' burgeoning breast feelings. Whereas Diana hopes to replicate her family legacy of acceptance and validation, Anya plans to sharply break away from her mother's critical, stigmatizing messages and, instead, focus on increasing her daughter's body esteem. Their stories suggest that breast talk is an important site for looking at how women negotiate body messages from previous generations.

In summary, Anya and Diana's narratives reveal the continuing significance of their own parents' breast perspectives. Diana spoke highly of her family's body validation and how she intends to uphold that tradition; she intends for her daughter to feel that her personal breast feelings are acceptable, regardless of what those feelings are. In contrast, Anya highlighted the trauma related to her mother's continual, derogatory breast, and body comments; she intends to parent quite differently in order for her daughter to have more positive body feelings. Anya believes that persistent, effortful parenting will enable her daughter to escape personal breast loathing, and, thus, she will equip her daughter with tools to love her future large breasts and accept her body, regardless of its appearance. In contrasting these parenting strategies, it is apparent that Anya and Diana's mothers' breast messages continue to affect their lives. For both women, the breast messages that they received in childhood significantly framed the way they intended to talk about breasts with their daughters. Despite the different approaches to parenting that they plan to implement, both women have created parenting plans in response to their own childhood breast scripts.

Works Cited

Arroyo, Analisa, Chris Segrin and Kristin Andersen. "Intergenerational Transmission of Disordered Eating: Direct and Indirect Maternal Communication Among Grandmothers, Mothers, and Daughters." *Body Image*, vol. 2, 2017, pp. 107-115.

Davis, Kathy. *Reshaping the Female Body: The Dilemma of Cosmetic Surgery*. Routledge, 1995.

Fredrickson, B., and T. Roberts. "Objectification Theory: Toward Understanding Women's Lived Experience and Mental Health Risks." *Psychology of Women Quarterly*, vol. 21, 1997, pp. 173-206.

Gimlin, Debra. *Cosmetic Surgery Narratives: The Effect of Thin Ideal Media Images on Women's Self-Objectification, Mood, and Body Image*. Palgrave Macmillan, 2012.

Hurd Clarke, Laura, and Meridith Griffin. "Becoming and Being Gendered Through the Body: Older Women, Their Mothers and Body Image." *Ageing & Society*, vol. 27, 2007, pp. 701-18.

International Society of Aesthetic Plastic Surgery (ISAPS). "ISAPS International Survey on Aesthetic/Cosmetic Procedures." *ISAPS*, 3 Dec. 2019, www.isaps.org/wp-content/uploads/2019/12/ISAPS-Global-Survey-Results-2018-new.pdf. Accessed 6 Feb. 2020.

Kraut, Roni Y et al. "The impact of breast reduction surgery on breastfeeding: Systematic review of observational studies." *PloS One*, vol. 12, 2017, pp. 1-17.

Ogle, Jennifer, et al. "Socializing Girls Whose Bodies May Not Align with Contemporary Ideals of Thinness: An Interpretive Study of US Mothers' Accounts." *Body Image*, vol. 23, 2017, pp. 13-27.

Neumark-Sztainer, et al. "Family Weight Talk and Dieting: How Much Do They Matter for Body Dissatisfaction and Disordered Eating Behaviors in Adolescent Girls?" *Journal of Adolescent Health*, vol. 47, 2010, pp. 270-76.

Reardon, Rhona, and Sarah Grogan. "Women's Reasons for Seeking Breast Reduction: A Qualitative Investigation." *Journal of Health Psychology*, vol.16, no.1, 2011, pp. 31-41.

Rodrigues, Sara. "To Learn the World Again: Examining the Impact of Elective Breast Surgery on Body Schema." *Human Studies*, vol. 41, 2018, pp. 255-73.

Chapter Fifteen

My Breast Reduction

Heather Jackson

My breasts. I never had an issue with my breasts until I became a mother and that seemed to change them. Maybe it was because I had my daughter when I was a teenager and my body was still developing. Or maybe I just did not notice them until I became pregnant. I remember my breasts immediately after I gave birth; they hung down to my waist, instantly swollen with milk. My breasts almost hurt more than the birth itself. I remember feeling so excited to finally sleep on my stomach after childbirth, but I could not: my stomach had flattened, but my breasts protruded from my small frame. They ached, and they were swollen. Stretch marks developed. They flopped around and banged into my body if I did not wear a bra; my nipples got huge. I chose not to breastfeed, so the milk did eventually dry up. My breasts did get slightly smaller over the years but not by much. They hurt and made my body hurt. They felt uncomfortable. They did not fit how I felt as a woman and a person.

This narrative explores my choice to get a breast reduction after many years of being a mother. I examine how my politics informed this decision as well as my physical and mental health, my being a mother, my history with an eating disorder, my thoughts on plastic surgery, and social norms. I also describe the surgical process, and my feelings and thoughts throughout.

My Breasts

My breasts were a 34/36DD/DDD depending on bra style and brand. I am barely 5'4, about 135 lbs., and have a small frame. Finding bras this size is rare, so I often shopped online at specialty stores. Bras are expensive, too, and I was very specific about the kind of bras I wore. They had to be unlined, underwire, and not have cross straps in the back; they also had to offer a lot of support. I could not wear bralettes, as I might as well go braless. Swimming suits were difficult, too. I tried to wear underwire swimsuit tops, which were hard to find. Shirts and tops were tight around the breasts and made them look even larger. To make matters worse, my breasts would unbutton shirts on their own. I did not show them off; I never wanted to. I often tried to wear clothing to disguise them because I felt so uncomfortable.

I gained a bit of weight in my twenties and lost weight later in graduate school, but my breasts remained the same; they might have gone down a band size but nothing significant. My breasts sagged. They looked like long tubes; the nipples were still facing the ground. They bounced so badly when I went to the gym that I wore special sports bras to keep them in check. They hurt. They hurt my body, and they hurt my chest. During warm seasons, they had their own sweat, and I would sometimes put cornstarch under them to prevent chaffing. During sex, they swung around like tire swings, sometimes hitting my partner or making a slapping sound. They were embarrassing.

My large breasts caused neck, shoulder, and back pain. It was dull pain that never went away. I tried professional massage, chiropractors, stretches, yoga, over-the-counter medication, hot and cold compresses, weight lifting, and physical therapy. I tried special bras, and an ex-partner even thought up a bra that would help alleviate pain. All of this offered some help, but it never offered any sort of permanent relief. The American Society of Plastic Surgeons (2017) states that patients often experience physical distress, including difficulty performing various tasks, emotional distress, wardrobe concerns, and physical pain associated with their breast size.

I did not feel like my large breasts were consistent with how I saw myself as a woman. I rarely wore low-cut clothing or any sort of clothing that would show my cleavage. I was getting to the point of wanting to bind them. I wore larger-fitting tops that would camouflage them. If I did not do this, I got unwanted attention. Mostly men would stare at

them, especially when I was bending down or when I was bike riding in a V-neck shirt. Sometimes I forgot why men would stare at me. Even my daughter would notice and say, "It's because you have large breasts." My large breasts often left me feeling insecure.

My breasts preoperation

My Eating Disorder and My Body Image

I had an eating disorder off and on since I was a child. My body image was horrible; my childhood was traumatic, and I was constantly in a war with myself about how I looked. I used food as a coping mechanism, restricted my diet, and abused laxatives. When I was in graduate school pursuing my master's degree in counselling, I was diagnosed with other specified feeding and rating disorder and was in treatment for three years. I met with a psychologist, nutritionist, and medical doctor once a week.

The first part of my treatment was stabilization and working on my relationship with food. I did this by gaining a better understanding of nutrition, appropriate intake, as well as the guilt and shame I associated with food. I also processed the trauma and the internalized messages from my family and society related to food and my body, and I worked on my body image (which I still do). I feel that if I had not been in

225

recovery with my eating disorder, having a breast reduction would have been associated with weighing less and making my body smaller. It was important for me to work through this before I made a decision to alter my body with a breast reduction.

My Choice, My Breasts

I always wanted smaller breasts, but I did not pursue it that seriously, although I did some research about the procedure online. I honestly assumed I could not do it because it would not be covered by health insurance, and I could not afford it out of pocket.

One day, I was on a coffee date with a friend, and we were discussing our large breasts and how uncomfortable they were. She mentioned breast reductions and how Medicaid might cover the cost. She asked to see my shoulders to see if there were indents from my bra and the weight of my breasts—there were. She had large breasts, too, and had also considered a breast reduction. We were both on Medicaid, and she encouraged me to pursue the idea further.

I kept the idea in my mind but did not pursue it for years. Then, while on state health insurance, I researched local plastic surgeons that accepted my insurance. I preferred a female physician who had specializations in breast reductions. Once I found one, I called her office and spoke to a nurse about how to go about setting up a consultation. The nurse told me to get a referral from my primary care provider (PCP) and compile the documents I had related to massage, physical therapy, and chiropractor care. I made an appointment with my PCP and started to contact previous providers to gather the documentation. I showed my PCP the documentation at the appointment, and she made the referral and then a consultation appointment with the plastic surgeon.

The plastic surgeon said I was a good candidate for the procedure, but my health insurance would need to approve it first. She took photos, checked my size, looked at documentation, and asked about my physical symptoms. She told me the office would call me with the decision from my health insurance. I was diagnosed with Grade III ptosis, which is when "a nipple is more than 3 cm below the crease or at the inferior pole of the breast" (Kirwan, p. 357).

(Figure taken from Kirwan, p. 358)

A few weeks later, I got a call. My health insurance did not approve the breast reduction because they wanted at least 600 grams removed. My plastic surgeon said that would be most of my breast. She told me that other types of insurance would approve for removing less tissue and would be happy to do it if I got a different insurance plan. I felt upset and defeated. This was something I wanted for a long time. However, it was helpful to know I was a good candidate for breast reduction and that my plastic surgeon would be open to exploring the option when and if I got a different insurance plan. I also kept in mind that at least I had tried; I also had received some answers and now knew that it was a possibility for the future.

In the summer of 2016, I got a job that offered the necessary insurance and went back to the plastic surgeon for another consultation appointment. She sent the paperwork in right away. My new insurance approved the procedure with a minimum of 450 grams to be removed. My plastic surgeon said she would remove that much from each breast. I would be left with a B cup and for me that was perfect—this was exactly what I wanted.

Politics, Feelings, and Motherhood

I am an anarchist. I see the state and capitalism as oppressive forces in people's lives. I do not feel that buying ethical products makes me a better person. I think that type of charity work is more of a Band-Aid and does not address the actual deep social issues affecting people. I think that the state oppresses people violently everyday (e.g., public assistance is state oppression). I think people should not have to purchase health insurance through companies or the state. My anarchism also believes that people should have autonomy to make their own

choices, without being harmful towards others. When I thought of my choice related to my breast reduction—that I was doing it for myself and that my choice would not harm others—I felt good about it.

I am a feminist. I have always taught my daughter to accept her body and to fight against social pressures for acceptable female body appearance. At the same time, I respect her choice to enjoy makeup, shave, and be more femme as her choice. She knew about my physical pain, so did my feminist friends—not only my physical pain but my emotional discomfort with my large breasts. My self-consciousness came along with not feeling like the person I was. I want people to be aware of how personal decisions can sometimes be made as a reflection of what society wants us to do or look like. So although I truly trust people to make their own decisions, I know that sometimes those personal decisions are tied into what society says. I took that into consideration with my decision, as well. I did not think my decision to reduce my breasts was in any way a reflection of what society wanted me to look like.

My feminist and anarchist politics had come up throughout this entire process; I had complicated feelings, and those feelings were amplified when I made my appointment. I often wondered about altering my body in such a drastic way and whether this was contradictory to my politics and what I had taught my daughter. I accepted that those feelings would be there, but I was also thoughtful in relation to those feelings, my politics, and my eating disorder recovery. Ultimately, I felt confident. After many years of trying to address physical pain and emotional conflicts, I wanted to do this. I was ready to do this.

Motherhood did make my breasts the way they were, and I needed to process my feelings related to that. My breasts did do a beautiful thing: they made milk for my child. Although I did not breastfeed, I did try, and my breasts still did make milk. When I was pregnant, they changed and grew and were prepared for me to take care of my child—they tried to provide my child with what she needed. As part of my decision, I also considered whether I wanted more children or not. I knew if I were going to have more children, I would want to breastfeed. Breastfeeding is usually possible after a reduction; however, it's not easy. That said, my daughter is in her late teens and I have spent my late teens, twenties, and thirties raising her as a single mother, and I am pretty set on not having any more children.

My breasts were active participants in my sex life, and I had many partners who enjoyed them; I often enjoyed them during sex, too. They provided my partners and me with pleasure. Some partners loved my breasts—the way they looked and felt. Some partners felt aroused by them, and were attracted to them.

My breasts sometimes acted as "body pockets," as I could put stuff between and under them when I went to shows or went camping, biking, and so on. They could act as a wallet, as I would often keep money, debit cards, and my ID between and under them. When I was playing guitar, I would keep extra guitar picks between them.

It was important for me not to hate my breasts, and I did not hate them. They provided positives in my life, but they also provided a source of physical pain and emotional frustration and stress. I felt that altering them by making them smaller would ultimately make me feel freer and happier as well as more comfortable with myself as a person.

The Breast Reduction Surgery

On a cold morning in December 2016, I checked into the Women and Infants Hospital in Providence, Rhode Island. A nurse called my name, and I was moved into the surgery prep area. An anesthesiologist came to review my history and went over the day's procedure and risks. My plastic surgeon arrived and drew a racquet-shaped pattern on my breasts to show where my nipples would be removed and replaced, and to help her determine where she should make incisions. I was given an IV with medication that would relax me, and I vaguely recall undergoing general anesthesia.

I woke up a few hours later in the same room, surrounded by medical staff. My throat hurt a lot from the endotracheal tube, and I was given more morphine. They went over aftercare instructions, which included staying home for two weeks, not lifting anything heavy for a few months, and setting up my postoperative appointment. They gave me a prescription for an intense painkiller, a stool softener (as painkillers tend to make people constipated), and 800-mg pills of Ibuprofen. They told me to wait a few days before showering and to change out my bandages every day. They also went over the postoperative breast reduction compression bras and gave me an extra one. I had to wear it around the clock for several months, even while sleeping.

(A photo of me in my compression bra the night after surgery)

Once I got home, my breasts were swollen, sore, and tender. I had to make sure I slept on my back, and I did not sleep well that night. I woke up several times with sharp pains where the incisions were, and I felt a lot of pressure. On the third day of recovery, I was feeling emotionally complicated. Even though this was something I had wanted to do for a long time, I was not able to bring myself to look at my breasts when I took my first shower. These emotions were very intense; I wanted to look at them to check on the healing, but I could not do it, nor could I look at myself naked in the mirror. Not yet, anyway. I had to get there little by little. I was also very nervous to have my partner look at my breasts.

For several months after my surgery, I did have episodes of pain where the incisions were. They got worse shortly before my period started, as my breasts swell slightly then. At each of my postoperative appointments, my plastic surgeon said that my breasts were healing great. At the time of writing this chapter, it has been a year and a half since the reduction, and my breasts feel amazing. Sometimes I forget that I had the surgery because they feel like they just fit so perfectly well with me, my body, and who I am as a person.

(My breasts a year and a half after surgery)

Final Thoughts

I felt it was important to discuss both my decision-making process and the actual procedure. My breasts changed so much after I had my daughter. Although my preoperative breasts made milk, provided me with pleasure, and acted as "body pockets," they also caused me physical pain and made me feel uncomfortable with who I was and am as a person.

I have struggled with an eating disorder most of my life. I went back and forth between bulimia and anorexia. Treatment provided me with the tools to eat better, work through the guilt related to food and eating, and process emotions and thoughts related to food and my body. It was important for me to work through this before I decided upon altering my body in the way I did. Because I was in a space where eating, food, and my body were not so dysfunctional and connected to guilt and hatred, I knew that my decision for a breast reduction was not tied up in body dysmorphia or my eating disorder. It was important for me to address all of these issues before I made the decision to go ahead with my breast reduction.

My politics of being an anarchist and a feminist were also tied up in this decision. Although I believe people have a right to do what they want to their bodies, sometimes those decisions are tied up in how

society thinks they should look. Finally, I do not regret this decision. I still have body image struggles, but I feel so much better about my breasts. I can say with confidence now that I love my breasts.

Works Cited

American Society of Plastic Surgeons. "2017 Plastic Surgery Statistics Report," *Plastic Surgery*, 2017, www.plasticsurgery.org/documents/ News/Statistics/2017/plastic-surgery-statistics-full-report-2017. pdf. Accessed Apr. 12 2018.

American Society of Plastic Surgeons. "Reduction Mammaplasty," 2017, Accessed Apr. 12 2018.

Kirwan, Laurence. "A Classification and Algorithm for Treatment of Breast Ptosis." *Aesthetic Surgery Journal*, vol. 22 no 4, 2002, pp. 355-63.

"Medicaid." *Medicaid*, 30 Sept. 2018, www.medicaid.gov/medicaid/ index.html. Accessed Apr. 12 2018.

A Comparative Analysis of Breast Reconstruction Postmastectomy: German and American Perspectives

Alina Engelman

My mother, a dual German and American citizen who had breast cancer and a unilateral mastectomy, faced the decision of whether or not to have postoperative breast reconstruction. Her experience highlights a divide between German and American breast reconstruction practices as well as related differences in national attitudes regarding breasts and the female body. In making her decision, as indicated in an intimate interview I conducted with her, she straddled two divergent national cultures.

My mother came to the United States (U.S) in 1971 at the age of twenty-six, after completing the equivalent of a master of arts degree in psychology from the University of Munich in Germany. She received her PhD from SUNY Stony Brook in 1974 and had two children. After working as a clinical psychologist in New York for thirty-nine years, she retired in 2012. Soon after her retirement, she was diagnosed with breast cancer.

Breast Reconstruction after a Mastectomy in the United States and Germany

It is noteworthy that mastectomy rates in Germany—as well as in Switzerland, Belgium, Austria, and Italy—are lower than those reported in the U.S. Furthermore, there was a decrease in mastectomy rates in those countries from 2005 to 2010 (Garcia-Etienne et al.). Disparities also exist regarding breast reconstruction between the U.S. and Germany. Every year in Germany, only 27 percent of the seventy-five thousand women newly diagnosed with breast cancer undergo mastectomies. Of this group of eight thousand, approximately one third of women (2,670) choose ipsilateral breast reconstruction (Gerber).

By contrast, in the U.S., of the 230,000 new cases of breast cancer every year, approximately 100,000 breast reconstructions (43 percent) are performed annually (Gerber). An analysis of patient data in the U.S. shows breast reconstruction followed 40 percent of breast removal surgeries in 2014, a marked increase from less than one quarter in 2009. Among all age groups, women in my mother's age range (aged sixty-five and older) accounted for the largest increase in breast reconstructive surgery—140 per cent. A dramatic rise in reconstruction surgeries also occurred among women without insurance, data from twenty-two states revealed, which indicates a willingness for American women to pay for reconstruction out of pocket. Most of the growth in reconstructive procedures occurred in hospital-based outpatient surgical centres (a 150 percent increase), much like the one my mother frequented (Miller). My mother subsequently speculated whether this large increase in breast reconstruction among older women is related to a growing bias in favour of reconstruction in the oncology profession and a lack of information about risk factors. As a result, women may be given the impression that breast reconstruction is an inherent part of the surgery.

According to an interview with my mother in September 2018, she faced a dilemma:

At age sixty-six, I was diagnosed with early stage unilateral breast cancer. I got a mastectomy of one breast in 2012. Prior to surgery, the breast surgeon recommended breast reconstruction and made a referral to a plastic surgeon. She indicated that a decision to go ahead with breast reconstruction should be made

prior to surgery, since it would alter the surgical procedure. The surgeon was vague in response to questions about the length and nature of the procedure, and advised that I question the plastic surgeon about details. The surgeon did not mention any risk factors and seemed to assume that I would want to have breast reconstruction. The possibility of not having breast reconstruction was not mentioned. Breast construction was presented as part of the normal course of treatment.

My mother never received any detailed information about the risks and benefits of reconstruction from her breast surgeon or medical providers in the U.S. By contrast, the German Law on Patient Rights states that each and every patient must be given timely, detailed, comprehensive information on all breast reconstruction procedures, expected outcomes, risks, and alternatives. This law also includes the offer of a second opinion and information on surgical procedures that are not offered in the physician's own hospital (Gerber). In our interview, my mother explained her decision-making process:

> Following the consultation, I started questioning whether to have breast reconstruction concurrently with chemotherapy. My doubts were reinforced when I called my cousin in Germany. She advised caution in going ahead with this procedure. She told me about a friend who had had problems with her implant and had recently had the implant removed. I learned from her that the implants have a limited lifespan, requiring replacement. Most important, she noted that many women in Germany decline to have breast reconstruction. Subsequently, I searched the Internet and was surprised and disturbed to find many testimonies of women who had had serious complications with the implants, including failed procedures and implant ruptures.

Though initially compliant with the idea of reconstruction, she ultimately decided against it and found that "the surgeon and the nurse practitioner were surprised, if not shocked, by my decision." After all, her breast surgeon had matter-of-factly said that after the mastectomy, her breast would of course be reconstructed—and had referred her immediately to a plastic surgeon. Looking back, my mother wondered why the breast surgeon assumed that she would want reconstruction.

Why would she want to suffer during breast cancer treatment by stretching the skin of the breast and enduring repeated surgical treatments? She later learned that far from being a simple procedure, it was much more extensive than her breast surgeon had indicated. She began to have doubts upon learning that it would be a nine-month process of repeated visits. Prompted by her phone calls to Germany, my mother meticulously researched the literature, which revealed that reconstruction was an involved process with multiple procedures that would extend her recovery time. What was the point of these extra visits and procedures that would prolong her recovery?

My mother's choice became clear. Why would you willingly insert silicone that could leak toxins or burst? Why would you want an extra foreign body or appendage? It was perfectly fine to stay natural and have a padded bra and swimsuits, fitted to specifications. The lobby inside the main entrance to the NYU Langone Perlmutter Cancer Center in Manhattan had a store with wigs, scarves, and, yes, custom-made bras and swimsuits. My mother elaborated: "At that point, I was comfortable declining the procedure, which my husband fully supported. I do not regret this decision; to the contrary, I am very happy I did not go along with the original recommendation of the surgeon. I am very comfortable with the silicone breast prosthesis inserted into a special bra or bathing suit."

Hence, although my mother was initially open to the idea of reconstruction, after consulting with relatives in Germany and searching the Internet, she ultimately came to question the American approach to reconstruction.

Factors Contributing to Disparities in German and American Practices

In Germany, breast reconstruction is not common, and, furthermore, it is perceived as a choice rather than a necessity, as framed by the American medical industrial complex and insurance system. A U.S. population-based study found that almost half of surgeons (44 per cent) referred women to plastic surgery prior to the mastectomy. High-referral surgeons were more likely to be women, to have a high clinical breast surgery volume, and to work in cancer centres, which fits the exact profile and conditions under which my mother was referred for

reconstructive surgery (Alderman et al.).

It came as no surprise that when my mother was diagnosed with breast cancer, she perceived the loss of her breast differently from some other Americans. In contrast to such conservative American tendencies surrounding the female body, my mother also noted that, upon her arrival in the U.S. in 1971, "I was struck by the obsession of many American men with breasts, especially large breasts, which I had never encountered in Germany." The implications of these two polarities concerning female nakedness are useful to consider in analyzing the attitudes of the American medical field towards breast reconstruction. The American breast fetish has been an important part of American culture, reflected in myriad ways, from the history of the Miss America pageant to Playboy magazine. This phenomenon has drawn the attention of American social scientists and feminists (Morrison and Holden). The great American obsession with the female breast is surely a factor in the higher incidence of breast reconstruction in the U.S. compared to Germany.

The modern American breast fetish has been noted by American and European scholars. It emerged and intensified following the flat boyish look of women in the flapper age of the 1920s. Breasts became uniquely American "objects of erotic awe, potency, and significance" (Morrison and Holden 5). This was reflected in women's fashions that highlighted breasts. Young girls were outfitted with training and padded bras. The fetish was reinforced by television programs and Hollywood films. Indeed, even Hollywood sex symbol Raquel Welch has lamented "an unfortunate obsession in this country with the mammary glands ... as an isolated symbol of sex" (qtd. in Morrison and Holden 6). The call for bra burning during the second-wave feminist movement of the 1970s targeted the breast fetish as a key component of sexism. However, recent statistics regarding American—as opposed to European—breast reconstruction suggest that uniquely American preoccupation with breasts persists.

At the same time, a puritanical attitude towards the female body in the U.S. is also at play. In general, a distinctly German openness towards the female body stands in marked contrast to what can seem like a deeply American, puritanical conception of womanhood and female sexuality, which, at times, seems rooted in the Victorian era. At five, I embodied this American attitude perfectly while exploring the beach on the Baltic

Sea in Travemünde, Germany with my extended family. It was a common sight to see other kids running around naked and their mothers topless. So my own mother pointed out that there was no need for the purple bikini top I had on—just look at the other kids, she said with an amused smile. Yet this quintessentially American conception of modesty had already taken hold in me and I refused. I insisted on covering up and wearing my two-piece bathing suit. My mother laughed, shaking her head nonchalantly. Her comfort with nudity conflicted with my sense of propriety. On hot, sweltering Brooklyn summers thereafter (sans air conditioning), my mother would comfortably walk around in our house in her underwear and a tank top or bra—her comfort with nudity stood in marked contrast to my sense of propriety. My reaction as an American suggests to me that Germans are more accepting of the female body, its beauty, and its imperfections—and, hence, less apt to seek breast reconstruction after a mastectomy.

Americans are beginning to become more aware of the complications associated with reconstructive breast surgery. There is beginning to be an increased awareness of and questioning of the risks of breast reconstruction in the U.S., although Peter Cordeiro, a reconstructive surgeon and breast researcher, has made a clinical recommendation in support of breast reconstruction: "It is now clear that silicone and breast implants are not linked to cancer, immunologic or neurologic disorders, or any other systemic disease" (Cordeiro 1590). However, after reading Dr. Cordeiro's article, cancer researcher Frank Vasey wrote a letter of rebuttal:

> Sanchez-Guerrero et al. found significant morning stiffness as a sign of immune activation, Karlson et al. described significant [immunologic abnormalities from silicone breast implants including] antibodies to single-stranded DNA, and Gaubitz et al. found significant antinuclear-antibody positivity and neuropathy. Arthralgias, tingling, myalgias, and fatigue occurred in fifty to seventy-five percent of these patients.... Rohrich et al. found that implant removal stabilizes and ultimately improves these symptoms. Plastic surgeons and rheumatologists need to get together to define the syndrome, study the influence of implant removal, and establish a health assessment-like questionnaire that plastic surgeons could use to counsel patients. (490)

Furthermore, both the Federal Drug Administration and the World Health Organization have reported breast implant-associated anaplastic large-cell lymphoma, a malignancy that can be fatal (Bennett et al.). A 2018 study found one in three women undergoing breast reconstruction had complications, including more surgery (one in five) or failed reconstructions (5 per cent) (Bennett et al.).

In light of these complications, Barbara Sharf's writing in "Out of the Closet and Into the Legislature: Breast Cancer Stories" underscores the need for shared biographies:

> Audre Lorde wonders in *The Cancer Journals*, "What would happen if an army of one-breasted women descended upon Congress?" Lorde presaged the notion that women with breast cancer can join together to influence the policy-making process. She alerted us to the idea that shared biographies are integral to advocacy, and advocacy can alter policy. (213)

Policymakers and practitioners in the U.S. need to reevaluate the promotion of breast reconstruction after mastectomy as a way for women to feel whole again, and it is in this spirit that I share my mother's story. Her experience in the United States is suggestive of how cultural factors as well as medical considerations have been critical for women's decision making in regard to postmastectomy breast reconstruction. However, disparities between the percentage of women in Germany and the U.S. who opt for reconstruction may decrease in the future given increasing attention in the American press about complications associated with the procedure—a possible trend worth monitoring. And such a trend is illustrated by the shift in coverage over thirty years in the *New York Times*, which ran the headline "Advances in Breast Reconstruction Ease the Trauma of Cancer" in 1988 but warned in a headline from 2018 that "One in Three Women Undergoing Breast Reconstruction Have Complications."

Works Cited

Alderman, Amy K., et al. "Correlates of Referral Practices of General Surgeons to Plastic Surgeons for Mastectomy Reconstruction." *Cancer*, vol. 109, no. 9, 2007, pp. 1715-20.

Bennett, Katelyn G., et al. "Comparison of 2-year Complication Rates among Common Techniques for Postmastectomy Breast Reconstruction." *JAMA Surgery*, vol. 153, no. 10, 2018, pp. 901-8.

Cordeiro, Peter G. "Breast Reconstruction after Surgery for Breast Cancer." *New England Journal of Medicine*, vol. 359, no. 15, 2008, pp. 1590-1601.

Garcia-Etienne, Carlos A., et al. "Mastectomy Trends for Early-Stage Breast Cancer: A Report from the EUSOMA Multi-institutional European database." *European Journal of Cancer*, vol. 48, no. 13, 2012, pp. 1947-56.

Gaubitz, M., et al. "Silicone Breast Implants: Correlation between Implant Ruptures, Magnetic Resonance Spectroscopically Estimated Silicone Presence in the Liver, Antibody Status and Clinical Symptoms." *Rheumatology*, vol. 41, no. 2, 2002, pp. 129-35.

Gerber, Bernd, et al. "Breast Reconstruction Following Cancer Treatment." *Deutsches Ärzteblatt International*, vol. 112, no. 35-36, 2015, p. 593.

Karlson, Elizabeth W., et al. "Association of Silicone Breast Implants With Immunologic Abnormalities: A Prospective Study." *American Journal of Medicine*. vol. 106, no. 1, 1999, pp. 11-19.

Kolata, Gina. "Advances in Breast Reconstruction Ease the Trauma of Cancer." *The New York Times*, 21 Jan. 1988, www.nytimes.com/1988/01/21/us/advances-in-breast-reconstruction-ease-the-trauma-of-cancer.html. Accessed 6 Feb. 2020.

Miller, A. M., et al. "Breast Reconstruction Surgery for Mastectomy in Hospital Inpatient and Ambulatory Settings, 2009–2014: Statistical Brief# 228." *NCBI*, 2006, www.ncbi.nlm.nih.gov/books/NBK481368/. Accessed 6 Feb. 2020.

Morrison, D. E., and C. P Holden. "The Burning Bra: The American Breast Fetish and Women's Liberation." *Deviance and Change*, edited by P. K. Manning, Prentice Hall, 1971, pp. 3-21.

Rabin, Roni Caryn. "One in Three Women Undergoing Breast Reconstruction Have Complications." *The New York Times*, 20 June 2018, www.nytimes.com/2018/06/20/well/one-in-three-women-undergoing-breast-reconstruction-have-complications.html. Accessed 6 Feb. 2020.

Rohrich, Rod J., et al. "A Prospective Analysis of Patients Undergoing Silicone Breast Implant Explantation." *Plastic and Reconstructive Surgery*, vol. 105, no. 7, 2000, pp. 2529-37.

Sanchez-Guerrero, Jorge. "Silicone Breast Implants and the Risk of Connective Tissue Diseases and Symptoms, 332." *New England Journal of Medicine*, vol. 332, no 25, 1995, p. 1666.

Sharf, Barbara F. "Out of the Closet and into the Legislature: Breast Cancer stories." *Health Affairs*, vol. 20, no. 1, 2001, pp. 213-18.

Trier-Engelman, Christine Synnöve. Personal interview, 4 Sept. 2018.

Vasey, Frank. "Comment on Breast Reconstruction after Surgery for Breast Cancer." *New England Journal of Medicine*, vol. 360, no. 4, 2009, pp. 419-20.

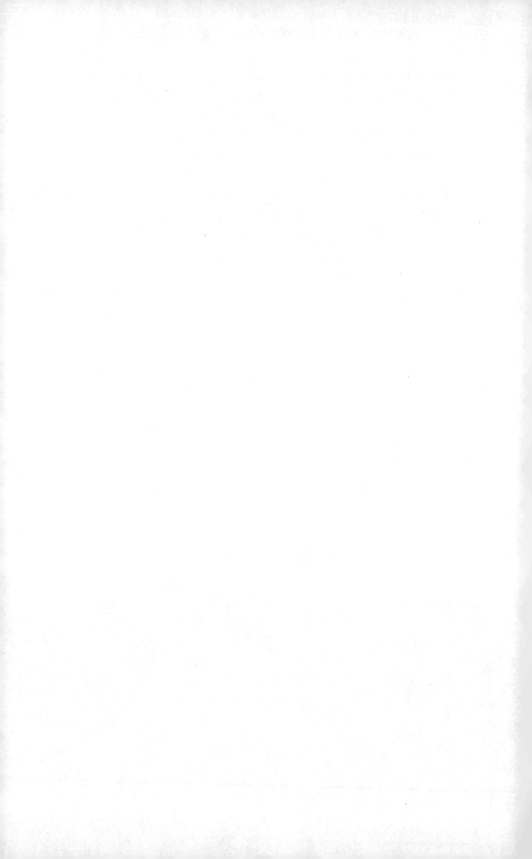

Unsent Letters: 1992–2020

Catalina Florina Florescu

To M, who imagines grandma
To my sister, with whom we continue our mother

Any Day

*D**ear Mom, two summers ago when I visited my friends in Romania, we were talking about next year's twenty-fifth high school reunion. My mind started to drift because I never told you what happened after October 27, 1992. I graduated high school. I stayed at home a year. I went to college. I married. I came to the States. I earned my PhD. I became an author, and I became a mother. I have been writing to you with words, sounds, and longings. I have been doing this uninterruptedly. I told M, my son, about you. I taught my students about (your) breast cancer. I published books and articles and spoke about cancer, and I don't think I will ever stop.*

When my mother was diagnosed with breast cancer, she did not tell me immediately. I was young, my body was developing, and she kept quiet. I have revisited her silenced pain many times so that I can feel her. She was forty-three when she was diagnosed. It was shortly after the end of communism in Romania when too many things were taboo, like talking about femininity, about what makes a woman a woman, and about pain and its undiluted ways to wreck a body. When I found out about her cancer, we were not home. I was with my mother in Bucharest because she had chemotherapy sessions. I was with her—not my older sister, not my father, not my grandmother. Maybe she took me

because I was the youngest. When she said she had cancer, the word did not register. Even when I waited for her to end her chemo session and I heard her moan discreetly, the word "cancer" did not sink in. I never told her that. My silence was different than hers; my silence was denial because I could not think of losing her. We returned to our town, Tulcea, and resumed our daily lives. Mother did not complete her chemotherapy (I think) because her body was too sick (in part) because of the treatment or, maybe, because she opted to decline a mastectomy.

One year later, I was, once again, the only one accompanying Mother on a trip that would be our last. It was a lovely mountain resort in Sinaia. Mother took me to an art gallery, and despite being in accelerated physical decline (inside her body, the cancer was spreading and metastatic), she was so radiant and beautiful. She masked what was happening inside; she was so gracious that she suspended cancer. Mother never cried in front of me.

> *Mom, after you died, my sister found a cassette with your voice. You were reciting poems. Your voice was breaking. Cancer was a fully-fledged reality. When you recorded yourself, you were heartbroken, aware of death, and devastated to leave us behind. After your death, cancer was a presence that I had to confront so I would get closure. Although now that I am aging and can spell out truths more easily, I didn't exactly need closure. I wanted to learn. I wanted to educate myself because I am a woman and cannot afford to be silenced.*

First Stop: Chernobyl

The accident at the nuclear plant located in Pripyat, in the former Soviet Union (present day Ukraine), had an exact date—April 25 and 26 1986. However, living under the increasingly harsh regime of Nicolae Ceauşescu in communist Romania, we did not hear about it immediately. The Romanian news agency, AGERPRES, finally related the news a few days after it had happened, assuring the population that there were no immediate consequences for our territory. After another week, communities of certain regions were advised to be cautious about consuming fruit, vegetables, and water. No doctor visits were recommended.

Years after Chernobyl, Romania authorities revealed that there was an increase in the number of cancer cases, although most were reported in Ukraine and Belarus. Although it is impossible to accurately measure the radiation's effects, I often overheard my parents talking with doctors, and, afterwards, intimately with each other about blaming my mother's cancer on Chernobyl. In retrospect, could we ever have avoided such a disaster?

Bleeding

One afternoon, the phone rang. It was one of my mother's co-workers, asking if my sister and I could stop by her workplace with a pair of underwear. I did not know what had happened, and since I was reassured that she was okay, I did not suspect anything. I was not taught to ask questions because education in communist Romania meant indoctrination. Later, I found out that Mother was bleeding after undergoing an abortion. Since abortion was illegal, nobody said a word. The co-worker had to make the call sound casual, "an accident," but Mother was in pain. Her intimacy was violated. Women died while undergoing nonsanitized abortion procedures, which were conducted in unsafe, secretive ways.

> *Mom, with you gone and my life in shatters, I realized that the puzzle I had to (re)assemble was bigger than I had anticipated. It was not only about cancer, poor treatments, lack of support groups, or the feelings of shame that people with an illness have and the resulting isolation such shame inflicts, it was also about being misinformed (i.e., Chernobyl), being disallowed to have control over one's body when it comes to having or not having a child— keeping or not keeping a breast, having or not having breast reconstruction surgery—and above all living in constant terror while paradoxically being free: the unbearable weight of silence during communism.*

It is morally necessary to inform you that women in communist Romania had dual roles: productive and reproductive. In order to have a prosperous society Gheorghe Gheorghiu-Dej, the first Romanian communist leader, and his successor, Ceaușescu, put great emphasis on increasing the number of women in the workforce. Encouraging women to work while also expecting them to maintain households and

imposing an accelerated natal rate created a national fiasco. During one of his many invasive and equally misinformed speeches, Ceaușescu stated the following: "The highest honor for women is to give birth, to give life, and raise children. There can be no dearer thing for a woman than being a mother." As he gained more powerful and eventually became a dictator, he increased his insane control over women's bodies.

Communist women were emotionally mutilated. They had neither personal nor collective agency. They were designed to be superwomen, theoretically speaking, capable of workplace productivity and household maintenance. As Barbara Einhorn argues,

> For working mothers, harassed, struggling to fulfill the tasks at work, take children to school or kindergarten and to make purchases on the way home, to cook, to clean, to wash, to help children with homework and take them to bed, to make notes for session topics for the day or during the qualification to which they were entered, super-woman was not only an insult but a joke. (19)

My mother had a great support from her own mother who lived with us. But life in a small town like Tulcea eventually took a toll on her. Always a dreamer, she retreated inside her own imagination. Her administrative work was limiting, so she imagined herself outside of what Tulcea could offer.

Headaches and Surgeries

Mother had severe migraines and often stayed in bed with the blinds down. Although migraines are common, hers were much more intense. She was consumed with not having a fulfilling career, and though not confirmed, she must have suffered from depression. But, again, everything was kept quiet. Life went on. I have inherited my mother's migraines, but I love what I do (i.e., teach and write), and I am not clinically depressed. My then theories about the etiology of Mother's cancer—which were not mine exclusively but were influenced by what I was hearing in my household—did not check out. Still, there is a huge difference between getting as much information as possible, even those hard to believe scenarios, versus assuming an illness is, irrefutably, the cause of a patient's lifestyle.

As a child, Mother had her tonsils, appendix, and polyps removed, and if I am not betrayed by memory, these were done because her father had requested them, not because of any medical necessity. When Mother was advised to have her cancerous right breast and underarm lymph nodes removed, she refused. She could not accept losing a breast. In her bedroom, she had a painting (which she had had for years, long before the diagnosis) featuring a voluptuous and full nude woman by the seashore, *Nud pe malul mării* (1962) by Nicolae Grigorescu. Mother associated the painted woman's body with perfection, and she loved it. Even with an indentation on her cancerous breast, which my sister washed and patched, she still refused surgery. The last medical intervention that she had was her abortion. I could be wrong, but I think she did not want to allow another invasion, which is unfortunate, since cancer did invade her body and later metastasized. Mother grew up in a patriarchal culture that assumed a woman had two breasts, and, therefore, losing one or both would be shameful.

Dear Mom, I have always tried to make peace with your decision. I am actually sorry because I was not strong enough and, even more importantly, educated accurately, so that I would tell you to go and have the breast removed. I am also sorry for speculating that if you had surgery, you would have lived to see me grow old. I have learned about the highly insidious ways in which cancer operates. I have learned that cancer is never singular; it's a complex of illnesses. I have learned cancer varies from person to person, so it is difficult to find a cure that works for everyone. However, the greatest lesson I ultimately learned is that through education and self-empowerment, one can claim one's own embodiment.

Artists and Writers as Support and Inspiration

With Mother gone, I wanted to read and educate myself. Over the years, I have gained support from words and art, mostly authored by women who have gone through cancer or have witnessed the pain of their dear ones. These works have enabled me to heal and have inspired my own creative and academic works.

Lorde

Writer Audre Lorde, who was diagnosed with breast cancer in the late 1970s, promoted a view of femininity that did not include two breasts. At the time of her diagnosis, Lorde discovered that prostheses were immediately recommended, and literature devoted to other options was practically nonexistent. As she admits, "To imply to a woman that yes, she can be the 'same' as before surgery, with the skillful application of a little puff of lambswool, and/or silicone gel, is to place an emphasis upon prosthesis which encourages her not to deal with herself as physically and emotionally real, even though altered and traumatized" (89). In addition, she writes the following: "Artificial limbs perform specific tasks, allowing us to manipulate or to walk. Dentures allow us to chew our food. Only false breasts are designed for appearance only" (63). Personally, it was a sad thing for me to discover that women in the United States had been addressing this for decades, whereas back in Romania, when Mother was diagnosed, only the traditional procedure of reconstruction after a mastectomy was recommended. Lorde was a great discovery because I realized how poorly informed many societies were and how little they valued patients' direct input. Something had to change to open up an honest discussion about breast cancer from the patient's point of view—a dialogue empowering women and their caregivers.

Spence

When British artist Jo Spence was diagnosed with cancer in the late 1980s, she was fully aware that words, photographs, and other media could accurately testify to the body in pain. Spence exposed her partially or fully nude body, thus revealing the raw impact of breast cancer. Naming her project *Narratives of Dis-ease: Ritualized Procedures* (1989), she voiced it as a manifesto:

> In these photographs is the beginning of a "subject" language, one which allows me to start the painful process of expressing my own feelings and perceptions, of challenging the "ugliness" of being seen as Other. In so doing, I cease to be a victim, becoming again an active participant in life ... If I don't find a language to express and share my subjectivity, I am in danger of forgetting what I already know. (135)

Throughout her works, Spence asserts that just as there are sanitized photographs, there are also sanitized discourses that can profoundly harm a person, and, by extension, a society. By refusing to have a mastectomy, Spence undermines not only the socio-political discourses of women with breast cancer, but she also shows that medicine is not ready to embrace and/or combine other methods of treatment. As she admits, "I do not think I have been so lonely in my entire life as I was after I'd refused traditional allopathic treatment for breast cancer—the mastectomy and radiotherapy" (198).

> *Mom, you covered your body when you were diagnosed with breast cancer. I am not sure how you'd react to Spence's nude photos; if you were to see them, maybe you would discover a sense of liberty and maybe you would like to be just as free as she was. In one photo, Spence writes on the cancerous breast "Property of Jo Spence." In another, which is collage-like, she raises a question to which I have often returned, "How do I begin to take responsibility for my body?" Probably one of the most cathartic pieces is when the photographer wears half a mask and holds a sign that reads "Victim?" Her naked body is exposed, and her cancerous breast is taped with bandages forming the letter X, a double entendre. Mother, powerful photos like these made me bold and assertive. I had to crush my silence, which in part echoed yours.*

Sontag

Another bold and unapologetic woman, Susan Sontag, noticed that the iconography of pain was not new: "The sufferings most often deemed worthy of representation are those understood to be the product of wrath, divine or human. (Suffering from natural causes, such as illness or childbirth, is scantily represented in the history of art; that caused by accident, virtually not at all—as if there were no such thing as suffering by inadvertence or misadventure)" (40). Sontag makes us aware that not all types of pain are being considered—some are ignored and/or silenced. Cancer is an accident happening in the body. We do talk about it but not always openly; we do not have the right tools with which to communicate. Katherine Young notes the following: "Storytelling is exceedingly rare on any medical occasion.... Patients produce

'replays' that do not achieve the status of fully-fledged narratives, stories that do not come to an end. In replays, there are no beginnings and ends, only ongoing events. So events do not appear to take a direction" (69-70).

> Mom, there is more than diagnosing someone and prescribing a treatment. I have learned that storytelling is palliative and that the humanities can alleviate one's pain. Intuitively, you knew. But that's not enough. To this day, many people become disoriented in a doctor's office and often feel they have just flunked an important exam; people discover being practically illiterate when it comes to their own bodies and their signs, symptoms, and functions. Those are the moments when people realize that while still in their body, they feel somewhat exiled. After you died, if anything hurt me, I said to myself that absolutely nothing could equal your pain. In part, I was right. But when I realized that I was repeating your silence, I decided to break the cycle of being forced to feel humiliated. Pain does not humiliate. Refusing to talk about it harms us infinitely.

Didion

> Mom, I have finished my first book. I am a mother. I look through my son's eyes, and I see you. Some days. Some fragmented hours. There are moments when I feel angry at having lost you too early, and this anger is new. I did not feel it when you died or when I finished high school or when I went to college or even when I got married. This anger came like an avalanche when I become a mother. Luckily, I refuse to dwell on the past. I'd rather learn and answer some questions, and if you were with me, however ironically, I'd tell you about a woman who taught me how to suffer in the wake of the pain of losing a loved one. Because when you died, I knew nothing. Who tells children how to live when their parents die?! Whose responsibility is that?

Joan Didion came in my life as a miraculous gift; the amount of loss this woman experienced and how she dealt with it reminded me of my grandmother. In her 2005 *The Year of Magical Thinking*, Didion negotiates her emotions after her husband's death:

I myself felt invisible for a period of time, incorporeal. I seemed to have crossed one of those legendary rivers that divide the living from the dead, entered a place in which I could be seen only by those who were themselves recently bereaved. I understood for the first time the power in the image of the rivers, the Styx, the Lethe, the cloaked ferryman with his pole. I understood for the first time the meaning in the practice of suttee. Widows did not throw themselves on the burning raft out of grief. The burning raft was instead an accurate representation of the place to which their grief (not their families, not the community, not custom, their grief) had taken them. (27)

No one can predict how one may feel when losing someone. Like Didion, I could not accept ignorance and deny myself access to information. I needed to learn, read, and become educated because knowledge is power and liberation at the same time. True, knowledge is not a panacea, but it is, nonetheless, a powerful tool to destroy malignant ignorance.

Cullar-Ledford

A "flat sister," as women who refuse reconstruction call one another, is American artist Thedra Cullar-Ledford. In conversation, Cullar-Ledford told me that she works with dolls because they do not have nipples; cancer, in its insidious ways, manages to sneak into nipples. Looking at one of her collages closely, we can see that scars have replaced the breasts, which are now gone. The bright-red, blood-like mass is placed front and centre. The piece says that we all have blood on our hands if we keep quiet and if we force breast cancer patients into expensive postmastectomy plastic surgeries. This is not a doll's silenced moment; instead, the central red is smeared on us. The artwork intimately connects women, as most of us have been in this kitchen, and some of us have experienced breast agony in this domestic space.

Figure 1: Thedra Cullar-Ledford, *Kitchen Eyelet* (2016). (Reproduced with permission from the artist)

Figure 2: Thedra Cullar-Ledford, *Untitled* (2018). (Reproduced with permission from the artist)

In another Cullar-Ledford piece, Figure 2 above, a woman's torso shows one breast and one very visible scar; it is inescapable. With this piece, Cullar-Ledford exposes how vulnerable women are and how beautiful they remain despite the pain. We talk about cancer victories, but when are we going to talk about what pains us? And when are we going to accept that cancer is not our fault?

Mia

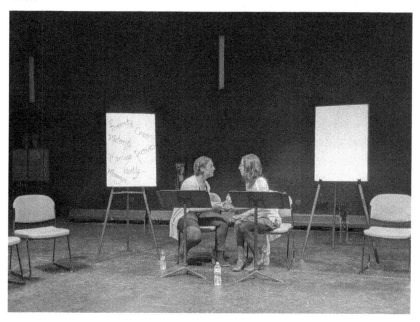

Figure 3: *Mia*, stage reading directed by Handan Ozbilgin, 2019, New York (personal archive)

In 2011, I published *Transacting Sites of the Liminal Bodily Spaces*, a book about people dealing with their new embodied statuses related to serious, long, and harsh medical treatments. I also presented at conferences and wrote short stories, yet something was still missing. *Mia* came naturally out of me. In part, she is me. In part, she is my mother. Still, she is an autonomous character in a play. She is fictional; however, in creating her, I have liberated myself from the too strict and sometimes rigid academic language we use when we cannot verbalize our pain. Luckily, dramatic writing is fundamentally cathartic.

Mom, I remember one night towards the end of your life. I remember I was praying. I will never forget what I was saying to whoever wanted to listen to me: "God, if you listen, don't let my mother die. I am willing to give her my healthy breast, but please just don't let her die." I did not know then that my sacrificial thought would actually mean so much to me as a woman and an educator. Breasts serve a purpose, but they do not define a woman's body. Mom, you did not want to hear about surgery, about flattening your chest partly, or about disfiguring your body. I was not strong enough, educated enough, and opinionated enough to convince you otherwise. I created this character in your honor and also because I wanted to empower other women to think they have an option and that surgery is not going to ruin their bodies.

In my play, Mia is in her late thirties and struggles to accept her new reality: she has lost one breast to cancer. When we meet her, two years have passed since the procedure, and she has still not had reconstruction. Mia is, thus, negotiating her new embodiment. In a conversation with her husband, she reveals that she would like to take her insides out because she feels betrayed. The more time passes, the more consumed she is because she faces yet another drama: she cannot become a mother. After another visit to the doctor when she thought she was finally pregnant (but is not), she decides to reinvent herself and cuts her past from her life. She gets a tattoo on the removed breast with the inscription that reads "Dignity."

Mother, every single time when I teach this play, I keep seeing you. I could not save you, so I wrote this to help other women and to help other children's mothers. I wrote this because I have a son, and I want him to know that it's okay to cry and suffer and that gender has nothing to do with how people should express their pain. My character could not end with a breast and that ordinary scar post mastectomy. I had to free Mia, and in doing so, I have finally freed myself of all the frustrations kept inside me since you died.

Mother Doll

Figure 4: *Mother* (Personal archives), ca. 1949.

When Mother was dying, she kept asking my sister and me to play Queen's iconic melody "The Show Must Go On" and to translate its lyrics. While sad, the lyrics are nonetheless soothing. If the show must go on, then I will not stop either, despite forever longing for her embrace. Love does not end and that makes me keep pursuing vital knowledge. I will educate myself and others until I know that women are listened to and that their choices are theirs exclusively.

> *Mom, I hold a photo with you. I think you were two years old. You hold a doll in your hands. Of all your photos, this is the one that makes me smile and cry at the same time. We say that time heals; I never accepted that expression. But now I see how plastic time is. You are younger than me in this photo. You look like my child. I like this illusion. I am mothering you, and because of that, I have switched from the love of a daughter to the love of a mother. Mamă, te iubesc. Pe curând.[1]*

Endnotes

1. Romanian for "Mom, I love you. See you soon."

Works Cited

Ceauşescu, Nicoale. "Discursul lui Nicolae Ceauşescu la sedintţa plen-ară a Comitetului Central al Partidului Comunist Român." *Iunie*, 1973, archive.li/26tMu. Accessed 5 Feb. 2020.

Didion, Joan. *The Year of Magical Thinking.* Alfred A. Knopf, 2011.

Einhorn, Barbara. *Cinderella Goes to Market: Citizenship, Gender and Women's Movements in East Central Europe.* Verso Publishing, 1993.

Florescu, Catalina Florina. *Transacting Sites of the Liminal Bodily Spaces.* London: Cambridge Scholars Publishing, 2011.

Lorde, Audre. *The Cancer Journals.* Spinsters Ink, 1980.

Sontag, Susan. *Regarding the Pain of Others.* Picador, 2004.

Spence, Jo. *Cultural Sniping: The Art of Transgression.* Routledge, 1995.

Young, Katherine. *Presence in the Flesh: The Body in Medicine.* Harvard University Press, 1996.

Chapter Eighteen

Future Breasts, Future Selves: Midlife Women's Thoughts

Rosann Edwards and Patricia Drew

T he chapters in this volume reveal that breasts are an organizing feature of mothers' lives. Sociocultural breast messages help shape women's self-concepts and social identities, and also structure women's body choices. In their journeys, the featured mothers have grappled with constricted agency, health concerns, modesty, pain, censure, and sensuality. As mothers look to the future, they often anticipate new thoughts and concerns. To conclude this book, we end with the voices of midlife women who share their perspectives on their future, imagined breasts:

> When I think about my breasts aging, I have to remind myself that they're not as old as I am. I didn't get them until I was fourteen or fifteen. So one thing that I keep reminding myself is they're younger than me, and thank goodness. Because as I'm approaching fifty, I do think about how my body is going to age and how that plays into my sense of vanity in ways that may be normal. But the thought of aging makes me feel kind of self-conscious. And why would I worry about such a thing? As we get older, we want to still be beautiful. We want to still be desirable. We want to still be seen. And this is just a part of all of that.
>
> —Rachel, forty-nine

I think that they will be more like I've always remembered my mom's breasts. And she's big breasted, and they're just long. Like they're long! They have length to them. They were always a place of comfort and warmth and softness. And in a bra, they made a shelf, and that was so lovely, and I would lay my head on her chest.

—Genevieve, fifty-one

I am feeling very thankful to have both breasts after going through cancer treatment and potentially being down to one. I was very interested in retaining as much of me as I could, and the doctors were able to do that. I kind of have a mix of feelings: I'm glad they're there. I'm happy with them, though sometimes I look at the left one and I'm mad at her. She betrayed me. After feeding two babies and doing all that stuff, she turned around and bit me in the butt. Yet she's still there. She looks mostly like me. There's some scar tissue, but, you know, I have never been particularly vain or concerned about the physical appearance of them. They're not super large, so they don't sag a ton. I expect that will change; there will be some sagginess; there will be smaller-ness. But they will be still there and still part of me.

—Betsy, forty-four

When I think of myself at eighty, I want to be alive. I assume my original breasts will be long gone, replaced by saline or silicone. Perky inserts under wrinkled skin; testament to some battle that I won. But if my actual, fleshy breasts are still there, I think they will be a comfort. My breasts, along with my aged arms and heart, will be tired but content from decades of holding my beloved family close. I will feel lucky.

—Liz, forty-three

I hope that they will continue to give me great pleasure, which is perhaps something that I would continue to look forward to in my life because I think pleasure there started for me mostly after having my baby because I had flat nipples, and there was a lot of pain associated with breastfeeding. And now they're not flat nipples anymore. And so there's just more to play with and in a

more pleasing way. So, I also hope that I will continue to get pleasure from them because I feel like I have some lost time to make up.

—Shauna, forty-eight

I see grandma boobs—tough, still fighting, still living. Definitely grandma boobs—boobs that still love their Docs and plaid shirts, boobs that cuddle and spoil young children on cold snowy nights and hang out in a bikini (with no apologies) at the lake on hot summer days. I should point out that I've never been big busted, even when they made enough milk for triplets, they were only a 36 B (maybe). After nursing two children they're still small and perky, so I think my boobs are going to hold up well for all that lies ahead.

—Franny, forty-four

Notes on the Contributors

Lara Americo is a writer, musician and defender of justice living in NYC.

Adriana Cavalcanti de Aguiar is a Brazilian medical doctor and holds a master's in public health, a master's in education, and a doctorate in education (Harvard University). She is a researcher in public health (Oswaldo Cruz Foundation and Rio de Janeiro State University). She is also visiting professor at École des Hautes Études en Santé Publique and a member of the editorial Board of the journal *Pedagogy in Health Promotion*.

Renée E. Mazinegiizhigoo-kwe Bédard is of Anishinaabeg (Ojibwe/Nipissing/Omàmiwinini) and French Canadian ancestry. She is a member of Okikendawdt (Dokis First Nation). She holds a PhD from Trent University in Indigenous studies. Currently, she is an assistant professor at Nipissing University in the Department of Native Studies. Her areas of publication include practices of Anishinaabeg mothering, maternal philosophy and spirituality, environmental issues, women's rights, Indigenous Elders, and Anishinaabeg artistic expressions.

Marta Ausona i Bieto is a university teacher of social work at the Pere Tarres School (Ramon Llull University). She holds a degree in social work and in social anthropology (The University of Barcelona). Marta has a PhD in social and cultural anthropology with a thesis about Spanish long-term breastfeeding and other uses of corporality in raising children. She is a founding member of *Mater: Observatori de les M(P) aternitats Contemporànies and* a member of GENI (an anthropology research group on kinship, migration, gender and social control at the University of Barcelona). She is the mother of one girl.

Maria Berruezo Martínez is a mother of two; she holds a degree in advertising and public relations at Universitat Ramon Llull and a master's degree in information and knowledge management at Universitat Oberta de Catalunya. She is the co-founder of LactApp Women Health (a leading breastfeeding application in Spanish-speaking countries), a breastfeeding consultant, and is a teacher at the Breastfeeding National Federation.

Serena Brigidi has a PhD in medical anthropology from the Universitat Rovira i Virgili (URV, Tarragona, Spain) and a degree in pedagogy (Genoa University, Italy). She is a member of Medical Anthropology Research Center of URV (MARC) and a founding member of *Mater: Observatori de les M(P)aternitats Contemporànies*. She is also a member of *Dona Llum, Associació Catalana per un Part Respectat* (the Catalan Association for Respected Childbirth). She has been working on the medicalization of the birthing process and obstetric violence. She is the mother of three children.

Laura Cardús i Font is a primary school teacher, with a degree in anthropology (UAB, UB, Brunel University in the UK) and a PhD in social and cultural anthropology (UB, CIESAS, UNICACH in Mexico); she completed a thesis about the visual ethnic self-representations of young men and women of Indigenous descent in Chiapas (Mexico). She is a founding member of *Mater: Observatori de les M(P)aternitats Contemporànies*. She is a member of *Dona Llum, Associació Catalana per un Part Respectat* (Catalan Association for Respected Childbirth). She is the mother of two children.

Erica Cavanagh's nonfiction and photography have appeared in *The Missouri Review, Iowa Review, North American Review, The Wilson Quarterly, Bellevue Literary Review, Gastronomica, Off Assignment, What's Cooking, Mom? Narratives about Food and Family* (Demeter 2015), and elsewhere. She lives in Virginia's Shenandoah Valley, where she teaches nonfiction writing and food studies at James Madison University.

Patricia Drew is an associate professor of human development and women's studies at California State University, East Bay. Dr. Drew's research examines the intersection of health and identity; in particular, she is interested in exploring how individuals' embodied experiences shape their social interactions and personal self-concepts. Her research projects include studies of identity transformation in weight loss

surgery patients; mothers who undergo postpartum breast reduction surgery; and gender messages in sexuality education films. She holds a PhD in sociology from the University of California, Santa Barbara.

Rosann Edwards holds a PhD from the School of Nursing at the University of Ottawa and is a frontline public health nurse as well as a lactation consultant. She also has a third-degree black belt and is the mother of boys. Rosann has published on breastfeeding and vulnerable populations in peer reviewed nursing journals, and she looks forward to sharing the results of her doctoral work on the breastfeeding experiences and transition to motherhood of older first-time mothers.

Alina Engelman, DrPH, MPH, is an assistant professor of health sciences at California State University, East Bay and a member of the Community Health Commission for the City of Berkeley. Dr. Engelman focuses on health initiatives for underserved populations, including the deaf and disabled, in her roles as a research affiliate at Health Research for Action at UC Berkeley, and as a collaborator on an NIH-funded project at Gallaudet University. Her teaching includes courses in epidemiology, community health, and research methods. She received her DrPH at UC Berkeley and her MPH in Global Health at Yale. Her interests include health disparities, disability justice, health literacy, and emergency preparedness for at-risk populations. She is a dual citizen of the U.S. and Germany.

Catalina Florina Florescu holds a PhD from Purdue University with specializations in medical humanities and comparative theatre. She is a Romanian-born American scholar who teaches at Pace University in New York. She is a published author of the following works: *Transacting Sites of the Liminal Bodily Spaces* (literary criticism; medical humanities); *Disjointed Perspectives on Motherhood* (mothers in literature and motion pictures; feminist criticism); *Inventing Me/Exerciţii de retrăit* (a memoir in Romanian); *Transnational Narratives in Englishes of Exile* (cultural and literary criticism; immigration; Englishes and plurality; diversity and diaspora studies); *The Night I Burned My Origami Skin* (poetry); and *Teatru* (in Romanian). She likes to travel to know the other firsthand. More information can be found about her here: www.catalinaflorescu.com/.

Saara Greene is a Professor in the School of Social Work, McMaster University and a mother of two awesome kids. She is involved in a number of community-based HIV/AIDS research studies funded by the Canadian Institutes of Health Research and the Ontario HIV Treatment Network. Her main activist and research activities are focused on highlighting the pregnancy and mothering experiences and needs of women living with HIV. Her most recent research projects include "The Positive Parenting Pilot Project" and Women, ART and the Criminalization of HIV (WATCH); she has also co-developed the Supporting Mothers in Ways the Work Toolkit: A Resource Toolkit for Service Providers Working with Mothers with HIV.

Debra Guckenheimer is a sociologist, diversity and inclusion specialist, and dissertation coach. She is currently a lecturer at California State University, East Bay. Previously, she taught and conducted research at Stanford University, the Hadassah Brandeis Institute at Brandeis University, and Bowdoin College. Her work has appeared in *Embrace Race, Women's Studies: An Interdisciplinary Journal, The Feminist Wire, Handbook of Positive Organizational Scholarship*, and *Doing Diversity in Higher Education*. She has been recognized by the American Sociological Association's Race, Class, and Gender section and the National Center for Institutional Diversity at the University of Michigan. She has a PhD in sociology from the University of California, Santa Barbara.

Heather Jackson, a former teen mom, is now a thirty-something single mom of a teen. She is often mistaken as her daughter's friend or sister. She is a former site producer of girl-mom.com. Currently, she works as a birth doula and an early childhood counsellor in Rhode Island. She published a chapter in The Bakken Goes Boom regarding the change of maternal health related to the oil boom in North Dakota (where she grew up). She is co-editor of Feminist Parenting anthology through Demeter Press. Her writing has also been published on thepushback.org, hipmama.com, girl-mom.com, and muthamagazine.com as well as in books, and zines. She loves bike riding, going to the beach, playing guitar, going to shows, making zines (etsy shop: ramonegirl), and writing.

Irene Rocha Kalil is a Brazilian journalist and researcher. She holds a PhD in health information and communication, and conducts research on contemporary discourses on breastfeeding and weaning from a

gender perspective. She has also a master's degree in education and a title of specialist in urban sociology, both from the Rio de Janeiro State University. Currently, she coordinates the Social Communication Centre of the National Institute of Health of Women, Children, and Adolescents Fernandes Figueira of the Oswaldo Cruz Foundation, the most important national research institution.

Catherine Ma is an associate professor of psychology at the City University of New York (CUNY). She earned her PhD in social-personality psychology from The Graduate Center, CUNY and is a mother to three fabulous children who make her proud every day. Having experienced numerous problems nursing her three children, she was inspired to use her research expertise to help women nurse their babies in an empowering manner and make informed decisions regarding infant feeding. She immigrated to the United States from Kowloon, Hong Kong, became a naturalized citizen at the age of eight, and overcame many struggles as a first-generation college student. Her love of breastfeeding research parallels her love of teaching at a racially diverse college because she finds it a privilege to teach students who share similar beginnings. Her research includes breastfeeding ideology, youth sports, the lived experiences of women, and the psychology of immigration.

Alba Padró is a mother of two girls and a university teacher of breastfeeding at Universitat Autònoma de Barcelona and co-director of the postgraduate on breastfeeding at the Blanquerna-Ramón Llull University. She is a nursing assistant and IBCLC (International Board Certified Lactation Consultant), a teacher at the Spanish Breastfeeding National Federation, as well as a coordinator, a speaker, and lecturer. She is a co-founder of LactApp Women Health (a leading breastfeeding application in Spanish-speaking countries), president of Alba Lactancia Materna, and the author of *Somos la Leche*.

Jessica Rodríguez Colón is a Puerto Rican artist and scholar living in New York City. She is currently a doctoral candidate in philosophy, aesthetics, and art theory at the Institute for Doctoral Studies in the Visual Arts. Her research focuses on maternal politics and performances in the Americas, ranging from evaluating maternal politics and aesthetics in the media, in performance arts, and in the visual arts. In her work, she questions the societal prescription of motherhood and

how aesthetic representations of the maternal influences maternal performances. Jessica has participated at conferences in the United States and Europe. Rodríguez-Colón also has a creative practice that ranges from performance arts and video installations; as an artist, her work has been presented in the Americas, Europe, and at the Museum of Contemporary Art in Taipei.

Lisa Sharik, BEd, MA, BA, is a feminist scholar, activist and graduate student in Gender, Feminist, and Women's Studies at York University in Toronto, Canada. Presently, she is finalizing her major research paper titled "Breastfeeding in a Sexualized World," which explores the relationship between the sexualization and objectification of women's breasts in Western cultures and the ongoing lack of acceptance and appreciation of public breastfeeding. Her central research pertains to how the normalization of sexual breasts in Western cultures has led to a lack of knowledge about the biological function of breasts, namely, lactation. She is also an Ontario certified teacher who works as a public educator with the Niagara Region Sexual Assault Centre and with the Kristen French Child Advocacy Centre. She lives in St. Catharines, Ontario with her beautiful daughter Sunshine, who she breastfed for 4 glorious years.

Robin Silbergleid is the author of the collection of poems *The Baby Book* (CavanKerry Press 2015), the memoir *Texas Girl* (Demeter 2014), as well as co-editor of *Reading and Writing Experimental Texts: Critical Innovations* (Palgrave 2017). She is an associate professor of English and director of creative writing at Michigan State University.

Wendy Simonds is a professor of sociology and gerontology at Georgia State University in Atlanta. She is author of *Abortion at Work: Ideology and Practice in a Feminist Clinic*; *Women and Self-Help Culture: Reading between the Lines*; and co-author of *Laboring On: Birth in Transition in the United States* and *Centuries of Solace: Expressions of Maternal Grief in Popular Literature*. Simonds is also co-editor of *Sex Matters: The Sexuality and Society Reader*, now in its fifth edition.

Jessica Whitbread is a global movement builder, who incorporates feminist perspectives into her work on HIV, gender, and key populations. A graduate of the Environmental Studies program at York University, she has a degree in building communities to ignite social change. She works in the realm of social practice and community art,

merging art and activism to engage a diversity of audiences in critical dialogue. Her body of work includes multiyear projects LOVE POSITIVE WOMEN; Tea Time; No Pants No Problem, and is a co-curator of POSTERVirus.

Kristin J. Wilson is the chair of the Anthropology Department at Cabrillo College in Aptos, California. She is the author of *Others' Milk: The Potential of Exceptional Breastfeeding* and *Not Trying: Infertility, Childlessness, and Ambivalence.*

Deepest appreciation to
Demeter's monthly Donors

DEMETER

Daughters
Naomi McPherson
Linda Hunter
Muna Saleh
Summer Cunningham
Rebecca Bromwich
Tatjana Takseva
Kerri Kearney
Debbie Byrd
Laurie Kruk
Fionna Green
Tanya Cassidy
Vicki Noble
Bridget Boland

Sisters
Kirsten Goa
Amber Kinser
Nicole Willey
Regina Edwards